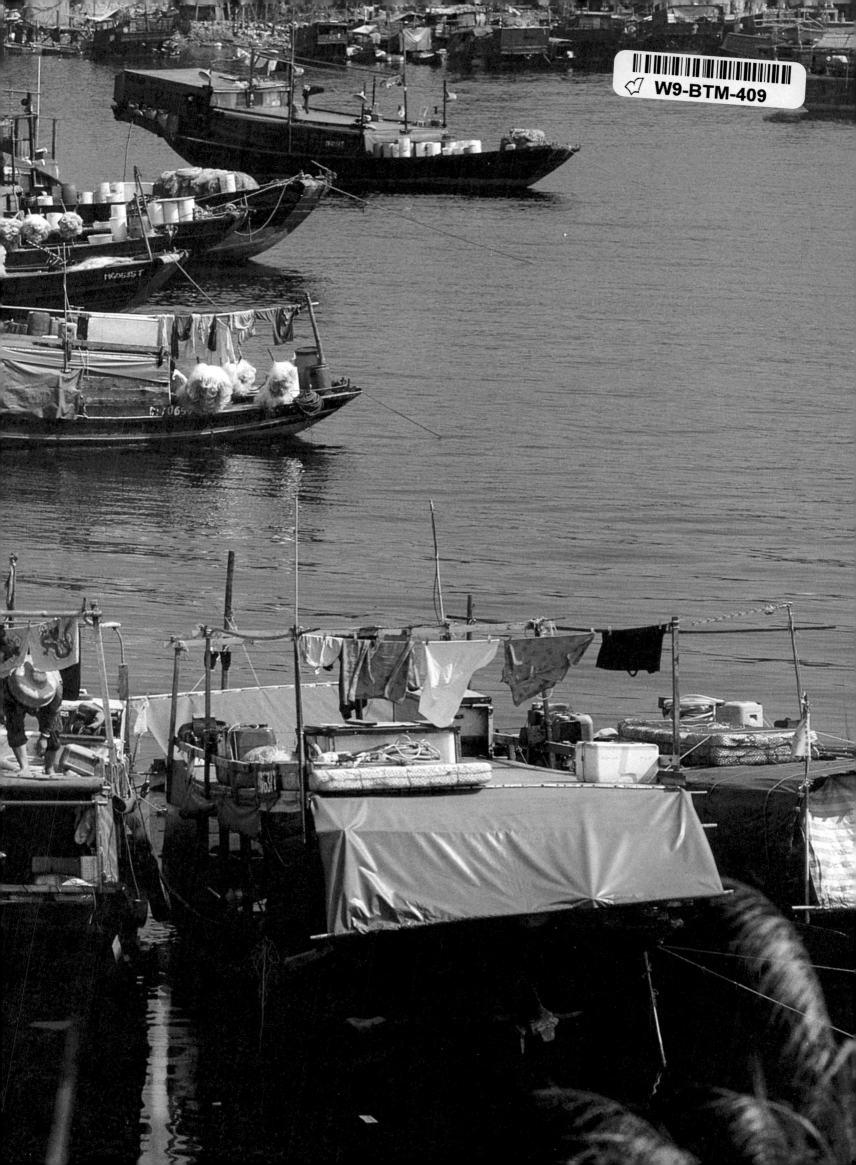

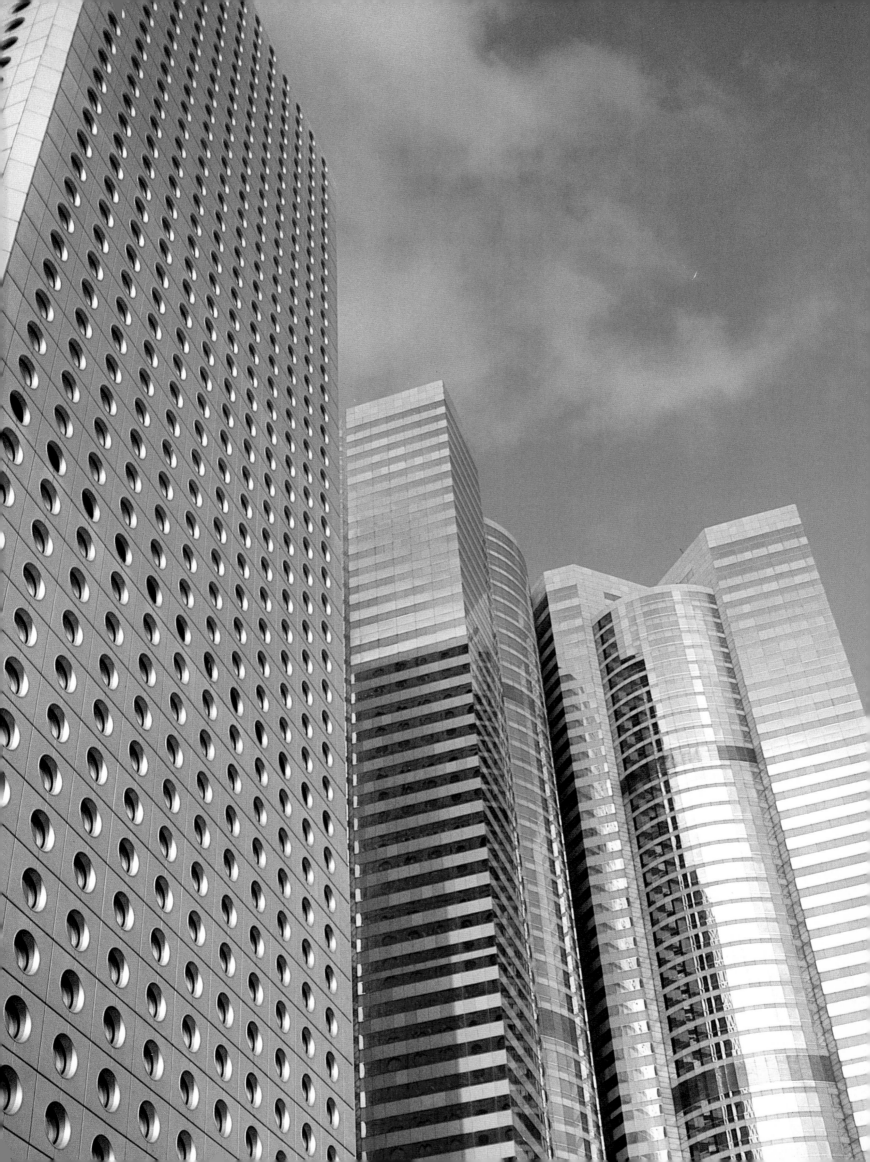

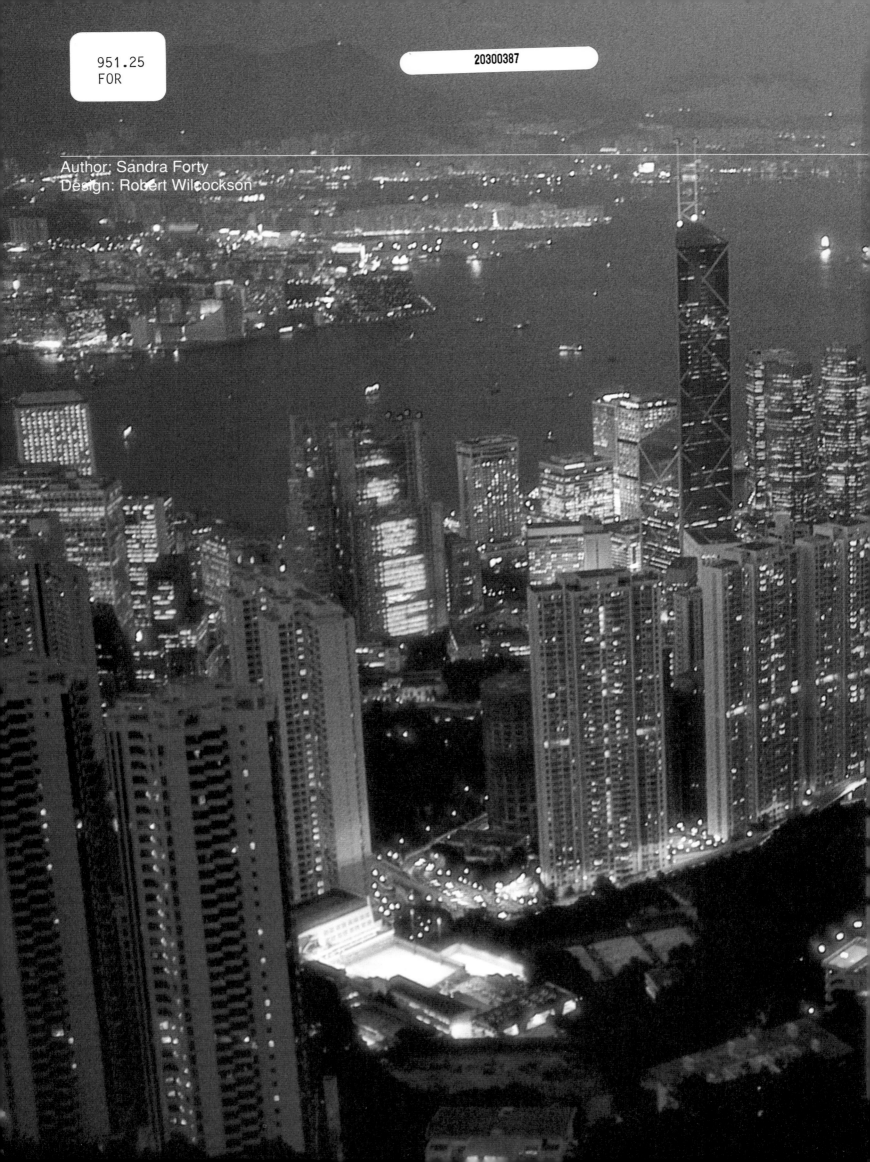

Author: Sandra Forty
Design: Robert Wilcockson

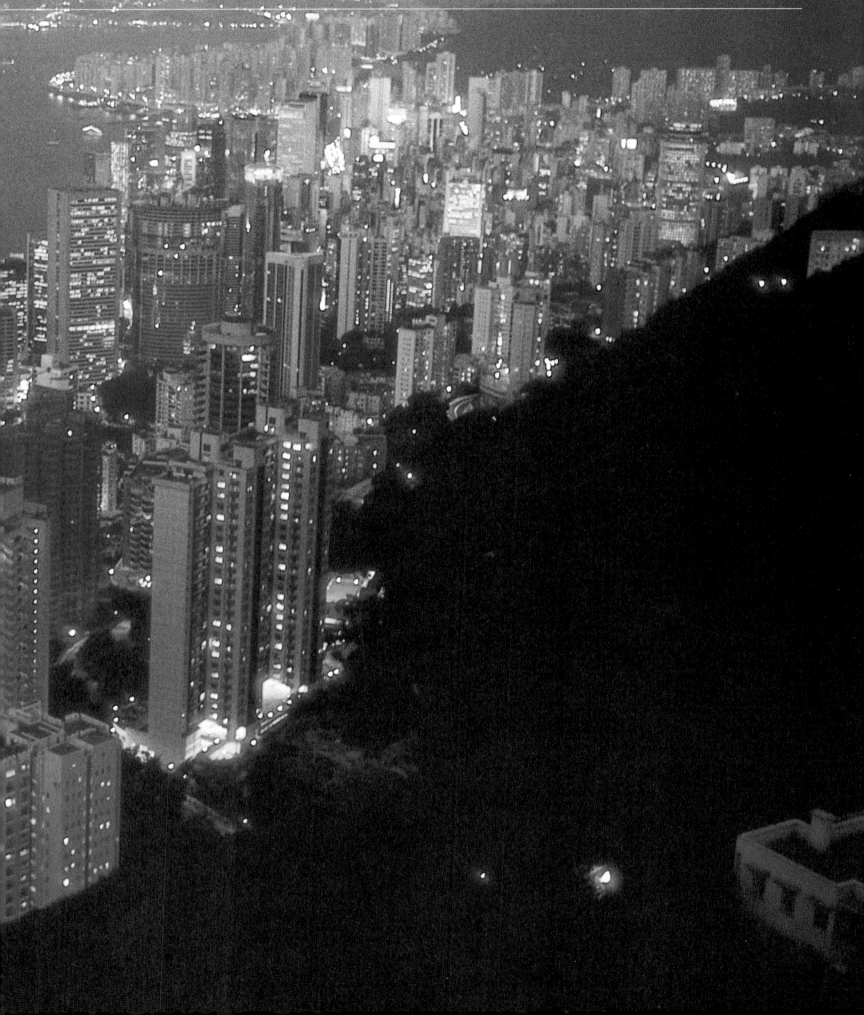

HONG KONG

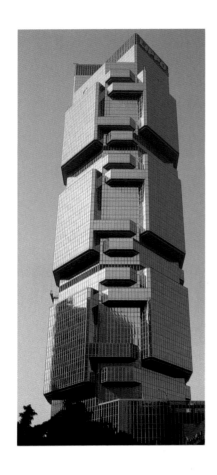

Hong Kong — the name alone inspires visions of the Far East and all the excitement that a distant and exotic city spells. It is the place were East meets West in an explosion of cultures which mingle to emerge as a distinct whole that is neither Occident nor Orient, yet is totally unique to Hong Kong. The two entirely different cultures merge in such a seamless way that something that starts out completely Western transmutes into something that is completely Eastern. For example consider the magnificent high rise office blocks around the centre of Hong Kong: state of the art innovative Western technology and architecture, all built by Chinese craftsmen using traditional methods alongside the modern and all the while working on and around bamboo scaffolding!

Hong Kong is a small city state in the South China Sea off the southern edge of the Chinese province of Canton at the mouth of the Pearl River, just south of the Tropic of Cancer: a British Crown Colony until it reverts back to the Republic of China on 1 July 1997. That is the day that the 99-year lease on 90 percent of the territory expires; the remaining 10 percent is the actual island of Hong Kong and the area of Kowloon south of Boundary Street both of which were ceded in perpetuity. They are not viable on their own, so they too will also be returned. On 1 July the area will become a Special Administrative Region of China under a compromise government the Chinese call 'the one country, two systems' formula. Hong Kong citizens have a 50-year guarantee of the same basic freedoms they enjoyed under the British.

As a Crown Protectorate, the territory has a British governor appointed by Whitehall — currently, and destined to be the last, Chris Patten. He is assisted by the Executive Council and the Legislative Council, with whose advice he enacts laws. The Urban Council looks after the city with six official and 20 unofficial members. The District Commissioner looks after the New Territories with the help of district officers. To assist with law and order the Royal Hong Kong Police Force is 22,000 strong, plus a Marine division of 1,300 officers and 45 launches.

Roughly five and a half million people live here: 98 percent of the population is Chinese, many of them former refugees from Communist China. About 168,000 are foreigners, most of them British but also Americans, Australians, Japanese, Germans, Indians and French. Many of the foreigners come to work here for a few years before returning (usually much richer) to their native lands. However at any one time, and particularly during the summer, the territory's numbers are inflated with millions of tourists who come to see the sights and sounds of this great city. The population is active, interested and literate: for example, there are 45 daily newspapers the vast majority of which are in Chinese, three are in English and one is in Japanese, plus numerous other newspapers for special interest groups such as sports and entertainment subjects. Then there are numerous periodicals as well catering for all manner of interests and tastes.

One of the great attractions of Hong Kong for the businessman — besides the lack of red tape in dealing with government — is that income tax, both personal and corporate, is among the lowest in the world. Furthermore there's no capital gains tax; no limit on the amount of money that can be brought in or taken out of the territory; and there are no import or export duties to be paid on goods and services.

Geographically, the island of Hong Kong is just one of the 236 islands that constitute the New Territories, making 1,050sq km (400sq miles) that were leased to Britain from China for 99 years. Uniquely Britain will actually be handing back more land than it acquired — approximately 26sq km (10sq miles) more — as land has been reclaimed in the central District and on the Kowloon side of the harbour enthusiastically for most of the century.

Hong Kong is 145km (90 miles) from Canton, the original honey pot for Europeans which attracted the greedy traders in the first place. The island itself is 17.7km (11 miles) long and 3.2–8km (2–5 miles) wide, with an area of about 77.7sq km (30sq miles). Much of the land is steep, unproductive, barren hillside — no use for farming or building. All Hong Kong's fruit and vegetables have to be imported from the mainland, as — crucially — does most of its water supply. Most of the population is squeezed onto Hong Kong island and on the immediately adjacent Kowloon peninsula. The magnificent natural harbour is 26km (16 miles) long and 1.6km (1 mile) across between Victoria Harbour and Kowloon.

Above
One of the Bond Centre's twin towers with the Bank of China in the background.

Previous page
View of Hong Kong Island's Central District from the Peak.

The weather is best and most equable in the autumn up until Christmas when the temperature is 15-27°C (60-80°F) with clear blue skies every day. Between mid-February and the end of April the humidity soars and life becomes sticky and hot. The dangerous typhoon season is from the summer until September; everything stops when an imminent typhoon warning is issued.

In common with Chinese everywhere, Hong Kong people are very superstitious: for example, the front and back doors must not face each other across a hallway lest evil spirits hurtle through the house. Door gods are painted on doors into certain rooms on New Year's Day when the house is thoroughly swept to rid it of evil. Much superstition is exemplified by the observance of the unwritten laws of geomancy known as *Feng Shui*. Wise men known as geomancers are called in to pronounce on the most auspicious siting for buildings — especially temples, homes and more recently, offices — the exact site, aspect, doors and windows of buildings; they are also consulted for their opinion on siting grave sites, new roads, etc. They use discs and compasses to arrive at their decisions which are taken very seriously indeed. Their adherents are quick to point out to sceptical Westerners that if this advice is followed bad luck will pass by and all will be safe and well.

An example of how this works is given by the building of the Bank of China. The fifth highest skyscraper in the world at 369m (1,210ft) tall, it was built 1986–89 on two steeply sloped acres. It was designed by I. M. Pei with a sharply angular obelisk-like shape made predominantly in glass and aluminium, and dominated structurally by triangles and pyramids, all shapes considered to have good *feng shui*. However the original plans were pronounced to be unlucky by local geomancers because the masts on top of the building looked like chopsticks held over an empty bowl — a symbol of poverty; there were also other signs of bad portent. Pei was persuaded to disguise or adapt all the problematic aspects and the building went ahead, although it was not completed and ready for the topping off ceremony on the due date — the eighth day of the eighth month in 1988 — a hugely lucky collection of numbers making it the most auspicious day of the century according to *Feng Shui* geomancers.

Numbers also play an important part in Chinese belief and superstition. Especially lucky numbers are the number 3 for living or giving birth, 6 for longevity, and 8 for prosperity. Red is regarded as a very lucky colour and is the predominant hue for virtually every celebration and festival.

HISTORY

At the beginning of the 19th century, following in the wake of the Portuguese who had already been granted trading concessions and land at Macau, the English, Americans and Dutch sent their fleets east in search of a share in the riches of the fabled empire of the Manchu dynasty. At first rebuffed, the foreign barbarians were eventually granted minor trading concessions far from the capital Peking. They were kept segregated from the native population and concentrated in one small area along the waterfront in Canton, where they could trade with only a select group of native merchants, whose guild was called Cohong. The Chinese were traditionally very suspicious of the motives of foreigners and forbade them by Imperial edict to go inland; so, as trade expanded, factories were built along the shores of the Pearl River.

All exports had to be paid for in silver bullion: the Chinese were very partial to silver and continue to be so. (This love of silver is still apparent in the Hong Kong dollar [HK$]. Based on the Mexican silver dollar which arrived in Hong Kong via the Philippines, the Hong Kong dollar has to be in silver.) But it wasn't long before getting sufficient silver became difficult — and too costly — for the traders. What could be found as an alternative? There was little that the Chinese seemed to want from the Europeans. However, the Portuguese had been successfully smuggling opium and the other Western powers, with Great Britain dominant, soon followed suit. British traders had access to huge amounts of opium (called 'foreign mud' by the Chinese) from Bengal, so it was a valuable and readily available commodity to trade. The illicit trade thrived as more Chinese became addicted and huge amounts of the drug entered the country.

Inevitably, once the true nature of opium was officially appreciated, the Emperor moved to legislate against the drug and in 1839 sent Lin Tse-hsu, Governor of Hunan province and personally strongly opposed to opium, to Canton to stop the trade. He confiscated and destroyed the foreigners' stocks —

A magnificent dragon head as seen at numerous festivals.

huge amounts of it — and expelled the traders from Canton. As they headed for the comparative safety of Macau, he cut off that area to them by threatening the Portuguese with repercussions if they gave them shelter: many took shelter in the harbour that would become Hong Kong.

If the Emperor, with his autocratic and remote view of the world, thought this would solve the problem, he was cruelly mistaken. The West — particularly the British — wanted free trade with China and had the aggressive attitude and the modern machinery of war that the Chinese had not developed. The British retaliated after their ejection from Canton with a remarkable show of gunboat diplomacy. In 1840 they sent a huge fleet in support of the British Trade Superintendent, Captain Charles Elliot, and the First Opium War began. It wasn't long before British forces had retaken Canton and the fleet threatened the Empire's capital city. Forced to negotiate, the Chinese tried to stall and fighting broke out again. It was in this period, on 26 January 1841, that Charles Elliot raised the British flag over the largely barren island of Hong Kong, as an alternative settlement to Canton particularly with regard to its outstanding natural harbour.

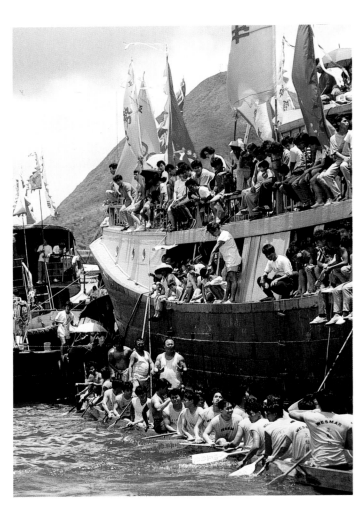

Elliot was not thanked for his choice of a base or his actions in the area (he himself was disgusted by the opium trade) and was recalled in July 1841 to be replaced by Sir Henry Pottinger, who was to become the island's first governor. Under Pottinger fighting flared up again and the fleet moved once more towards Peking, taking cities and ports as it went. Following the fall of Shanghai, with Nanking threatened, the Chinese capitulated. In 1842, the Treaty of Nanking ratified Hong Kong as a British Crown Colony and freeport in perpetuity, and provided the British with trade concessions in five mainland Chinese cities.

Few people foresaw the potential of this infant colony, despite its magnificent harbour and deep water port. All the action was in Canton and the other Nanking Treaty freeports. The colony grew up as a backwater, with a population of less than 20,000 and a difficult life in the swampy malaria-infested area. But better times were just around the corner. In 1856 an incident on the British-owned *Arrow* gave the British the chance to send another fleet, in the process setting in motion the Second Opium War. This time, with the French, they would occupy Peking itself. The British were then able to dictate terms, forcing more trading concessions. In 1860 the Convention of Peking saw China cede more territory to Hong Kong colony, this time part of the mainland itself — the peninsula of Kowloon up to Boundary Road.

Hong Kong grew rapidly after the Second Opium War, attracting business and businessmen: Jardine Matheson was the first large trading company to build along the waterfront, and it is still responsible for firing the Noon Day Gun — a Hotchkiss three-pounder which stands in front of the Excelsior Hotel. The gun points out at the Royal Hong Kong Yacht Club and is fired at midday out over the new typhoon shelter. Everyone in the territory sets their watch by it.

The Hongkong and Shanghai Bank was set up in 1864 and the colony became the centre for much of China's foreign commerce — although the opium trade still accounted for most of this. The population grew rapidly — even more so following the final land concession in June 1898 following the cessation of the Sino-Japanese war. From 1 July the so-called 'New Territories', along with 230 small islands, were leased from China by Britain for the span of 99 years. Interestingly, there was one Chinese enclave in the area — the Walled City which remained an area of contention thereafter.

The Chinese were learning slowly that they had seriously underestimated the European powers. In 1878 ambassadors had been dispatched to the outer barbarian countries, to learn more of their customs and intentions. Racked with internal strife, the old empire tottered on. Some provincial governors had learned to change, to develop modern armies and communications, and from the 1890s onward more and more young men were sent abroad to study (including the forthcoming Communist leadership).

But the Imperial court remained focused on the restoration of the past. In 1898 the young Emperor attempted across-the-board reforms but was deposed by the Empress Dowager in a conservative coup. In 1900 a wave of xenophobia sparked off the Boxer Rebellion, a final attempt to rid the empire of the unwelcome barbarians, but it was doomed to failure from the start. By 1905 Dr Sun Yat Sen was leading an anti-Manchu movement, which finally overthrew the old monarchy, and in 1911 the Republic of China was born with President Sun Yat Sen at its helm.

By now the population of Hong Kong was about half a million, fed by the influx of mainland refugees. By 1921 it would increase to three quarters of a million, rising to one million in 1937, and 1.6 million by 1941. The early years of this century saw a change in business emphasis following the end of the filthy

Dragon boat racing in Aberdeen Harbour.

and deplorable opium trade. It was also Hong Kong's last period of real peace until after the end of World War 2.

In 1925 Sun Yat Sen died and into the ensuing power vacuum stepped the Kuomintang, the Chinese Nationalists based in Canton. Such a militant movement so close to the colony was a source of much trouble, culminating in a total economic boycott of the colony and a general strike which damaged both its commercial and manufacturing capability. While the strike didn't last for long, more trouble was on the horizon. China was in a state of civil war between Communists and Nationalists and on top of this the Japanese invaded. First Manchuria; then they pushed southwards until by 1939 they had occupied Canton — despite the alliance in 1937 of Communists under Mao and Nationalist Kuomintang to fight the Japanese.

It was only a matter of time before Hong Kong was invaded. With its small area and minor forces, any attack was bound to succeed. It came on 8 December 1941, the day after the attack on Pearl Harbor. Outnumbered two to one, by the 13th the British had to withdraw to Hong Kong Island; on the night of the 18/19th, the Japanese forces got a foothold on the island and on the evening of Christmas Day, the British forces surrendered. Both the civilian and military populations were imprisoned in infamous camps in Kowloon and on the island.

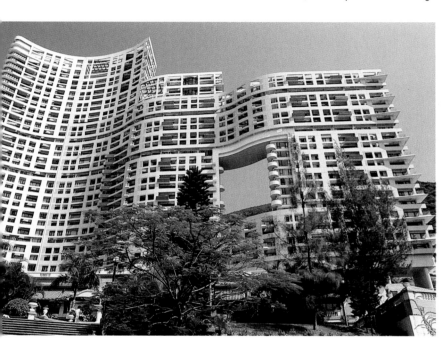

The dark years of oppression only lifted in 1945 at the end of the war. Following the Japanese surrender the British reasserted their rights to the colony, moving to reoccupy it swiftly and scotch any attempts to alter its status to that of an independent international port. Though impoverished by the war Hong Kong now began to rebuild both its population and economy.

In 1949 the Kuomintang lost its struggle for domination of China to Mao's Communists; its leadership fled to Taiwan but many of its supporters plus fugitives from the Communists, fled to Hong Kong. The colony's population was swelled hugely — by 1956 it was calculated to be 2.5 million. Apart from the serious housing shortage and dreadful living conditions for the majority of the Chinese, there were riots between rival Communist and Nationalist factions. This placed a huge burden on the colony which had already been stretched by the UN embargo imposed in 1950 on all trade with China following its support for North Korea in the Korean War. At a stroke this move wiped out the foundations of Hong Kong's economy as an entrepôt between the West and China. However the embargo actually turned out to be a blessing in disguise as it forced Hong Kong's businessmen to turn away from straightforward trading to becoming an industrial economy — and even more prosperous in the process.

The immigrants were not all bad news; they brought positive benefits too: skills and, above all, a vast and cheap labour force. Hong Kong became a full manufacturing centre instead of just a halfway house. The authorities began emergency housing programmes — made even more necessary in 1962 when China let out a huge wave of refugees. Also tourism began to grow, partly assisted by off duty US servicemen on R and R from the Vietnam War.

The next significant event in Hong Kong's history — indeed, the history of the whole of the area — was Mao's cultural revolution in 1966: it brought chaos. Red Guards stormed Macau and there was unrest and riots in the colony. But, surprisingly, everything calmed down by the end of 1967: both colonies were far too important as sources of foreign currency to be jeopardised by Beijing.

The story of Hong Kong in the late 1960s and 1970s is one of rapid growth, prosperity and economic gain on the one hand — but overpopulation, illegal immigration and corruption on the other. In 1969 there was the first Festival of Hong Kong. In 1971 the cross-harbour tunnel was opened between Victoria and the mainland. In 1973 the first new town in the New Territories — Tuen Mun — was opened. In 1976, amid tremendous celebrations, Queen Elizabeth II became the first reigning British monarch to visit the colony. In 1977 the High Island Reservoir was opened as part of a programme to satisfy the island's constantly increasing demand for fresh water. In 1979 the state-of-the-art Mass Transit Railway, costing US$1 billion began running.

At the same time, however, the Territory — the word colony has been rarely used since the 1970s — was filling to bursting point from a combination of illegal refugees from the mainland and the victims of war escaping from Vietnam. The boat-people began to arrive, at first a trickle and then a flood. By the end of 1978 so many had arrived that Hong Kong ended its tolerant immigration policy of allowing any refugees who made it safely across the border to stay.

With the refugees came poverty and crime: the number of triad groups increased and the Walled City became a no go area to government officers. In 1974 an attempt was made to quell the rampant

Block of flats at Repulse Bay, complete with a hole in the centre so that the dragon living in the hills can still see the sea — as dictated by *Feng Shui* geomancers (see page 42).

corruption with the setting up of the ICAC (Independent Commission Against Corruption); one of its first and foremost targets was the police force. Having grown up as a free-trading colony, with few rules and general democracy for the vast proportion of the population, and furthermore one founded on the traffic of drugs, it was inevitable that Hong Kong would suffer from endemic corruption in-built with its power structures. Drastic measures were needed. In 1975 there was a huge anti-drug operation brought about through the international co-operation of several countries including the US, the UK and Thailand. But yet only shortly afterwards, at the insistence of the Hong Kong Police Force, there was an amnesty for all crimes of corruption before 1 January 1977.

The People's Republic of China was recognised by the United Nations in 1971 allowing her a voice in international affairs, followed the year after by the American President Nixon's visit to China. 1977 saw Mao and Chou-en Lai in their graves and Deng Xiaoping in ascendancy and beginning to operate from a different agenda. The future of Hong Kong was very much in the balance — would China insist on the 1997 deadline or could she be persuaded to extend the lease? The answer became clear in 1982 when British Prime Minister Margaret Thatcher paid an important visit in person to China and Hong Kong to start negotiations on the future of the territory. Sovereignty became the crux of the matter with Beijing insisting that the original territorial concessions to Britain were invalid as they were imposed by force of arms and not arrived at by mutual and friendly consent: China wanted Hong Kong back.

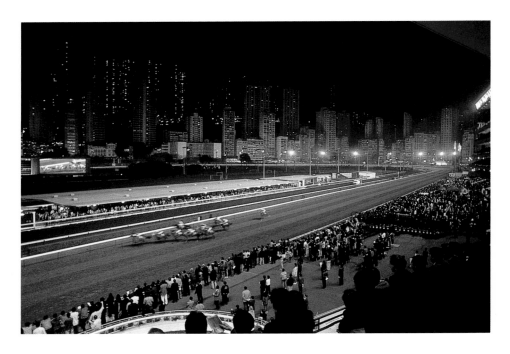

In the area next to the colony on the mainland Deng created the Shenzhen Special Economic Zone which by 1983 created much cross-border commerce to the advantage of both sides. Sino-British talks continued, with China stating that it would govern Hong Kong as a Special Administrative Region, which would be allowed to remain a capitalist system, with its own judiciary and police. But confidence in the colony eroded over such Chinese ambitions, and stocks and shares plummeted. By 1983 in the complicated discussions over the territory, it become apparent that the Chinese were not going to budge on their demands for the return of the New Territories, and that without their co-operation Hong Kong would not be able to stand alone: Britain had no option but to return the entire area to China.

Prime Minister Thatcher was reluctantly persuaded to concede complete sovereignty to China, and once this hurdle had been passed everything began to go more smoothly. Although amongst the Chinese population, many of whom had originally fled the upheavals and regimes of the mainland, there was much less optimism and real fear of reprisals. Many began converting their assets and if not actually moving elsewhere, at least moving much of their capital to safer countries in anticipation of later forced emigration.

On 26 September 1984 a Draft Agreement on the Future of Hong Kong was arrived at and then signed in Beijing on 19 December by British Prime Minister Margaret Thatcher and Chinese Premier Zhao Ziyang, ending two years of acrimonious negotiations. The end was inevitable given the relative size and distance of the two countries, only Hong Kong's commercial usefulness and considerable financial prosperity to both parties had ensured its survival.

Over the years the different messages sent by Beijing have been distinctly chilling and depressing — the massacre of civilians in Tiananmen Square by Chinese Guards was a brutal repression of attempts to introduce more personal freedom for ordinary Chinese. But although many have left Hong Kong and continue to leave, many more remain, reasoning that China will continue to need their massive resources as one of the world's richest and largest commercial and manufacturing centres, busiest port, highest concentration of humanity on the planet — the list of superlatives is endless, and should guarantee that this great interface of culture and commerce between east and west continues to exist.

FESTIVALS

Hong Kong is an exciting, vibrant city which revels in the colour and pageantry associated with festivals all year round. One of the great highlights of the water-bound year is the great and spectacular Dragon Boat Festival, enjoyed almost as much by landlubbers and tourists as by the sea dwellers. This has been held for the last two millennia on the fifth day of the fifth moon, which is usually in early June. The festival commemorates the unjust death of a learned and honest minister of state for Yuan (who died in

Happy Valley Racecourse is built on drained and reclaimed marshland.

288BC). He conscientiously advised his Emperor well but his master was turned against him by devious enemies. He was eventually ordered into exile. Instead of fleeing safely into obscurity, he jumped into the River Mi-Lo in Hur Province. The dragon boat race commemorates the frantic attempts of his friends vainly rushing to his rescue, while others threw rice dumplings into the waters to feed the hungry fish and sharks who infested the waters.

Day-long elimination heats are held amidst great excitement and tremendous cacophony. Seemingly everyone in Hong Kong comes to enjoy the great dragon races, and crowds throng the shores and fill the decks of every available boat. All the locals have a favourite team whom they support by carrying their exuberant bunting. Every available mast and rope has colourful triangular pennants and streamers rippling in the wind.

A gunshot signals the start of each race when the waters instantly erupt into an explosion of noise, colour and spray. Onlookers scream their encouragement as the pounding of the drums insistently beat out the pace for the rowers and gongs and cymbals clang energetically to ward off evil spirits.

The dragon boats vary in size, carrying anything between 20 and 80 paddlers, plus a drummer who

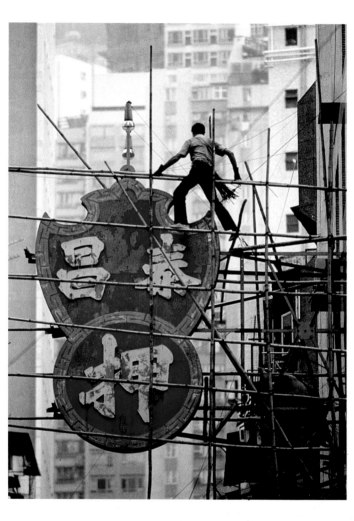

stands in the middle of the boat beating out the rhythm of the strokes. The boat itself is actually a large canoe with a huge, elaborately carved and gaudily painted, dragon's head on the prow and an appropriately matching tail at the stern. The teams tend to be made up by members of various clubs, army, police, firemen and so on. Europeans are allowed to enter teams to compete against the expert Chinese. The final is eventually held between the three fastest boats.

This is just one festival: within the year are numerous other colourful and exciting occasions honouring the gods or historic events. For the visitor this means in all practical terms that there is some sort of celebration virtually every month. However, because the Chinese use the lunar calendar their festivals fall on different days from year to year. Sadly fireworks are no longer allowed by law to be let off in Hong Kong because of the Red Guard's political riots in 1967, although for centuries they were such an historic and integral part of many festivals.

The year starts with the most important festival of all — Chinese New Year. Exactly when it occurs is decided by a complicated calculation carried out by geomancers. This means that it can fall anywhere between the end of January and the end of February, but traditionally when the peach blossom is in flower. Both peach and plum blossom is considered particularly lucky at this time, in particular for lovers. In addition kumquat trees and narcissus flowers are also especially lucky and gardeners do everything possible to get these flowers to bloom on New Year's Eve.

Legend has it that many centuries ago in the Yellow River basin the peaceful rural life led by the peasants was shattered one dreary winter day by a mysterious monster called Nein who attacked the people and destroyed their crops and homes. Wise men who investigated the phenomena said that he had appeared after 365 appearances of the sun — but that he was obviously afraid of three things: noise, lights and the colour red. Thus on the 365th evening of each year devout Chinese light up their homes as brightly as possible, make sure that they have 100 solid objects painted red, and finally, to make absolutely sure, they strike drums and gongs and leap around doing energetic dragon dances. The frightened monster disappears.

Homes and other buildings are festooned with colourful bunting, flags, pennants and decorations but most predominantly with red — the lucky colour — and with scrolls and posters with Chinese characters asking the gods for prosperity, long life and happiness. This is a time for family gatherings, gifts and for visiting friends and relatives. The eating and giving of food is significant. New clothes are bought and all debts are paid to start the New Year with clean slate. The air is riven with the continuous shattering reports of firecrackers exploding. It is the only time of year when Hong Kong more-or-less closes for three days — although the traditional festival actually lasts 15 days. Children are given paper boats and bright red packets of *lai see*, lucky money which they burn so that their ancestors will have everything they need in the afterlife. Leaping lion dances are customary in the residential districts, but the big hotels tend to put on special displays for tourists. The salutation *kung hay fat choi*, meaning 'wishing you to prosper', is heard everywhere, exchanged between friends and strangers alike.

On the 15th day of the first moon comes Yuen Siu Festival — the Lantern Festival — which marks the end of Chinese New Year. At this time traditional brightly coloured lanterns are hung out in houses, temples, restaurants and shops. These lanterns can be in a variety of shapes symbolising different aspects of Chinese mythology: a butterfly is the symbol of longevity; a lobster signifies mirth; star-

Buildings in Hong Kong are still built with the use of bamboo scaffolding.

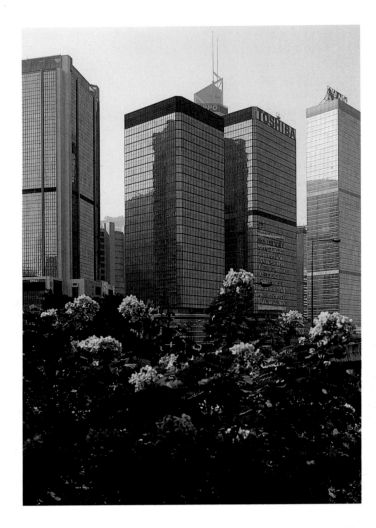

shaped fruit are the sign of autumn; the carp is the old symbol for the emperor meaning above all power, but also strength, courage and wisdom.

In April at the beginning of the third moon on the 106th day after the winter solstice is Ching Ming — the Clear and Bright Festival — when entire families visit their ancestors' graves. It is a public holiday. Chinese families take food and paper money, joss sticks and incense as offerings to the cemeteries of their ancestors. The money and incense and joss sticks are burned and the food is offered to the departed. But it becomes a great picnic and a very happy and cheerful occasion as the food is consumed by the living. Prayers are said for the departed and blessings sought for the living. The family graves are swept and tidied up. Extra public transport is laid on for the cemeteries. The festival also signals the beginning of spring and of a new farming year.

The birthday of Tin Hau falls in either April or May on the 23rd day of the third moon. She is the guardian of seafaring people and their boats are decorated and hung with brightly-coloured banners and the noise of firecrackers exploding echoes across the waters all around Hong Kong. On shore this is another excuse for energetic lion dances. Tin Hau's temples are visited by the fisherfolk to beg for luck in the coming year and offerings of food are made, especially of fruit and pink dumplings given as a mark of respect. The temples are brightly decorated and Chinese operas are performed illustrating the legends and parades and dancing are held at most of the Tin Hau temples around the territory.

On the eighth day of the fourth lunar month is the festival of Tam Kung, the second patron saint of the fishing people. This means in May in the Gregorian calendar. This is a much smaller festival which is only really held at the temple in Shau Kei Wan on Hong Kong Island.

An even quieter and more sedate festival is held by Buddhists in May to celebrate the birth of the Lord Buddha. At this time his statue is taken out of the monasteries and reverently bathed with scented water.

Another of the biggest festivals is held on the eighth day of the fourth moon — Tai Chiu, or the Bun Festival, lasts for four days in late April or early May on the normally quiet rural and fishing community island of Cheung Chau. Thousand flock to the island to take part in and watch the celebrations. Presiding over the festival are three gods: Shang Shaang the red-faced god of earth and mountains; To Tei Kung, a household god who brings good luck; and Dai Sze Wong, the ruler of the underworld. Effigies of them are built and villagers pay homage to them.

The festival is held to placate the restless spirits of the innocent victims of a ruthless 18th century pirate called Pak Pai and his cohorts, although they were supposedly revenged by a series of dreadful plagues in the 18th and 19th century. The ceremonies started after old bones were found on the

Above
Skyscrapers built in the 1970s at Victoria Harbour.

Right
Fishermen of the Tanka tribe preparing their catch for sale.

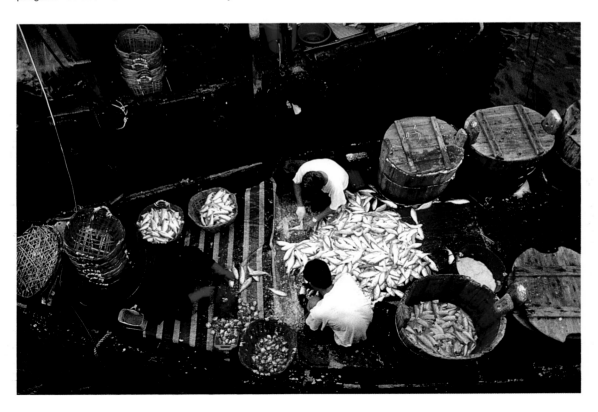

proposed site of some houses. Three important Taoist priests pronounced on the significance of the find and consulted the gods. They decided to be on the safe side and placate the spirits of the dead bones, in order to rid the site of bad *Feng Shui*

As part of the ceremony, outside the temple of Pak Tai about 20m (65ft) high bamboo scaffolding is erected and studded with pink and white edible buns. Competitions used to be held to see who could climb the highest and grab a lucky bun to eat — the higher, the luckier — but since an accident in 1978 caused by over-enthusiastic gang fights, the buns are just distributed from the bottom of the frames after the celebrations which consist of dances, operas and parades. One of the highlights comes on the third day with a procession of floats, carried on long poles with teams of traditionally-costumed children depicting the vices and virtues of mankind. They ride in frozen tableaux through the streets while stilt walkers make their way through the crowds. The entire island throbs to the beat of drums, ringing of gongs and clash of cymbals. Another highlight are the lion, unicorn and dragon dances. There are lots of religious services, opera performances — and noise!

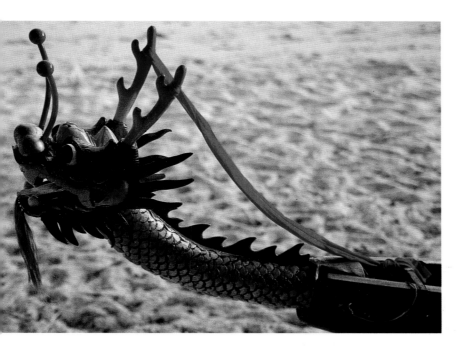

On the 13th day of the sixth moon falls the birthday of Lu Pan. This has become a holiday for everyone who has anything to do with the building trade. Lu Pan was a master builder living around 1600BC, a skilled carpenter who possessed miraculous powers. Banquets are held in his honour on his festival day and there are ceremonies at Lu Pan Temple in Kennedy Town.

The seventh day of the seventh moon (around mid-August) sees the ancient 1,500-year old Maiden's Festival or the Seven Sisters Festival. This is particularly honoured by young girls and their (would-be) lovers. At this time prayers and offerings are made to the six sisters of Chih Nu, who was cruelly separated from her lover by the Queen of Heaven.

Yue Lan — the Festival of the Hungry Ghosts — is on the 15th day of the seventh moon, when offerings are made to appease and placate the spirits of the dead who are released from the underworld for just one day to roam the earth. This is generally considered an unlucky day when accidents are apt to happen and sinister and unsettling events occur. To mollify the dead, offerings are made of elaborate papier-maché models of food, money, houses, furniture, cars etc. They are then ceremonially burnt, often outside on the pavements so that the ghosts can take the objects back to the underworld with them.

On the 15th day of the eighth moon is Chung Chiu — the Moon Cake Festival in September. At this time small cakes are made in the shape of the crescent moon: most of them are made from sesame seeds and ground lotus seeds and mixed with duck egg yolk. Gifts of sticky moon cakes (*yueh ping*), wine and fruit are exchanged between family and friends. The festival coincides with the time parents take their children out onto the open hillsides with lanterns. Then, just before they watch the moon-rise, they each light their lanterns after which the children are allowed to eat their cakes. In Hong Kong every open space is congested with people trying to get a glimpse of the full moon. The day after is a public holiday. The tradition commemorates a 14th century revolt against the Mongols, when the rebelling Chinese hid a call to arms for an uprising written on pieces of paper, hidden and stuffed inside the cakes and distributed to the populace. Everyone read the message, rebelled against the Mongols and won the day!

Also in September is the ceremony commemorating the birthday of Confucius at the Confucius Temple in Causeway Bay.

The ninth day of the ninth month (October) sees the Chung Yeung Festival when large crowds climb up The Peak and other nearby hilltops in commemoration of a soothsayer who advised an old man to take his family up a mountain for 24 hours to avoid disaster. On the family's return everything in the village had died but they were saved. This is also a time for refurbishing family graves.

Although Christmas is not a Chinese festival, Hong Kong has a large Chinese Christian population ; even those who aren't love any excuse for a party so they join in the Christian celebrations with gusto. Streets are lavishly decorated with exuberant colours, lights and flags, many of which stay in place until Chinese New Year. Father Christmas and reindeer appear and Christmas trees are becoming more popular each year. Christmas carols even ring out through the shops.

Dragon head prow on festival boat.

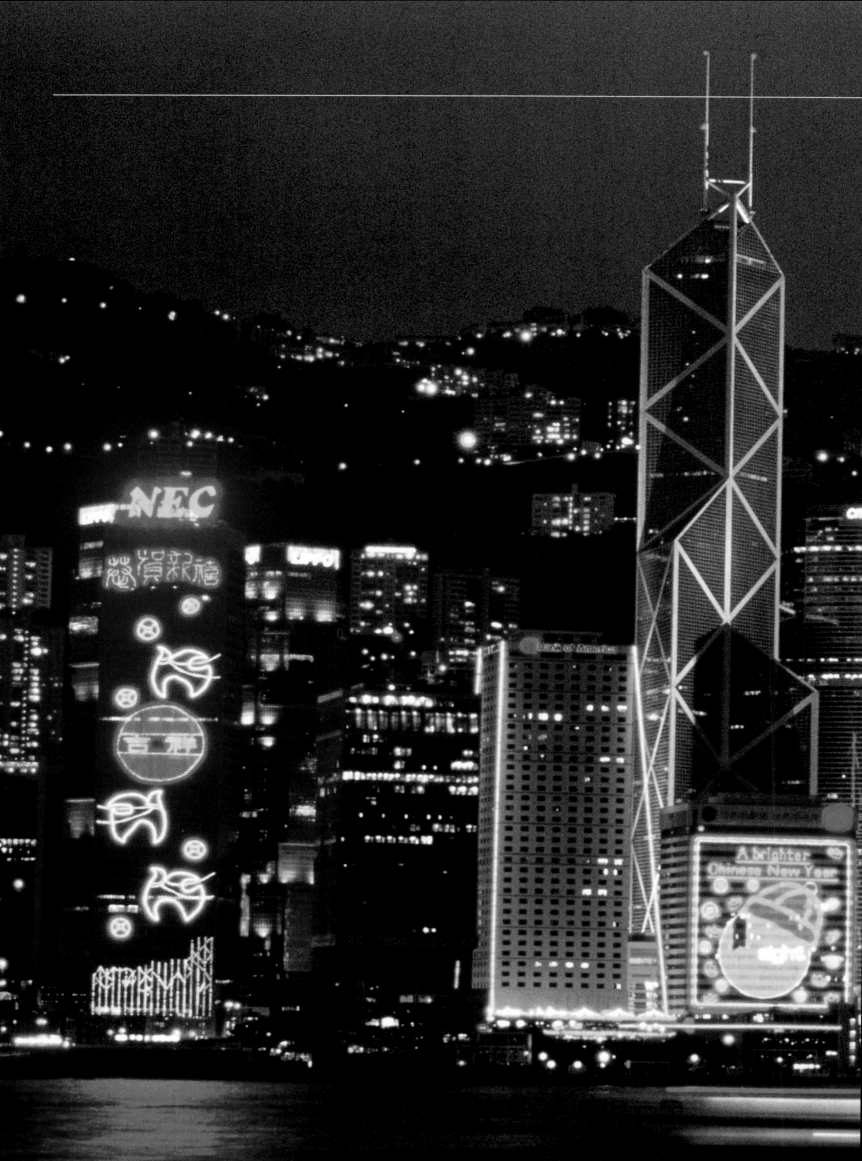

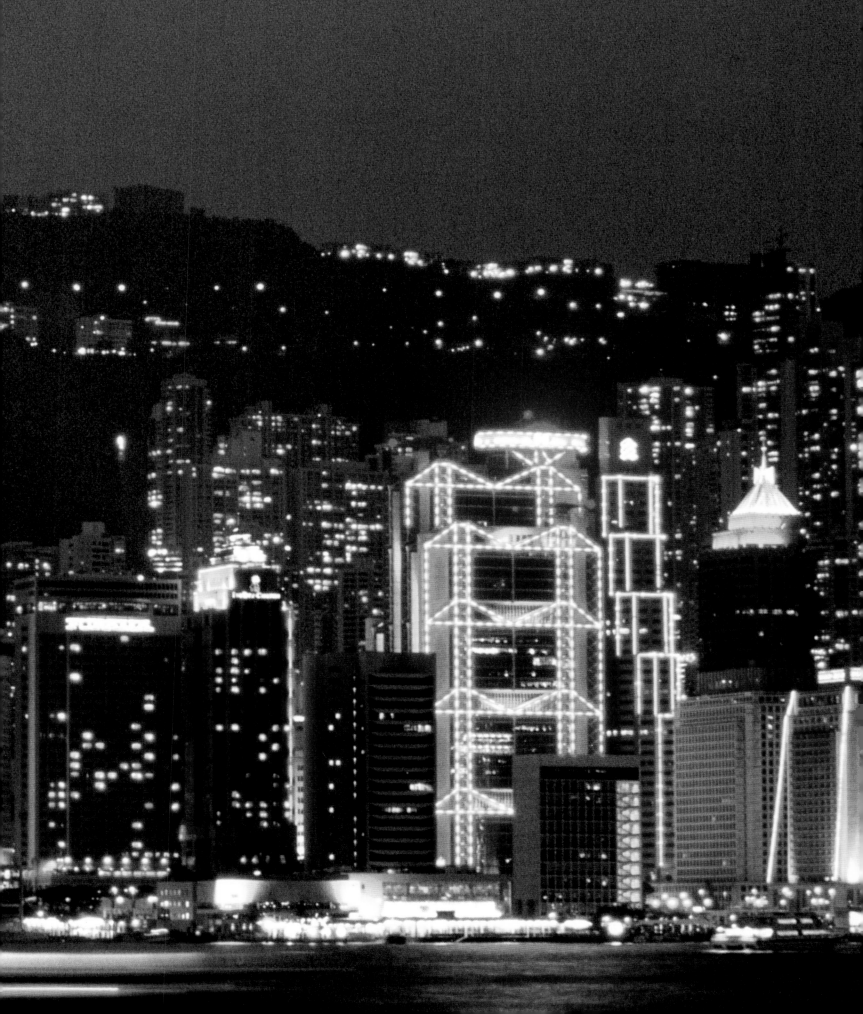

2

Just a few minutes by ferry from the mainland lies Sheung Wan, better known to non-Chinese as Central. Only a small reclaimed slab of land stretching a few blocks from the Harbour, this is the financial and administrative heart of Hong Kong. Brazenly brash and commercial, there are almost no buildings with any historical pedigree. Instead there are vastly impressive and expensive monuments of modern architecture. Office space here is at a premium, making it the most expensive piece of real estate anywhere in the world and Central consequently boasts some of the most costly and exciting architectural masterpieces anywhere. Here all the great financial institutions and businesses have their massive prestige buildings and important employees — Hong Kong gives way to only London and New York as larger financial centres. It is said that the density of Rolls-Royces here is the highest in the world!

Queen's Road marks the old waterfront where the 'godowns' and warehouses used to lie; all the land in front of here is reclaimed, most of it rescued this century. Queen's Road still has many traditional Chinese craft shops, particularly ship's chandlers who used to supply all the traffic of the busy port. Also here is Lane Crawford, the most famous luxury department store in the whole of Asia.

On all the reclaimed land the tall buildings have to stand on massive pilings driven deep into the earth to secure the colossal edifices above them. Because Central is in a typhoon zone, safety requirements are rigorous: Hong Kong load requirements for buildings are twice those of New York and for safety of structure during earthquakes the guidelines are four times as stringent as those for buildings along the San Andreas Fault in Los Angeles. Despite this, buildings are pulled down and put up quicker here than anywhere else in the world; red tape is kept to a minimum and there is no room for sentimentality, even for the older buildings. Here in Central the prevalent noise is not that of the clacking of mah jong tiles as it is elsewhere in the colony, but the ear-splitting rat-a-tat of jack hammers and compressors as the smaller buildings are knocked down and rebuilt. The buildings are constructed so tightly together that there is little space to walk or breathe, so much of Central has elevated walkways and escalators to take people up above the roar and pollution of the traffic. One elevated walkway in particular takes a spectacular route via footbridges alongside the Harbour and then deep into Central itself.

Central has a real 21st century skyline, with ever-taller high-rise office blocks thrusting their way high into the air. But the dominant institutions have the most pre-eminent buildings — namely the imposing spires of Hong Kong's three main banks: the Bank of China, the Chartered Bank and the Hong Kong and Shanghai Bank, the latter said to be the most expensive building in the world. Designed by Norman Foster it cost nearly £900 million, has 52 storeys and is almost 179m (587ft) tall. A staggering 3,500 people work in it. The building is so tall that natural light would have difficulty penetrating the interior were it not for an ingenious solution: on the south front of the building, where it can collect the most sun, is a computer-controlled mirror which reflects sunlight onto a second mirror above the central atrium. From there 120 directional antennae beam the daylight down into the main hall! The bank was built on the site of a 1930s building, the only part of which to survive the destruction were two bronze lions, Stitt and Stephen, who — in accordance with Chinese tradition — guarded the entrance to the building to protect the it against evil spirits. They now guard the main entrance to the bank as well as the colony's currency as they are found on one side of the Hong Kong dollar.

Nearby and completely overlooked by the massive Bank of China lies an oasis of greenery and trees surrounding what is virtually the only surviving relic of turn of the century Hong Kong — the colonial style Supreme Court Building which houses the Legislative Council. Its simple Ionic-colonnaded white facade and dome serve as one of the few permanent landmarks on the edge of the Harbour. Also in Central are three stock exchanges making Hong Kong — along with New York, London and Tokyo — one of the big four of the world's stock exchanges. They are housed together in a building faced with pastel pink marble and glass. Everything inside here is computer-controlled right down to the building's environment which is electrically-operated to produce the optimum environment. There are even talking elevators!

Right at the heart of Central, at the water's edge, is the Star Ferry Pier. Ferries have run from here across Victoria Harbour since 1898, giving one of the cheapest and most memorable ferry rides in the world. The double-decker, diesel-operated ferries are named after stars — *Meridian Star, Morning Star, Evening Star* and so on. They carry around 100,000 passengers a day between Hong Kong, the mainland and the outlying islands.

1. (Previous Page) The stunning city skyline illuminated at night.

2. Shops, restaurants and offices are all contained in the vast development at Pacific Place in Western District.

3. Imposing modern architecture: on the left, the Hong Kong and Shanghai Bank, on the right the tower of the Bank of China.

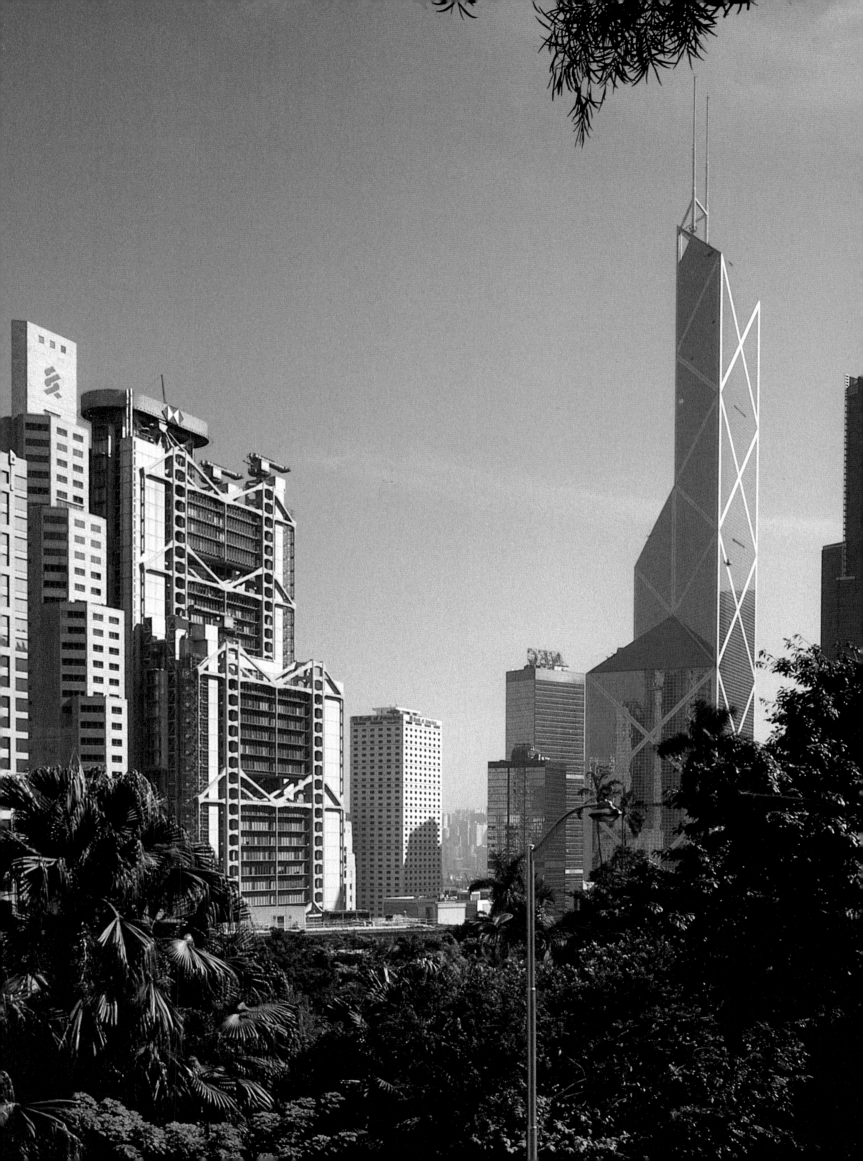

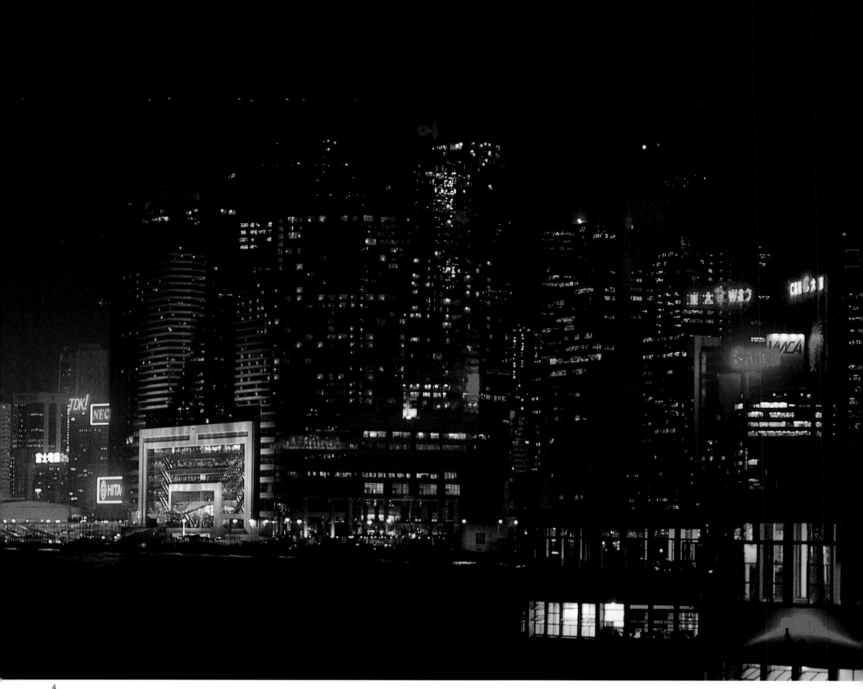

4

5

6

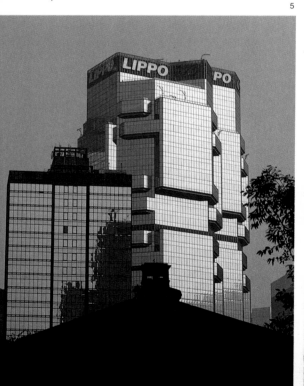

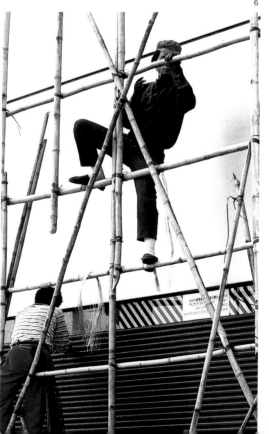

4. If anything, Hong Kong becomes even more spectacular at night when the lights in the offices counterpoint the colourful neon glow of the signs. Note the string of lights high up on the Peaks behind the skyscrapers.

5. The twin towers of the Bond Centre.

6. It takes a good head for heights and the balance of an acrobat to erect and then work from the bamboo scaffolding which is used in the construction of all the buildings in Hong Kong.

7. The Bank of China was designed with the advice of Feng Shui experts.

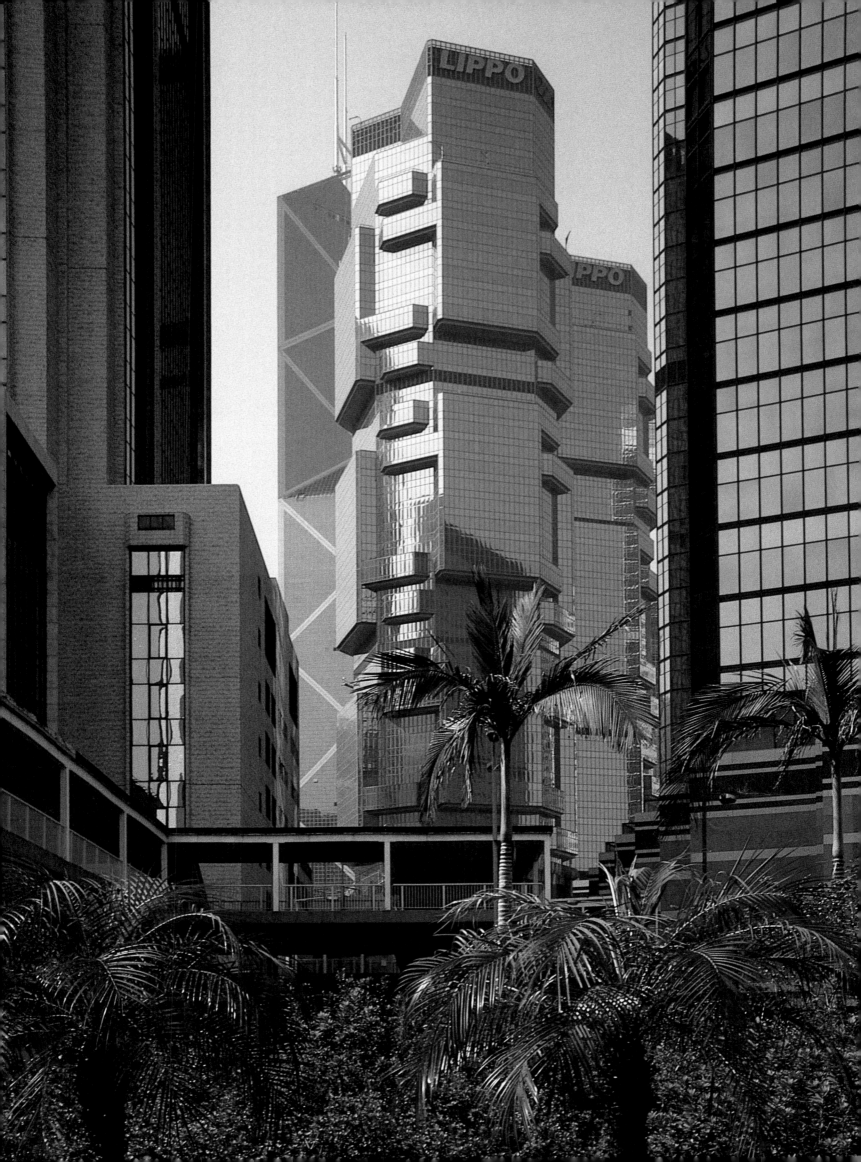

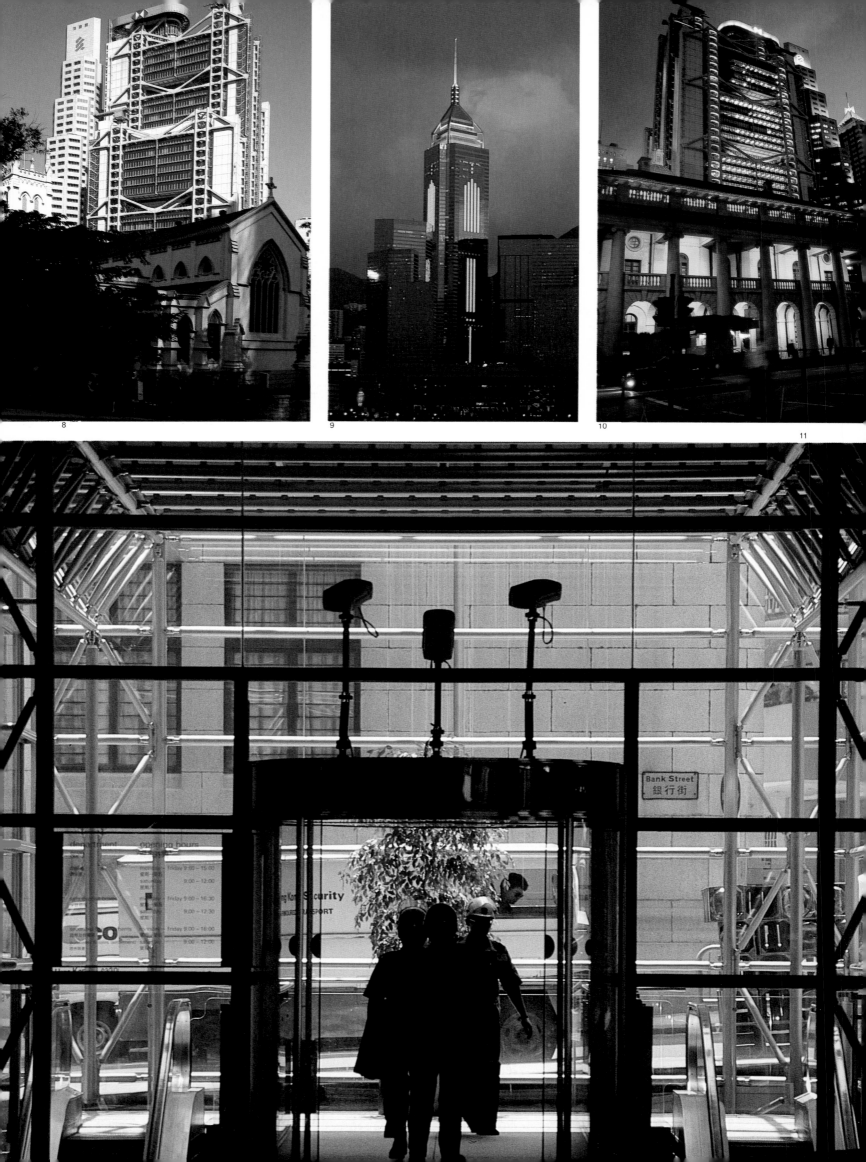

8

9

10

11

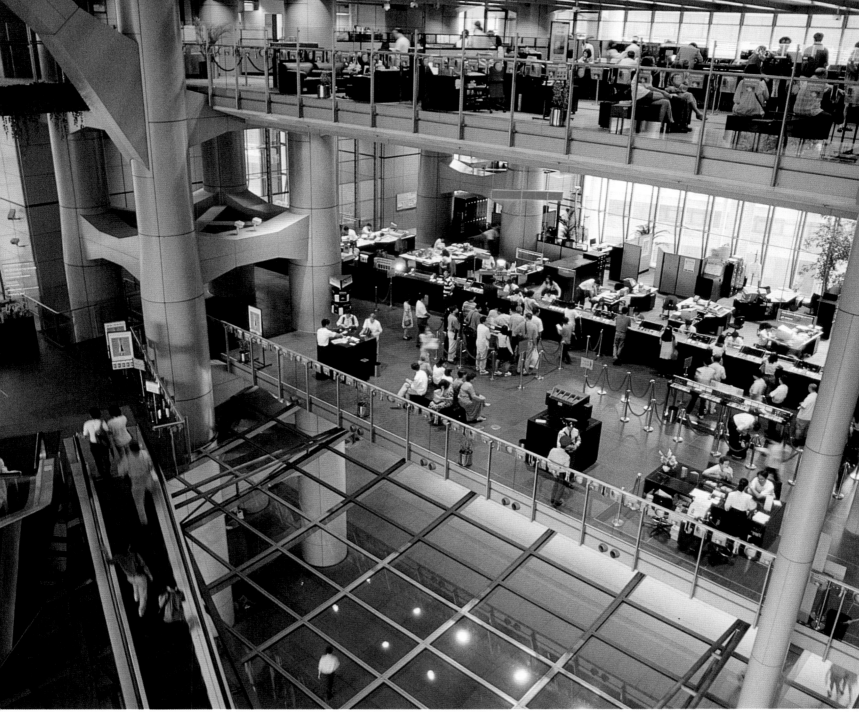

8. Hongkong and Shanghai Bank; in the foreground the Anglican cathedral.

9. The Plaza Building lit up at night.

10. The Supreme Court in the foreground is one of Central's few surviving colonial buildings; it now houses the Legislative Council.

11, 12 and **13.** Views of the impressive Hongkong and Shanghai Bank designed by Norman Foster.

14. Impossible to be unimpressed: the skyscrapers of Central District.

15. A view from Victoria Harbour of skyscrapers.

16. Central Exchange Square.

17. Hong Kong is rightly famous for its fabulous architecture.

18. Faceless but impressive, skyscrapers in Central tower above the formal planting and wide walkways.

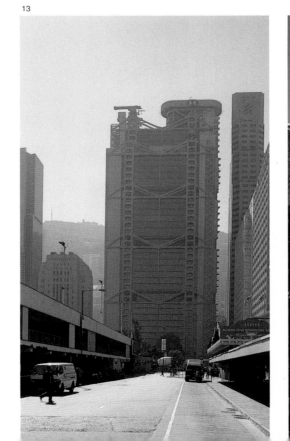

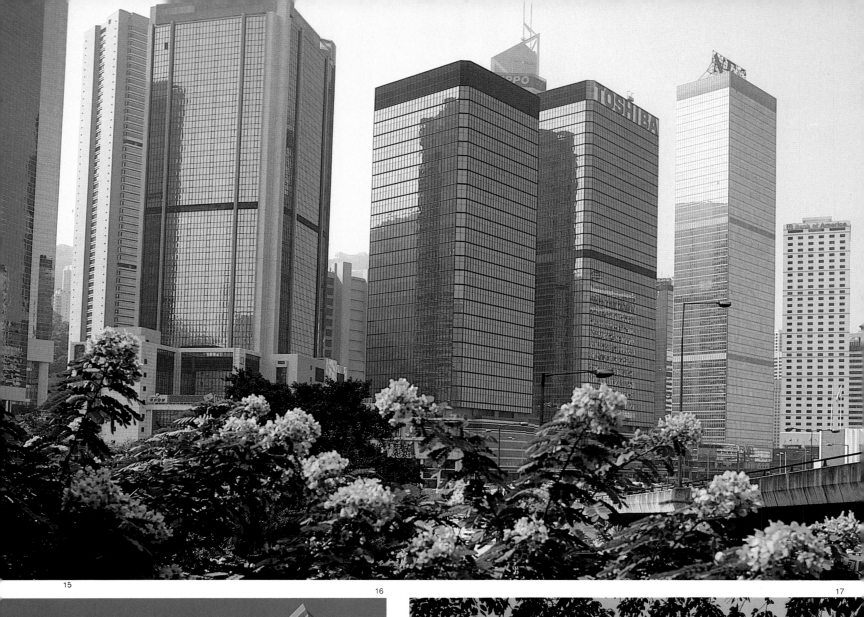

15

16

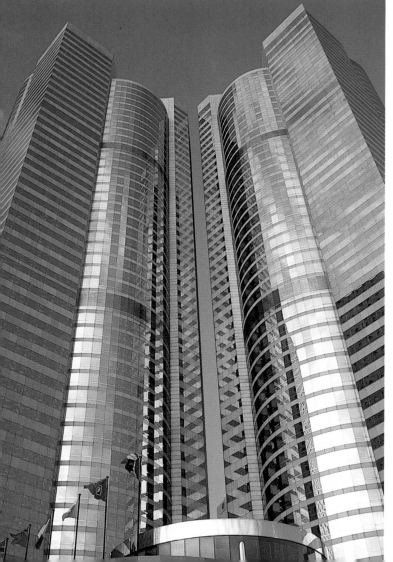

17

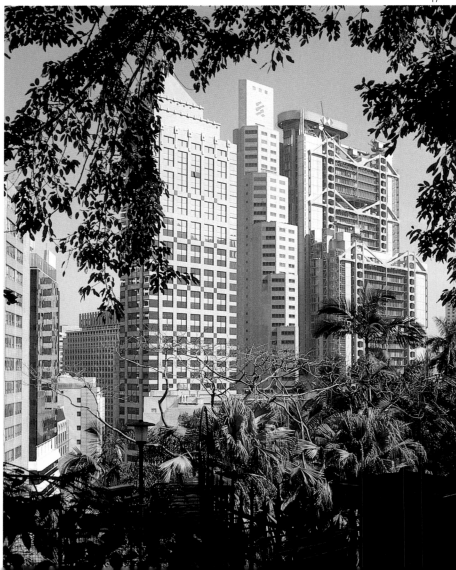

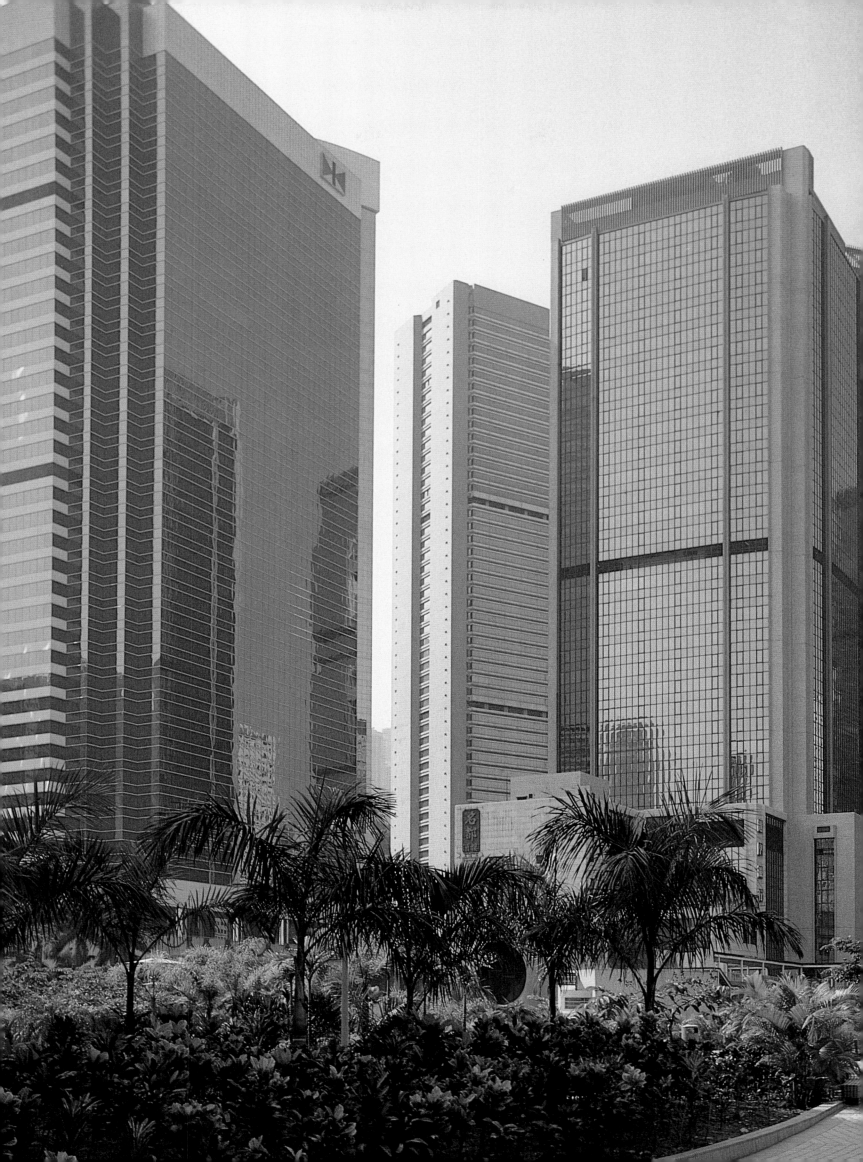

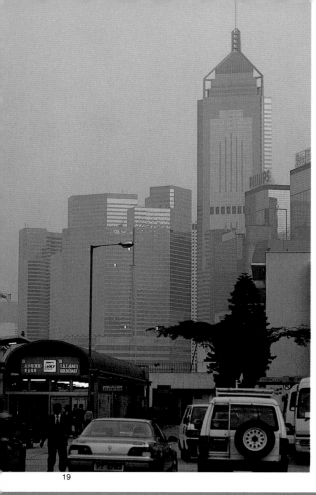

19. Central Plaza.

20. Skyscrapers in Central, with a view of The Peak in the distance.

21. Lush greenery is never too far away even right in the heart of the city. This is the Botanical Gardens. The colonial style building at left is Flagstaff House, once the residence of the commander of British Forces in the Territory now, somewhat prosaically, it houses the Tea Museum.

22. Mirror-glass is used extensively in Central, giving the impression of even more buildings, as the structures are reflected and counter-reflected on each other's facades.

19

20

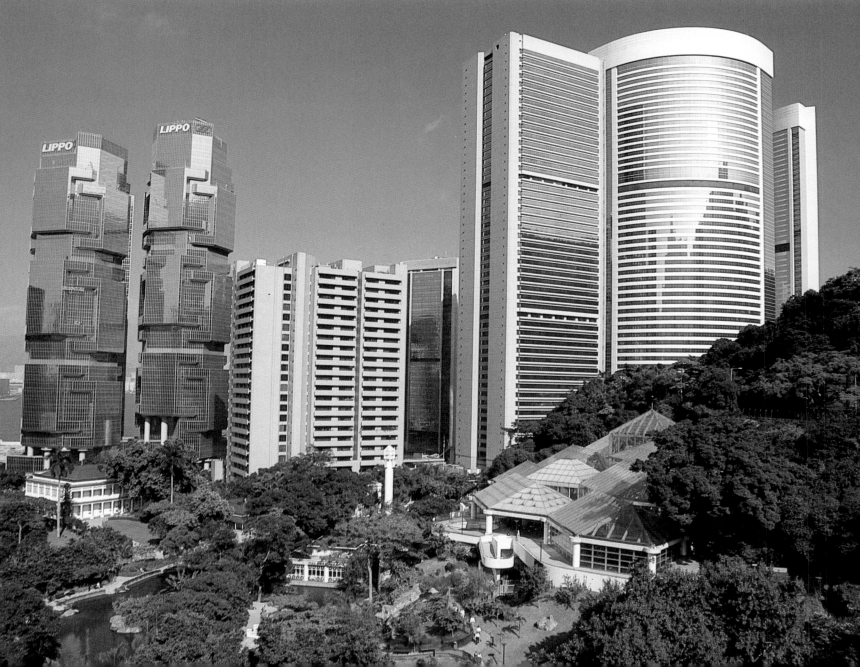

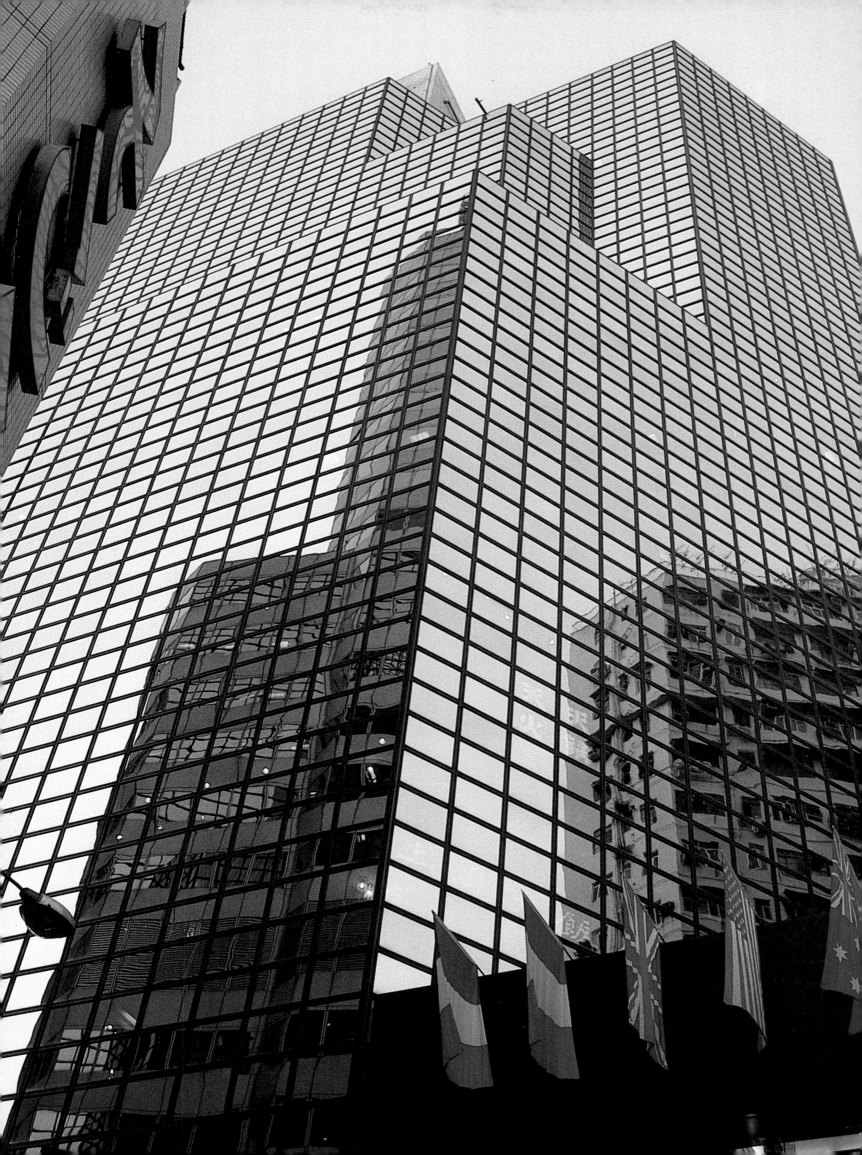

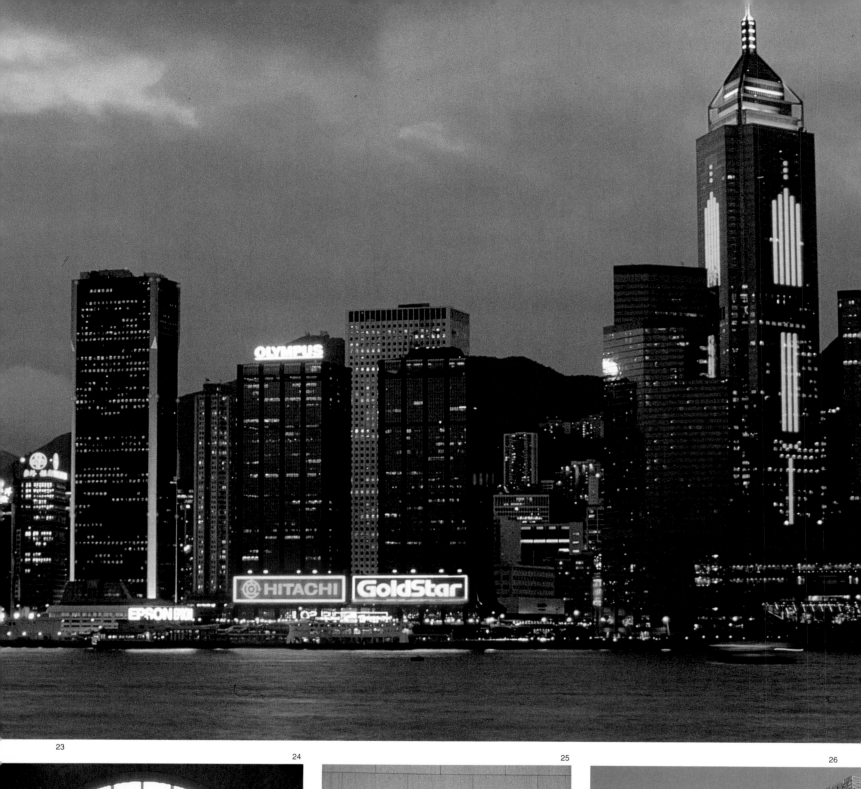

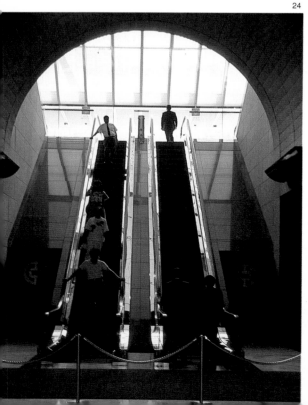

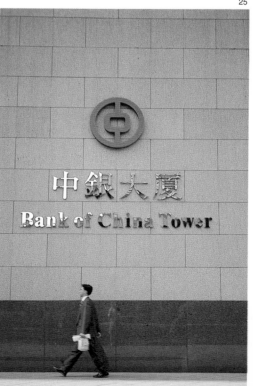

中銀大廈
Bank of China Tower

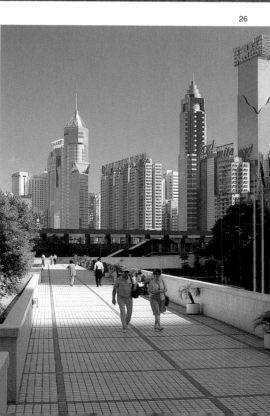

23. Central skyline at night from Kowloon.

24. Inside the Bank of China.

25. A businessman walks past the Bank of China Tower on his way to work.

26. Once notorious as a red light district, Wan Chai has been extensively redeveloped.

27. The Stock Exchange in Hong Kong is one of the most important in the world.

28. Central boasts the longest escalator in the world at 800m.

29. A view of Central from the Botanical Gardens.

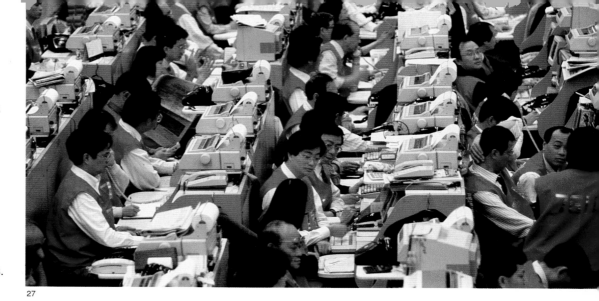

27

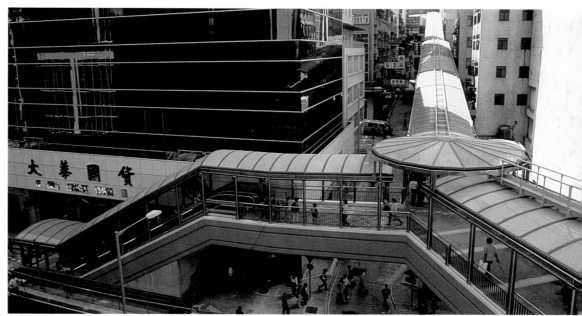

28

29

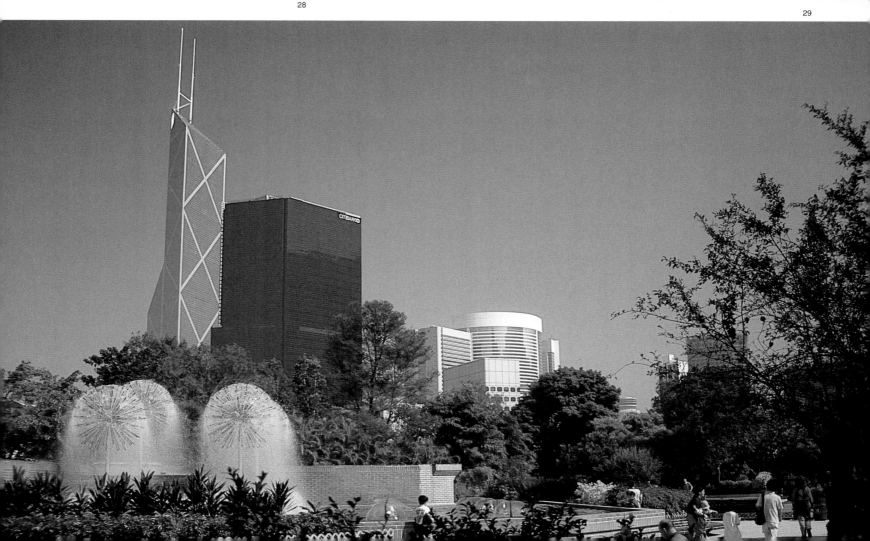

30

30. Aw Boon Haw Gardens, otherwise known as Tiger Balm Gardens.

31. The lights of the traffic and city merge into a glorious riot of colour along the King's Road. It will be interesting to see whether 1997 brings right-hand drive to Hong Kong.

32. Stanley Beach: Hong Kong has miles of glorious sandy beaches, some of which have been artificially created. Although sharks are a constant threat, there are stringent protective measures.

33. The cross-harbour tunnel entrance — a notorious traffic black spot.

34. The Eastern District road system.

35. Causeway Bay Sino Plaza building.

36. A view across the harbour of Causeway Bay.

37. Looking across Causeway Bay towards Wan Chai.

31

32

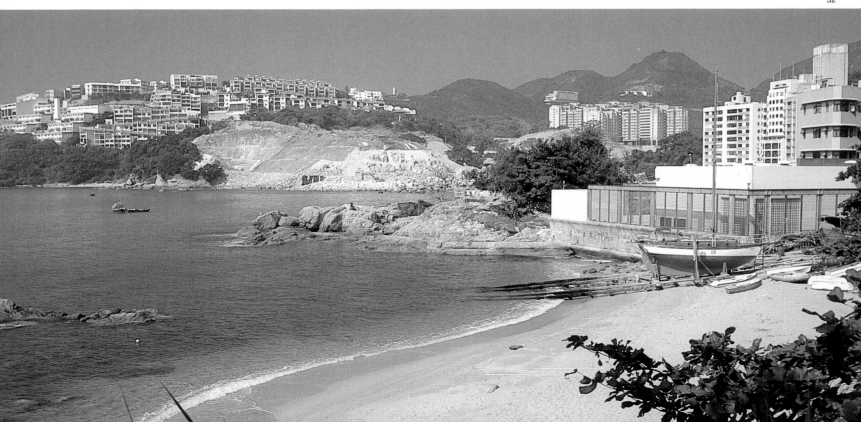

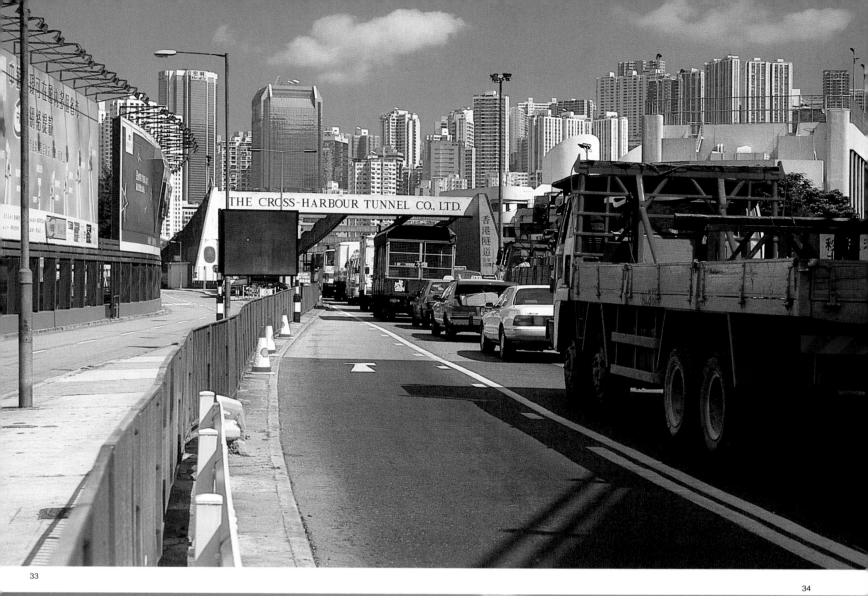

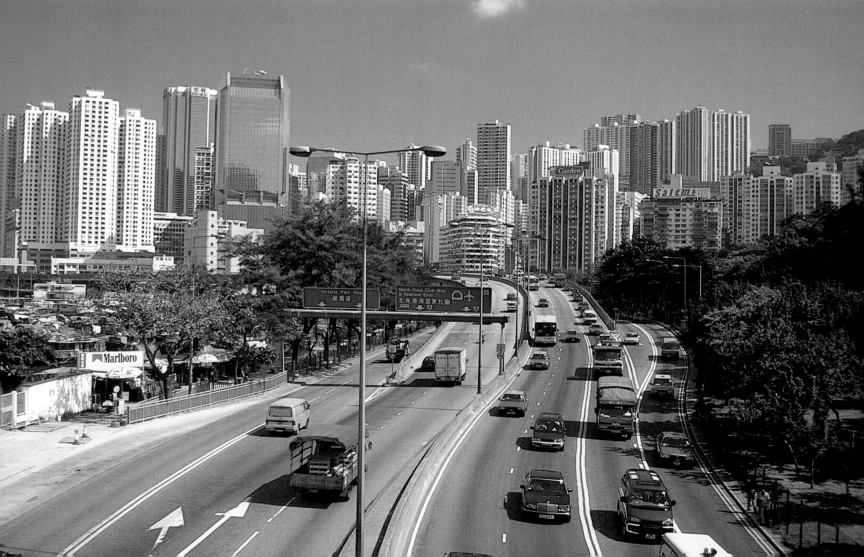

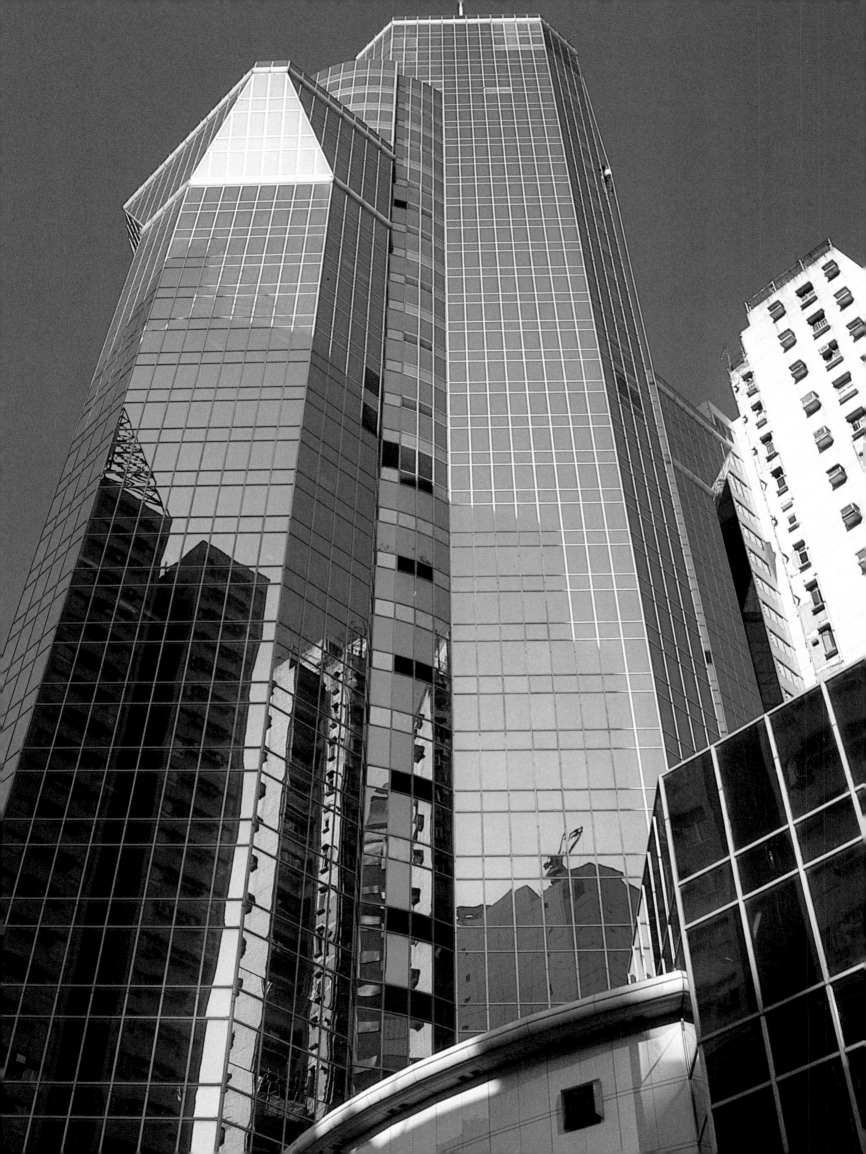

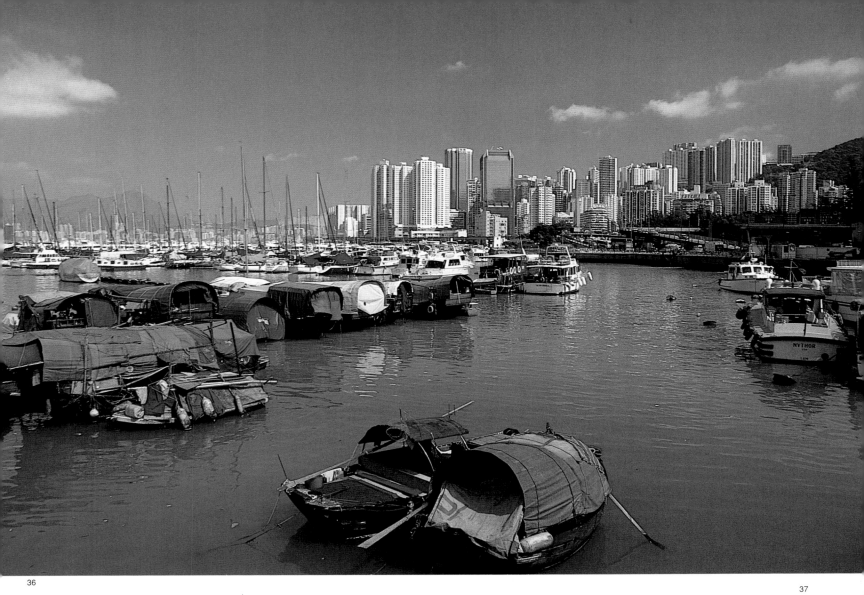

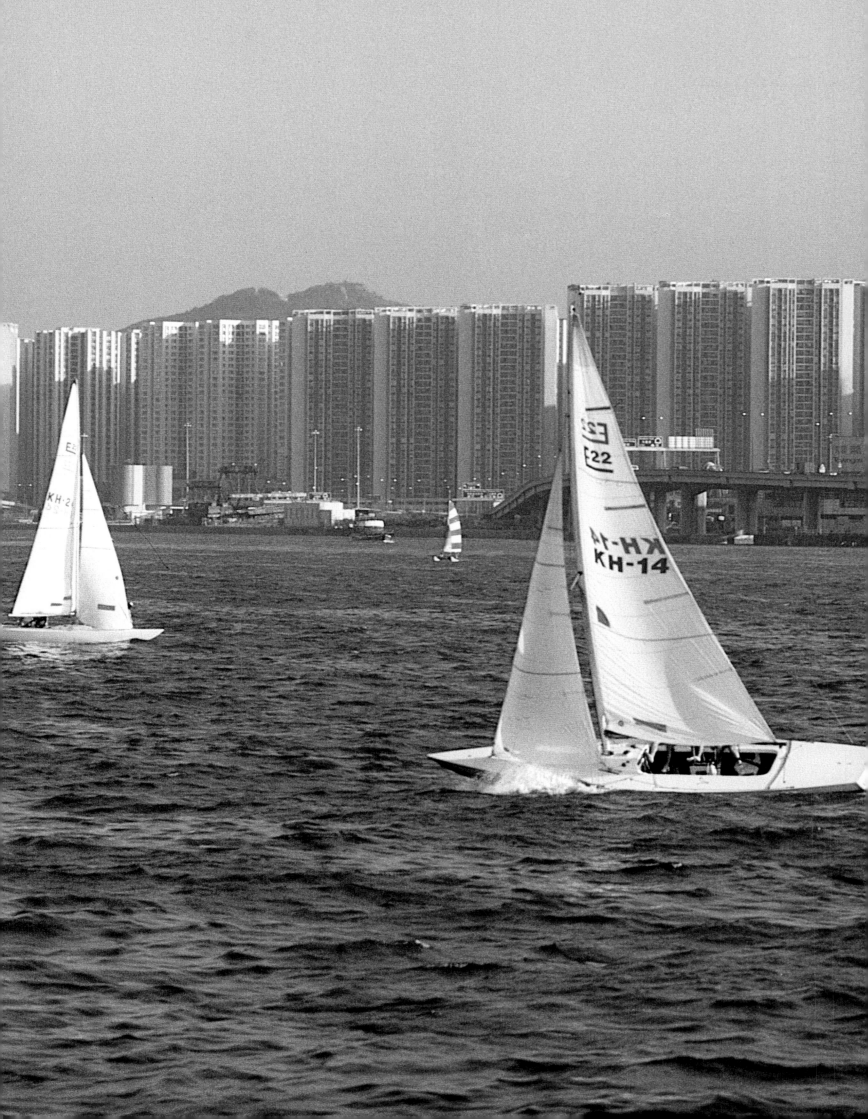

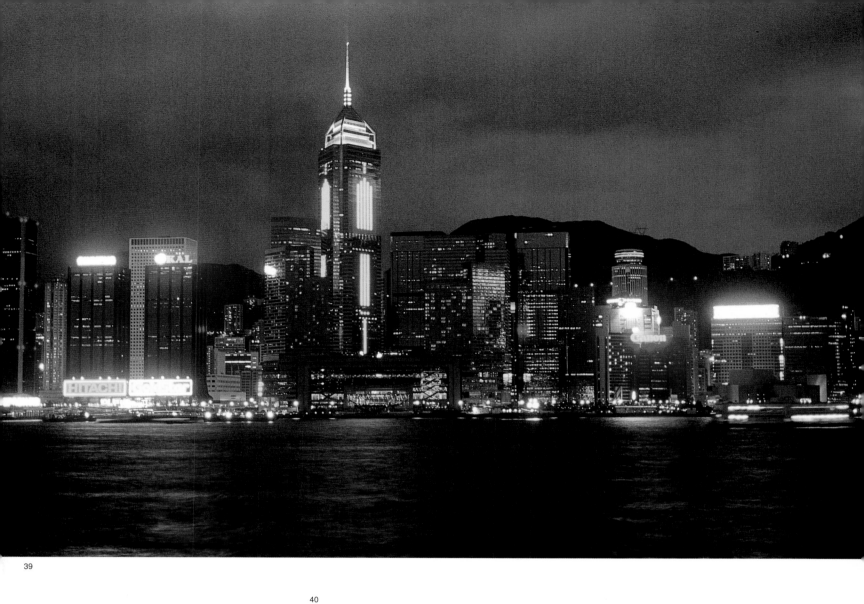

39

40

38. The azure waters all around the islands and mainland are ideal for sailing — here, one of the many regular regattas is in progress.

39. At night the Plaza Building points like a beacon to the sky.

40. Most Hong Kong residents go shopping at a market at least once a day for fresh fruit and vegetables, meat and fish.

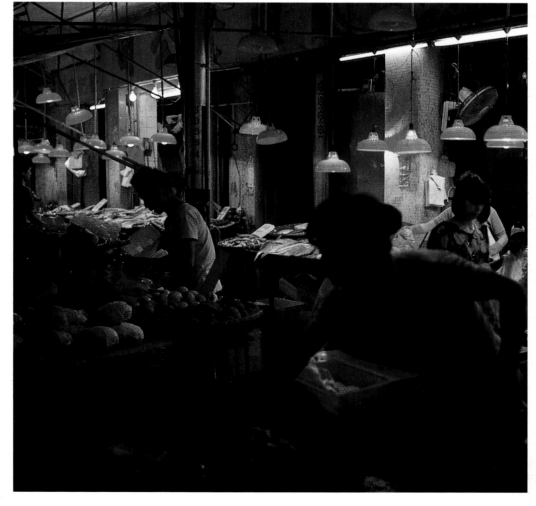

VIEWS FROM VICTORIA PEAK

41

In the long blistering summer days Hong Kong can become so hot that life becomes difficult to cope with and any relief from oven-high temperatures is worth a premium. High above Hong Kong, and framing one side of the city, lies a ridge of hills; the highest of these at 556m (1,824ft) is Victoria Peak. The higher up you go the fresher the air becomes and little breezes begin to lick around the trees and cool the skin. Furthermore the higher up, the better the views, until the whole of Hong Kong and its amazing harbour, surrounding waters and islands become visible. It is absolutely stunning on a clear day when the Nine Dragon Hills of Kowloon can be seen and, in the far distance, mainland China. From the top you are literally looking down on all the high-rise skyscrapers which, for once, look diminutive in size and scale. The panorama at night is spectacular as the ships in the harbour light up and the horizontal street lights are criss-crossed with vertical pillars of sparkling light from the tall buildings; all punctuated by a rainbow of neon illuminations, signs and street lights glowing through the darkness. The sheer excitement and movement of the city is transmitted by illumination alone, without any of the noise and clatter of street-level life. The entire city appears alive and pulsating with lights and movement.

Unlike the earliest days of the colony there are various ways to visit Victoria Peak other than taking the bus or walking. By far the most exciting of these is by tram or, more accurately, funicular railway. At the top there is a maze of little paths, delightful shady walks and gardens to enjoy, where the twittering of birds replaces the roar of city traffic. These have all been planted and cultivated over the last hundred years or so as area was just bare rock when the first British settlers arrived. Then, of course, with the foliage came the fauna and, if you believe the rumours, monkeys right at the top.

This is and always has been the best place to live in Hong Kong — but the views, the cool air and the exclusivity all come at a price only the wealthiest can afford. The first path to the top was cut in 1859 and within 20 years it had become a popular retreat from the summer heat and diseases, in particular the endemic malaria found in the lower levels. The first British settlers were quick to discover the improved climate and healthy conditions of the Peak, particularly welcome as wives and children were forbidden to stay in Canton and either had to live apart from their husbands by remaining in Britain or by living in Macau. Even then it was difficult to get to heights:h most people were transported up there by sedan chairs carried by coolies.

All this changed on 28 May 1888 when the Peak Tram opened and revealed the top to those without the time, ability or inclination to climb the heights for themselves. Strictly speaking the Peak Tram is a funicular railway, with the car going up counterbalancing the car going down. The ride takes about eight minutes and rises to 398m (1,305ft) above sea level at the same time as travelling about 1,400m (1,500yd). Most of the journey has a 27° gradient but this angles up to a vertigo-inducing 45° on the steepest section. Despite this seemingly precarious mode of travel, it is proudly boasted that the tram has never had a single accident in all its years. As additional security, the track brakes on the wheels can stop the tram within 6m (20ft). Then in 1989 the old cars were replaced with new computer-controlled cars capable of carrying 80 passengers at a time. This was not just a concession to the many tourists, but a practical improvement as the Peak Tram is principally used as commuter transport for the many wealthy businessmen who live at the top but work down in the city.

The first road up to the Peak was made in 1924 and this signalled the real influx of permanent homes for the wealthy and important members of local society. Now tall tower blocks punctuate the horizon with comparably high prices; anyone who has sufficient money can live there. Less exclusive but still sought-after are the Mid-Levels, roughly half-way up the Peak; there are still a few of the grand old houses left but the area is mostly filled with new apartment blocks.

The Peak is always worth a visit, although be warned: between mid-February and about the end of April it is often hidden by clouds, as are the views, because of the high humidity. At this time the climate up here can also be surprisingly cool. Ontop of the Peak and near the terminus is the Peak Tower complete with viewing deck and telescopes for admiring the spectacular view; plus of course the obligatory tourist shops and restaurant. From here you can walk around the Peak on a circular route along the Lugard Road which takes about an hour depending on how long you take to admire the extraordinary views. Round the top there are spectacular views over Aberdeen and Lamma Island, until Kowloon comes into view. Or take a stiff walk up Mount Austin Road for a further 150m to the landscaped Victoria Garden. This is now all that remains of the one-time residence of the British governor, which was destroyed by the Japanese during their occupation in World War 2. Alternatively it is possible to walk back down the Peak via one of the steep valleys, but it can be quite taxing.

41 and **42.** Looking down from The Peak onto the skyscrapers below.

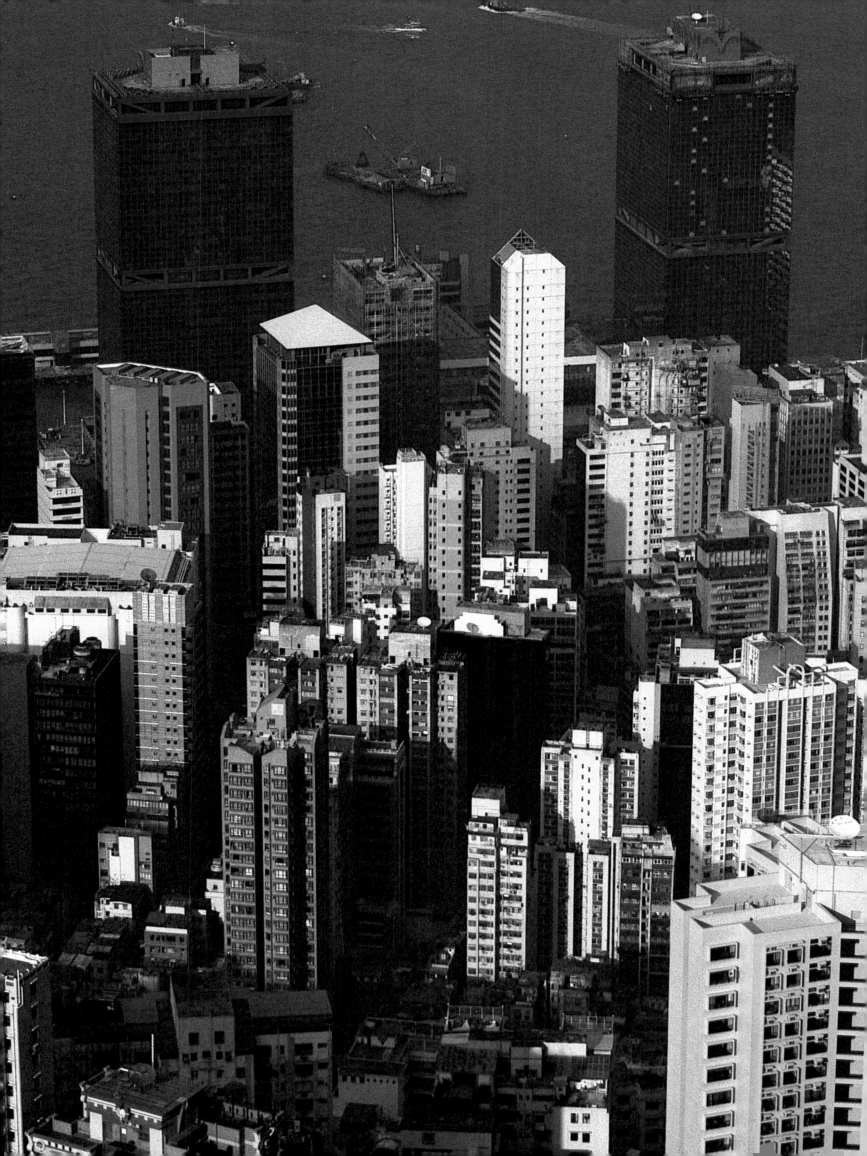

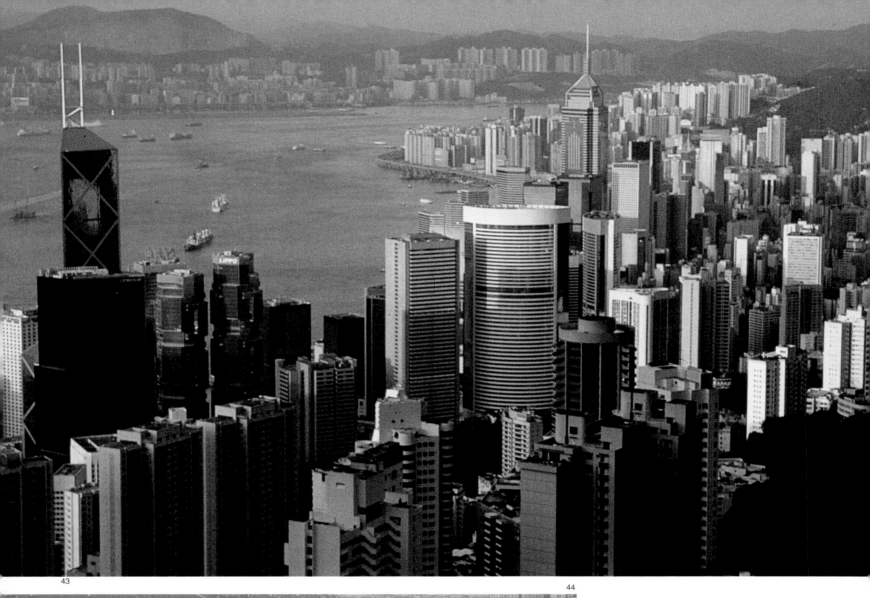

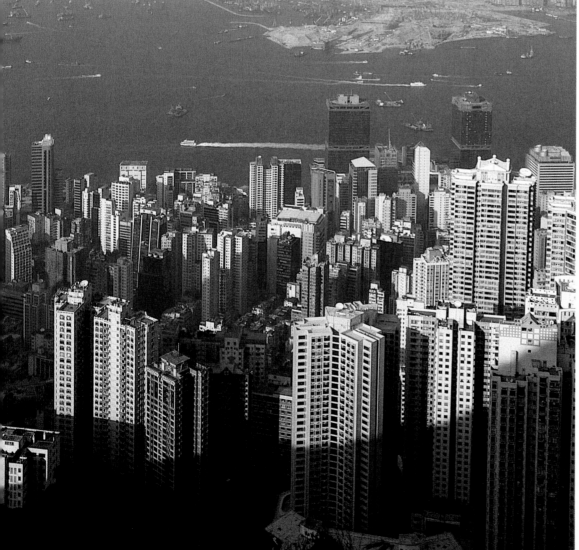

43. Looking down on the banks and financial buildings of Central.

44. View across the harbour towards Kowloon and the typhoon shelter.

45. Tower blocks overlooking the harbour.

46. Victoria Harbour is constantly criss-crossed by vessels of all descriptions going about their business.

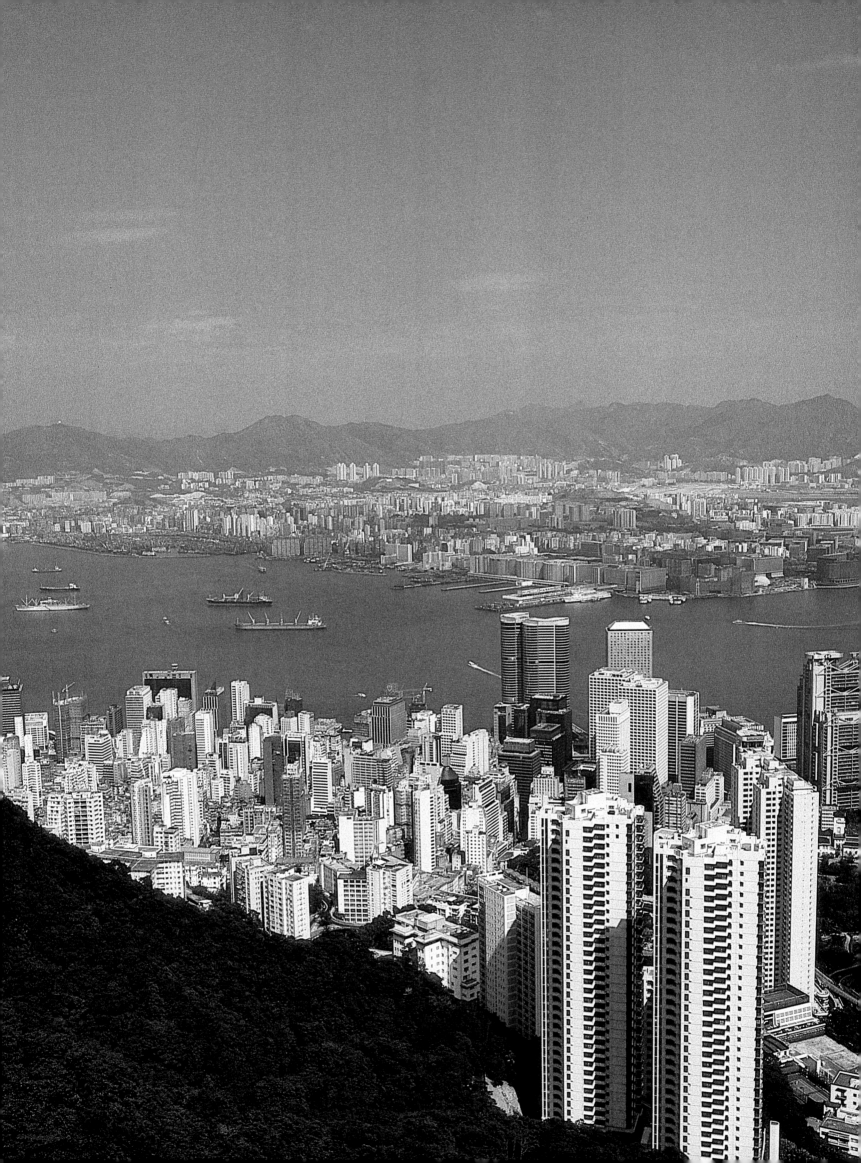

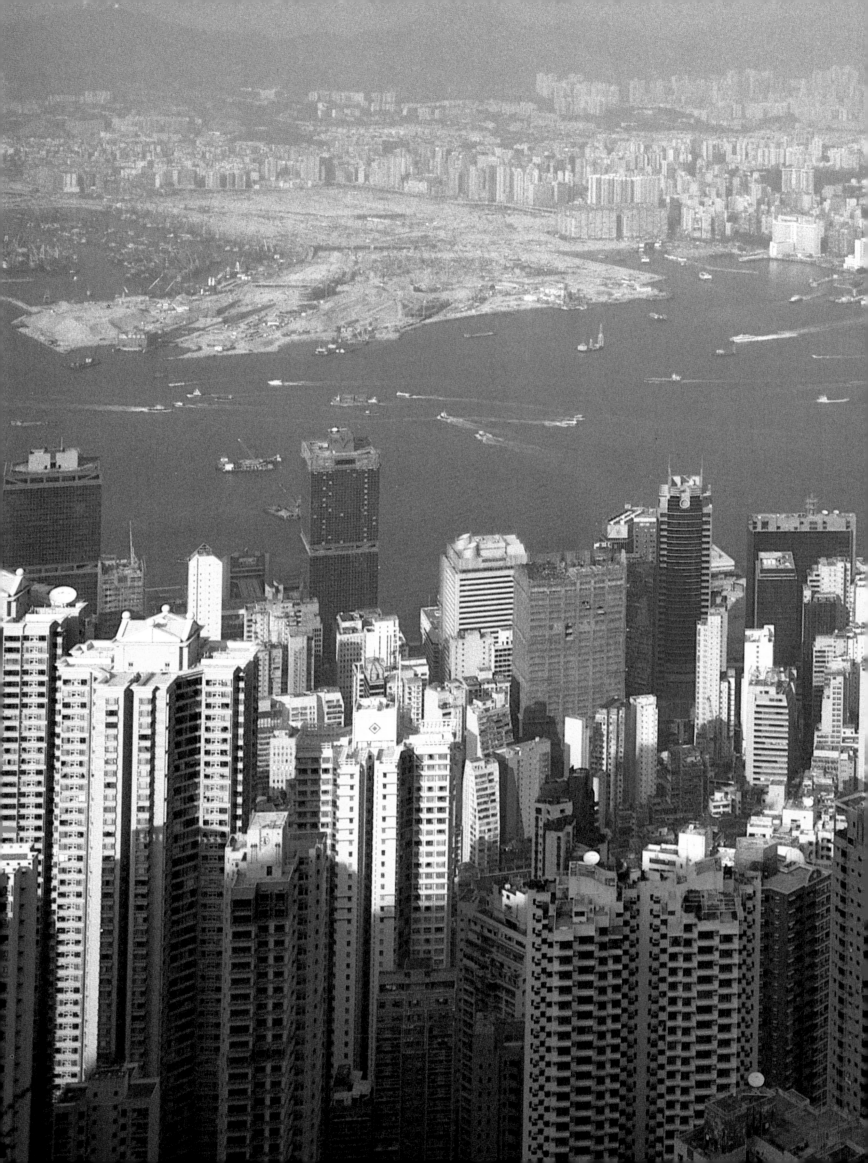

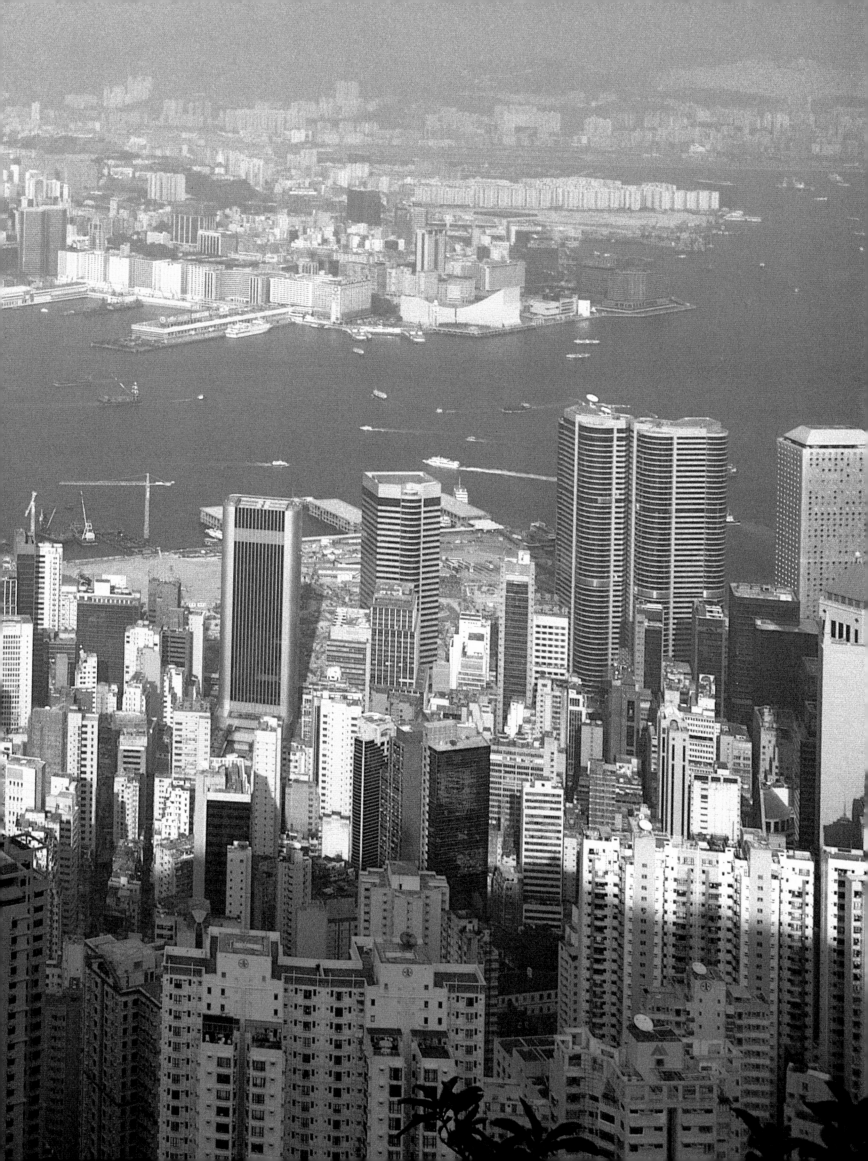

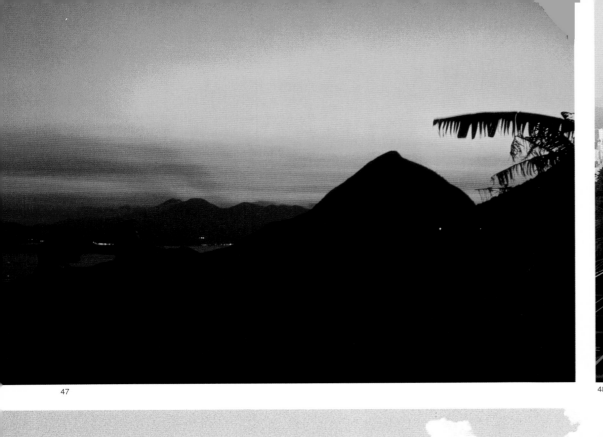

47

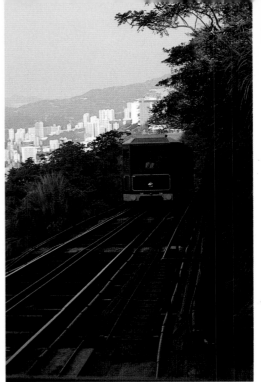

48

49

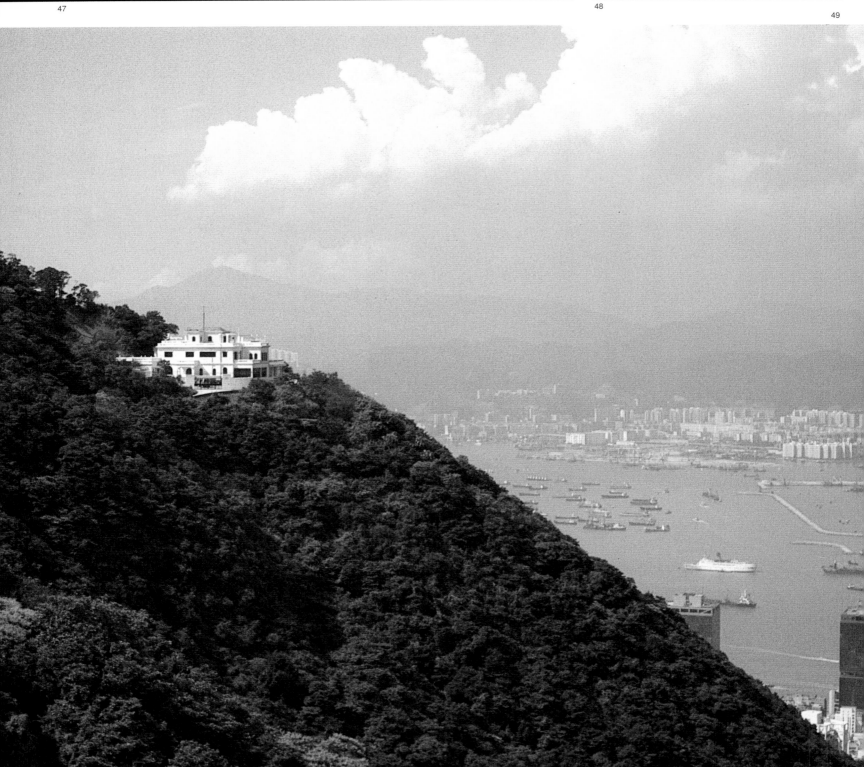

47. Sunset from Victoria Peak with the lights of the mainland twinkling in the distance.

48. The famous Peak Tram, which opened in May 1888, is actually a funicular railway and still a highly impressive feat of engineering.

49. The once barren hillsides of Victoria Peak are now covered with lush growth of trees and bushes.

50. Even the vast tankers look magical in the half-light of early morning.

51. Kai Tak's runway, where the big jets land, juts out into Victoria Harbour.

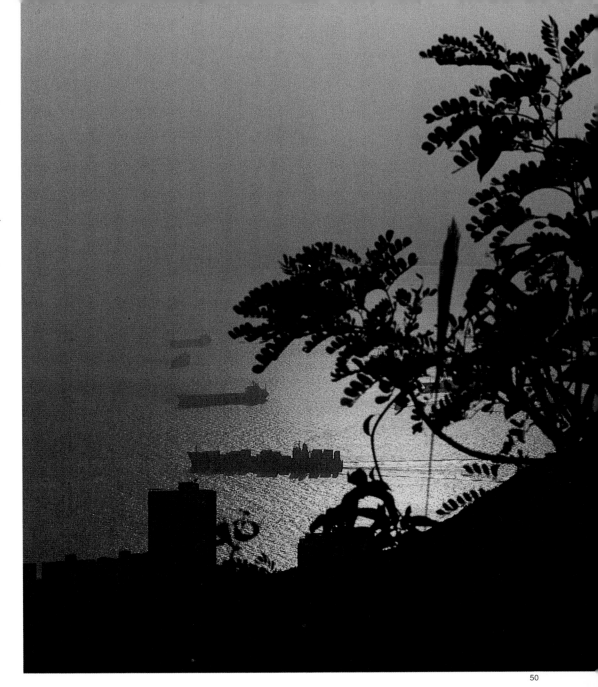

50

51

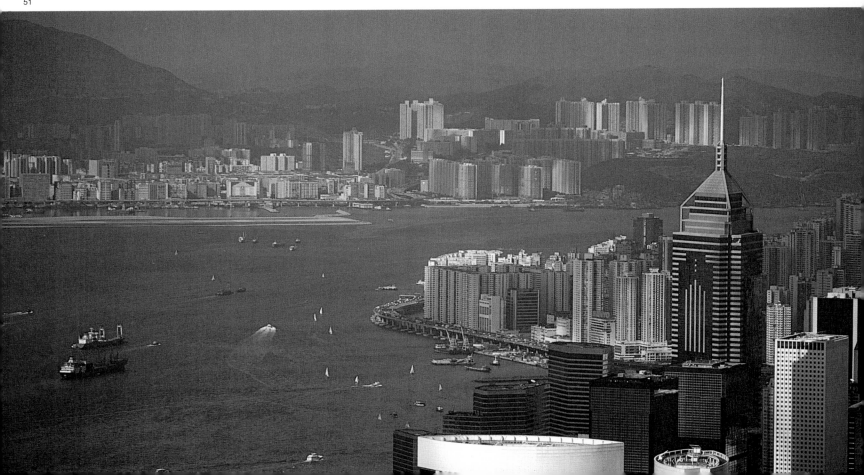

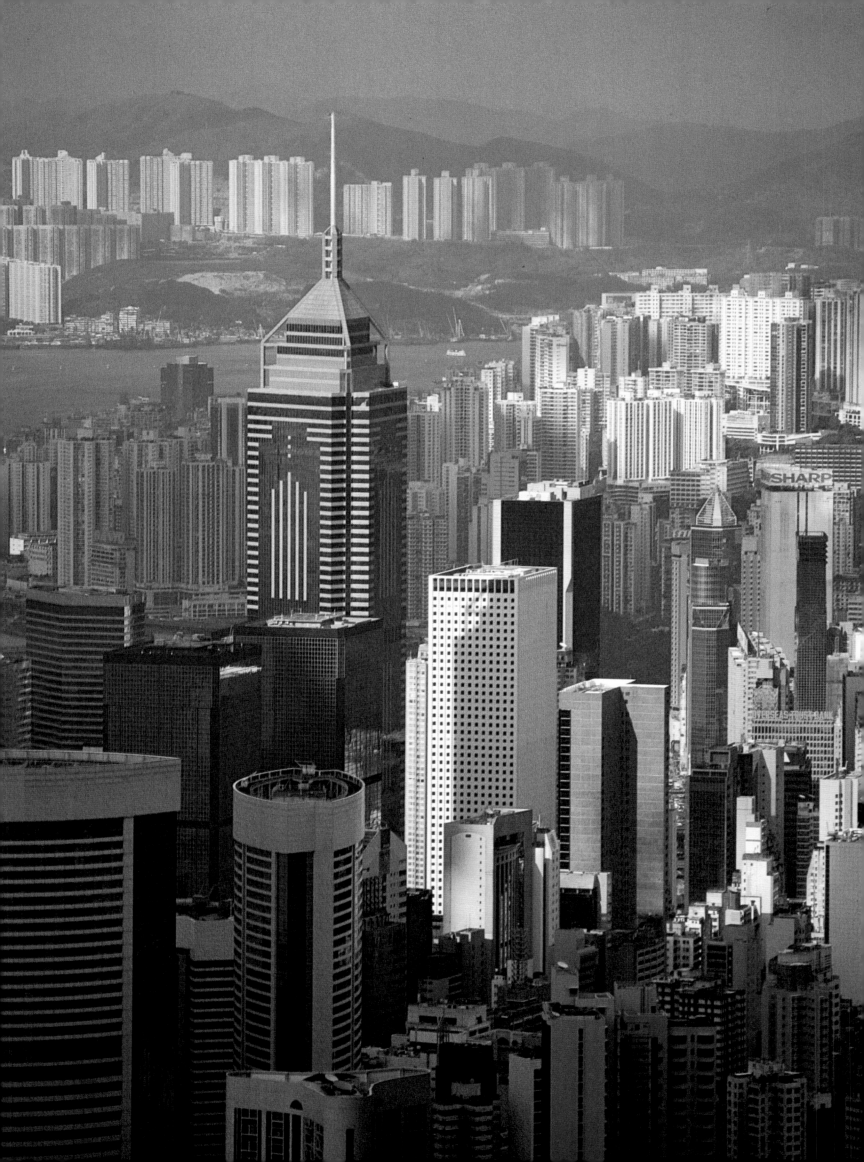

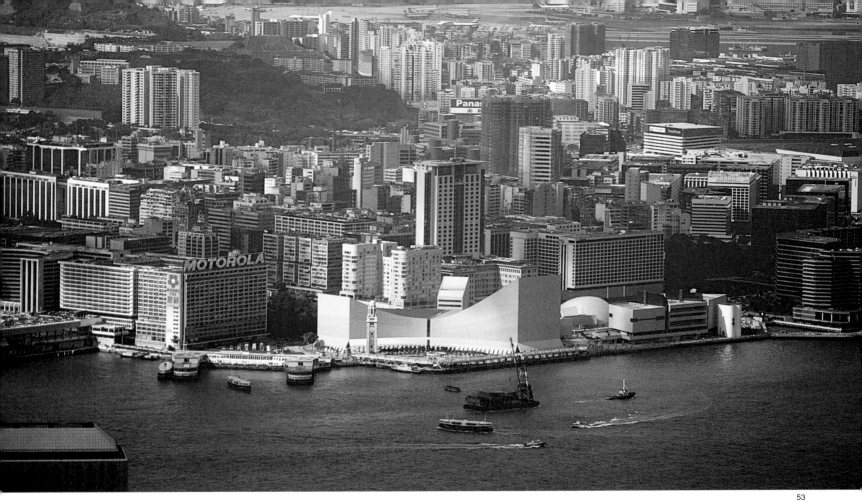

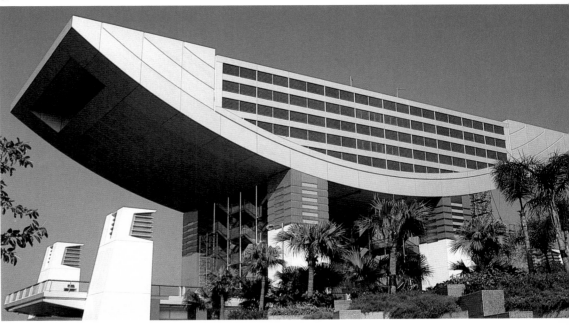

52. From the Mid-Levels you can look right into the heart of the city.

53. The clock tower, in front of the Cultural Centre, is all that remains of the grand station that was once the Far East terminus of the Orient Express. The two piers abutting the foreshore are the Star Ferry termini from where services run to Central and Wan Chai. The boldly-designed, if windowless and featureless, Cultural Centre on the tip of Tsim Sha Tsui was opened in 1989 and contains theatres and concert halls.

54. The new Peak Tram terminal built in 1995.

55. The Peak Galleria is a popular shopping centre.

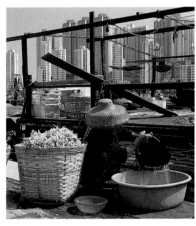

56

On the south-west corner of Hong Kong Island is another fine natural harbour ideal for riding out and sheltering from the seasonal typhoons. Pirates who terrorised the South China Seas used the harbour as a hide out, but the area has been settled since the very earliest days by the Hoklo and Tanka peoples who used it for shelter and fished the waters of the surrounding archipelago. The Chinese call the area Heung Keung Tsai, which translates as little Hong Kong. However, when the British arrived they renamed the bay after the Earl of Aberdeen, the Secretary of State for the Colonies in 1848 and who had been Foreign Secretary in Peel's 1841 Cabinet.

It is now a large town in its own right and is a particularly popular residential area. Around 60,000 people live here now, but only a few hundred of them on the sampans and junks moored in the typhoon shelters in the harbour. These once large, ancient, self-sufficient floating communities used to number around 5,000 junks and sampans with about 30,000 inhabitants; but the people here too are being encouraged by the government to relocate and rehouse on dry land in specially built high rise flats fringing the harbour and to find work in local factories. One of the prime motivations behind this effort was to reduce the sanitation problem created by the thousands of people living on boats without the benefit of sewerage removal in any other way than by tide. This process was speeded up by two devastating fires in successive years, 1987 and 1988, which destroyed well over 2,000 boats.

Like Hong Kong, Aberdeen has been busy reclaiming land from the sea, and the town itself has been renovated at great expense, particularly to improve and extend its shopping facilities. It is a wealthy and chaotic town with a dynamic and exciting atmosphere of its own. It is alleged that much of its wealth has come from smuggling — both in the past as well as the present! However, it is still a big and important fishing harbour, though most of the catch today goes for sale locally to the many restaurants which brings in Aberdeen's second catch: this time of richer fish — tourists. Women tout sampan rides out to the floating restaurants for which the harbour is famous, in particular the three huge floating restaurants which are not actually in Aberdeen harbour, but in the yacht basin of Shum Wan. These monsters are not historic buildings but relatively recent constructions, although they look antique. They are specially built, huge, multi-storied, predominantly red and gold pagoda-topped boats that become particularly magical at night when the millions of golden lights which outline their superstructure are turned on

Other than at night time, Aberdeen is most exciting in the early morning when the fish market is in full swing. Later in the day, look for jewellery in one of the many specialist shops. At the junction of Aberdeen Main Road lies the Tin Hau Temple. Built in 1851 it has unusual circular cut-out doorways. Ferries and sampans work between Lamma Island and the Poi Toi Group, and out to the large island of Ap Lei Chau.

Nearby are lovely beaches such as Repulse Bay which attract thousands of weekenders onto the white sands. Repulse Bay on the south coast is the most popular beach on Hong Kong Island, attracting as many as 200,000 sun-seekers on high days and holidays in fine weather. Bathers are fewer than you might expect until you learn about the dangerous sharks, eels and jellyfish that fill the local waters. At one time there stood the very grand colonial Repulse Bay Hotel where tea dances and cocktails were the rage. But now in its place stands a modern hotel with none of the old glamour. There are also some new flats: as usual *Feng Shui* experts were consulted about their location and situation. They reported that a dragon lives in the mountain behind the proposed building and he must have a view of the sea. Work on the building stopped immediately and the architects came up with a solution — by making a hole in the building and sacrificing 2,000sq metres (21,600sq ft) everyone could sleep happily at night and the dragon could still enjoy his sea views. So that's what they did!

56. A fisherman washing seaweed at Aberdeen Harbour.

57. Lit up with myriad lights, one of the huge floating restaurants for which Aberdeen is famous.

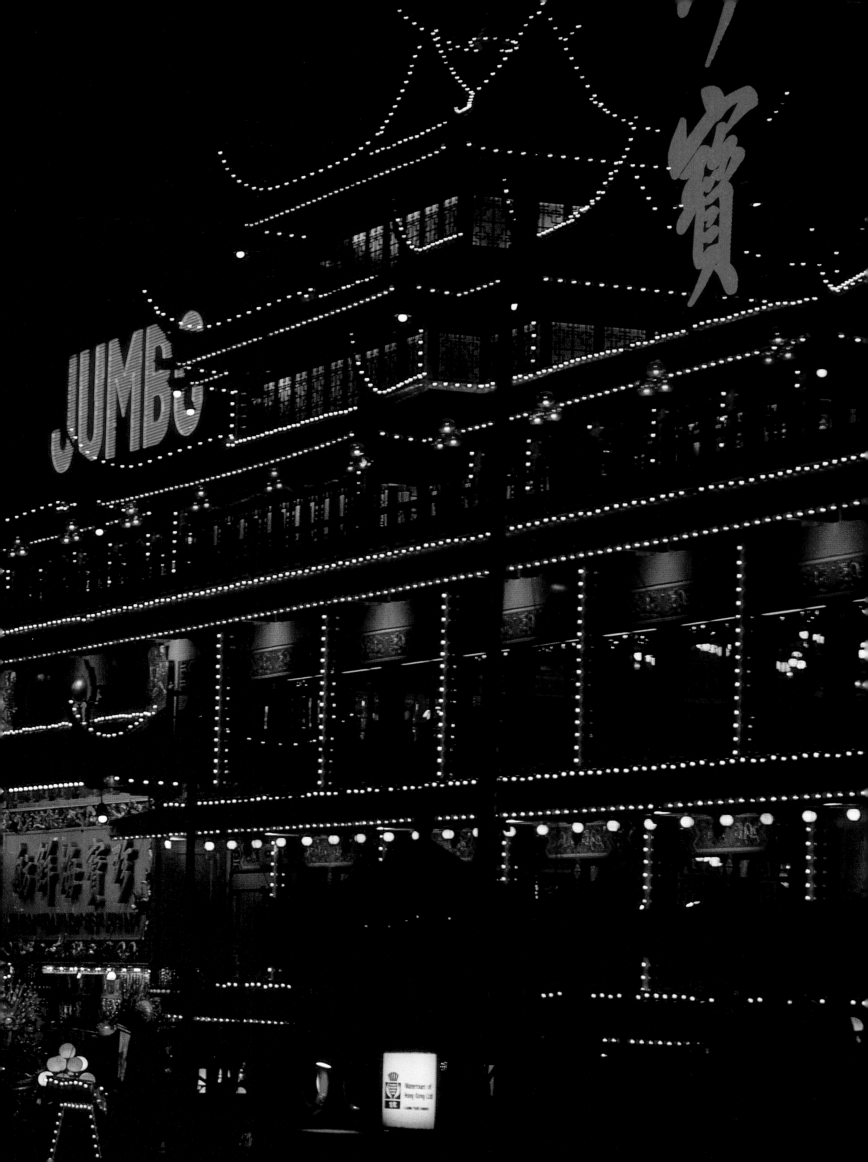

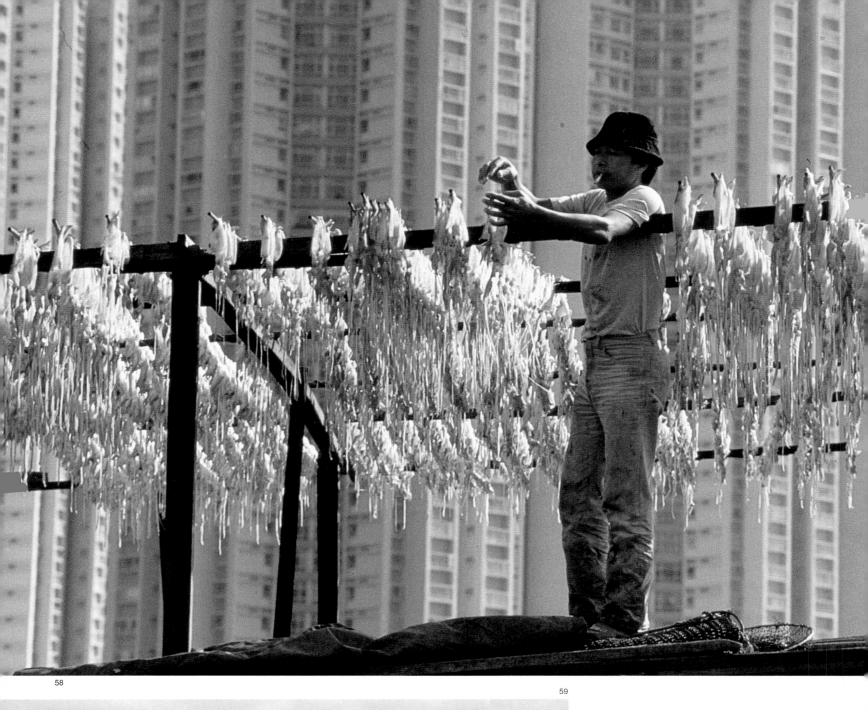

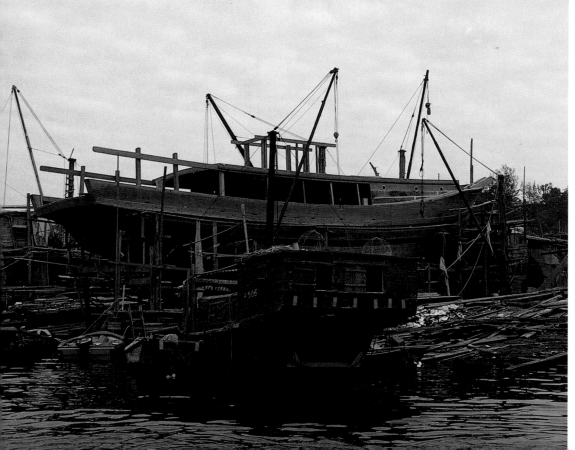

58. One of the few Tanka fishermen remaining in Aberdeen dries fish in the sun.

59 and **60.** A wide variety of Chinese junks around Aberdeen Harbour.

61. The Jumbo restaurant is not actually in Aberdeen Harbour but nearby in Shum Wan yacht basin.

62. Most of the Aberdeen boat people have been moved off the water and into government developments along the waterside.

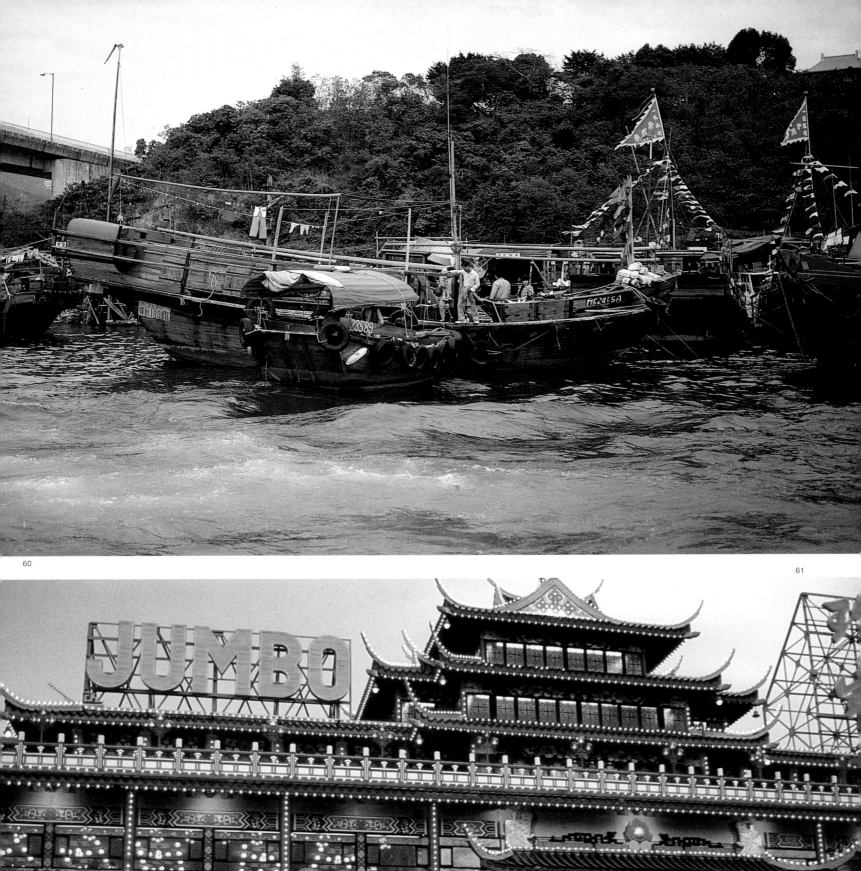

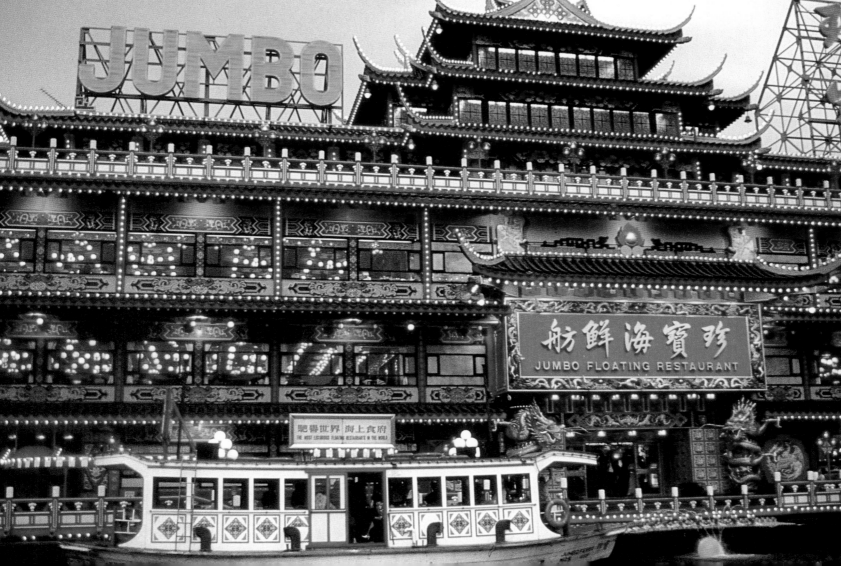

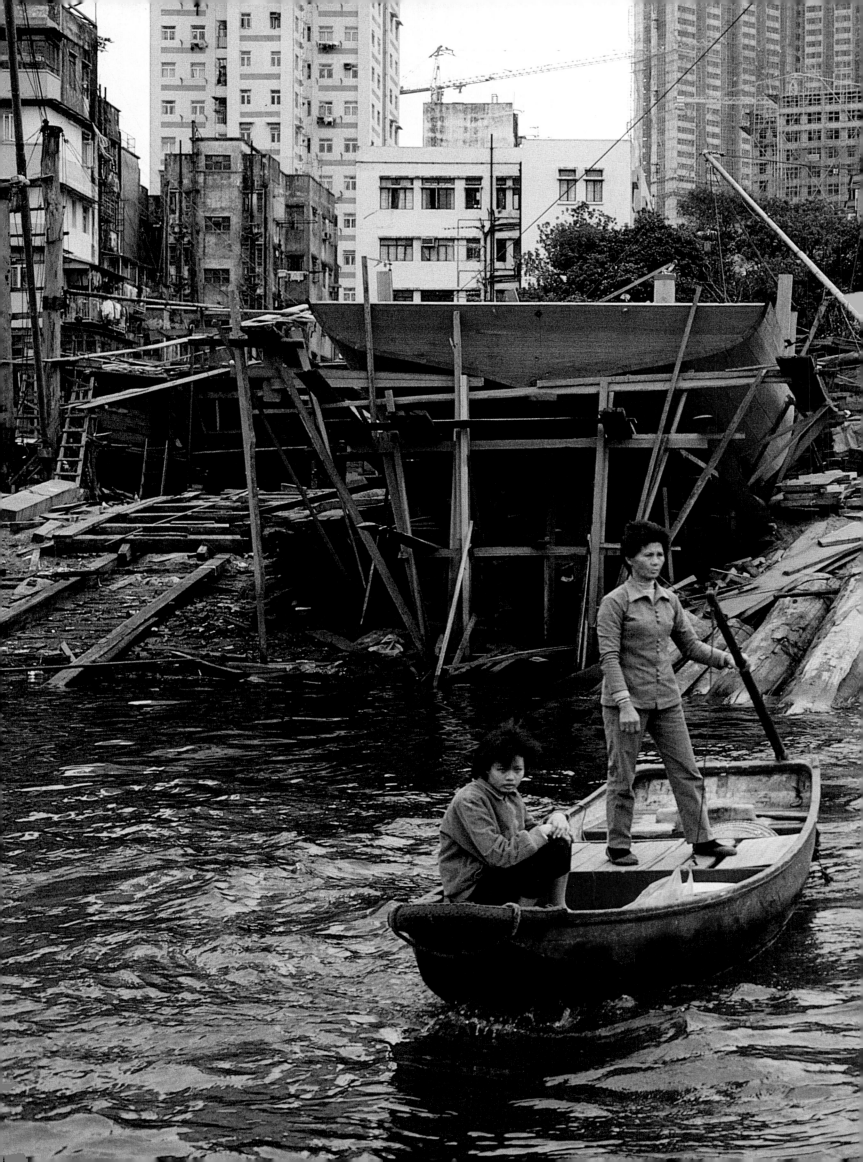

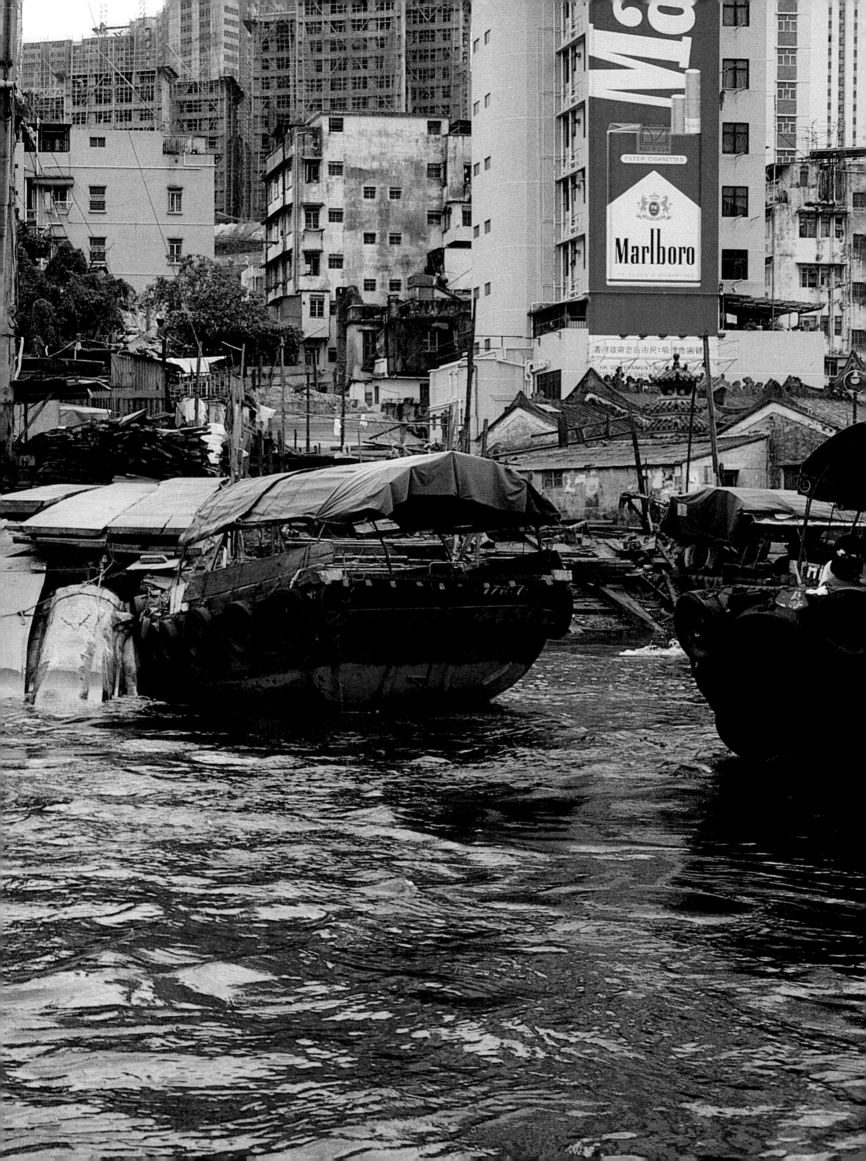

Victoria Harbour is the very essence of Hong Kong and it sums up everything that the city stands for — the name Hong Kong, after all, means Fragrant Harbour and Hong Kong is the world's largest container port. Just the sight of the ancient lateen-rigged junks with their large matting sails gently cutting through the waters, as they have done across the China Seas for millennia, is enough to evoke visions of times long past — yet here they are set against the dramatic backdrop of some of the most modern, technologically innovative and costly high-rise buildings in the world.

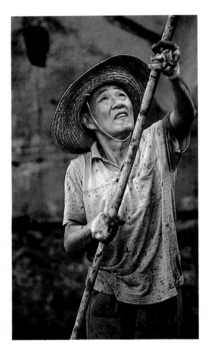

63

Hong Kong was chosen by the British for its natural deep-water harbour and the waters have ever since provided the colony with its most invaluable asset. For the native Chinese, the sea provides their living or the means for their living — whether by fishing or commerce. Ever since the early days of its foundation, and increasingly ever since, the harbour and its surrounding facilities have made Hong Kong one of the biggest and busiest ports in the world. Yet, unusually, many thousands of people actually live within the confines of the harbour. These are the romantically named Boat People, who live on sampans, junks and lighters in the typhoon shelters, earning their living by fishing and lightering duties. It is said that many of them spend their entire lives without leaving the water or ever putting foot on dry land. Their hard and austere lifestyle is irredeemably changing forever, yet they give the harbour its essential 'feel'.

The boats are still very old-fashioned looking, albeit painted in as many colours as the owners can lay their hands on and in many cases with flowering windowboxes to cheer up the view. Movement is constant here, where everything is moved by boat; children and pets skip around the vessels and small craft are always darting to and fro, selling fruit, vegetables and supplies. Tradesmen cross from boat to boat by pushing long poles into the waters to propel themselves through the narrow passages. Larger vessels sell drinking water and fuel and water taxis move the boat dwellers themselves around and between the vessels. Rigging dangles from masts and roofs and windows lurch at crazy angles — organised chaos is the impression most strongly left to an observer.

There are an estimated 35,000 Boat People, but this number is diminishing as they leave the sea for land-based homes, sponsored by a government improvement programme. The majority of the Boat People come from the Tanka tribe — literally meaning 'egg people' because they used to pay their Imperial taxes in eggs — most of the others are from the Hoklo tribe. They are, in the main, fisherfolk, forbidden by Imperial edict as well as prejudice to marry landed Chinese. Improvement in social status until recently has been out of the question as they were forbidden to take the Imperial civil service exams.

Like fishermen everywhere the Boat People are very superstitious and their lives are structured around religious beliefs and traditions. Many of Hong Kong's festivals have (inevitably) a strong maritime influence. For the fisherfolk the most important deity is Tin Hau, the Mother Goddess of the sea. She provides comfort and solace to sailors, and above all hope for a safe return, particularly during the typhoon season. She was a real person, the sixth daughter of a Sung dynasty mandarin (AD960–1279) who was deified after her death. Her real name was Mo Niang from the fishing village of Pu Tien in Fukien Province, born in the eighth year of Emperor Yuen Yan's reign (1098 in western terms). She attracted attention because she could accurately forecast the weather — a very valuable gift when your life and livelihood depend on the winds and waves. Tin Hau was furthermore granted the ability to calm the storm and level the waves, keeping fishermen from harm and shipwreck and to provide them with bountiful catches. As an additional attribute she was even reputed to be able to walk on the water if given a straw mat under her feet. Her reputation was such that the Emperor K'ang-hsi (AD1644–1911) beatified her and gave her the title of Heavenly Queen.

Tin Hau has the honour of providing the reason for Hong Kong's greatest festival on her birthday, the 23rd day of the third moon. At this time the great fishing fleet of Hong Kong readies itself to sail at first light: every banner, flag and pennant they can lay their hands on is produced and attached to the masts. It is a spectacular and colourful sight unmatched anywhere in the world as their banners whip and stream in the wind. The majority of the boats process in line to the most important of the many Tin Hau temples — the Da Miao Temple in Joss House Bay.

63. An old painter in Victoria Harbour.

64. Star Ferries have been ploughing across Victoria Harbour since 1898. They carry about 100,000 passengers a day between Hong Kong Island and the mainland.

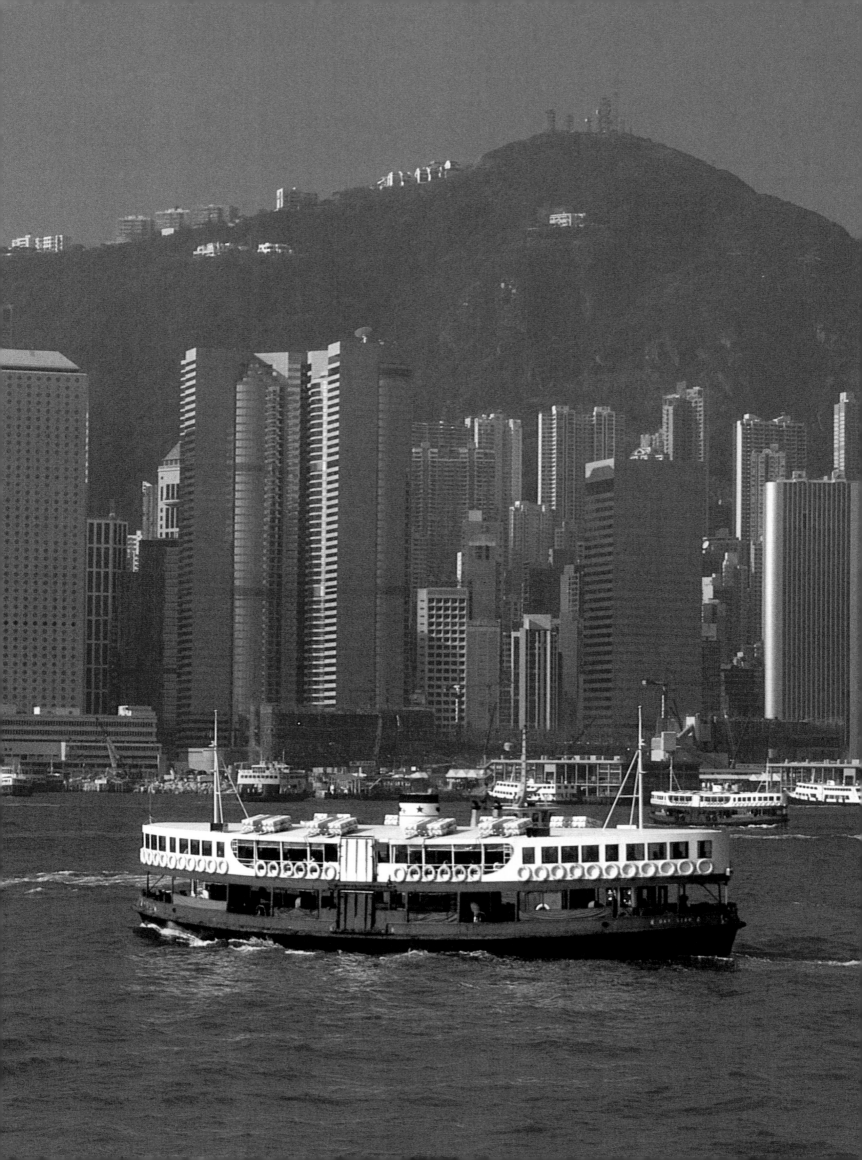

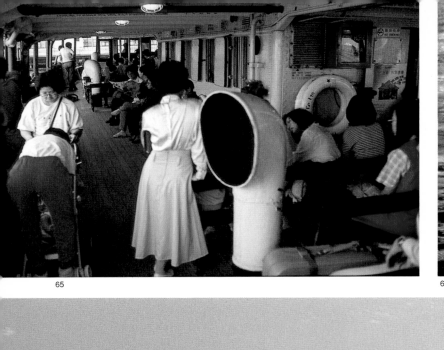

65

66

67

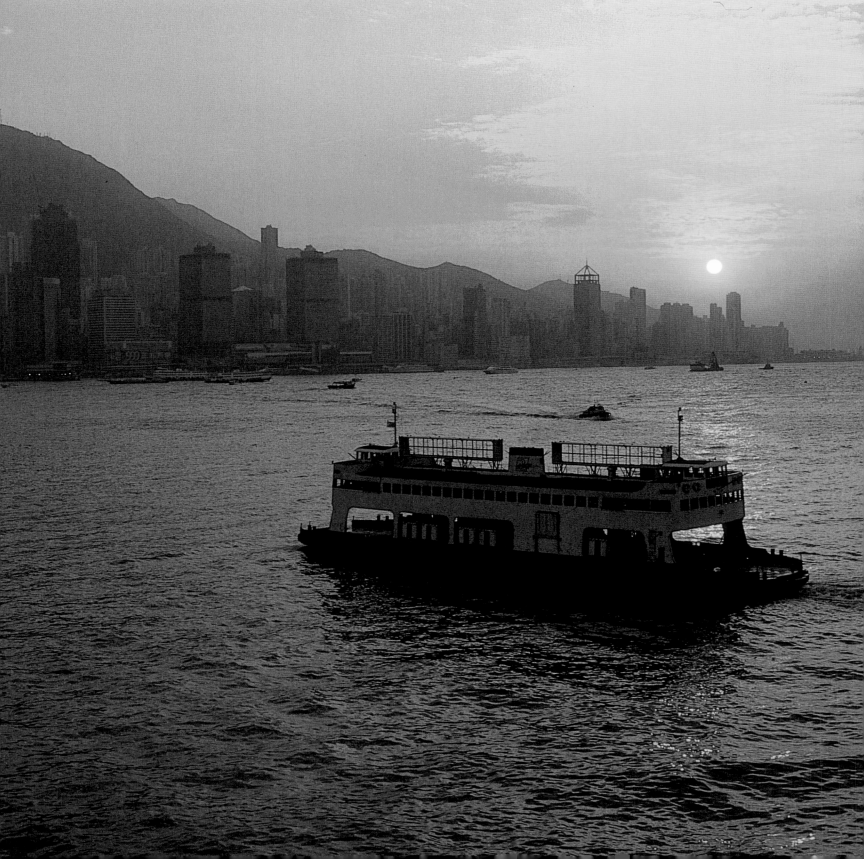

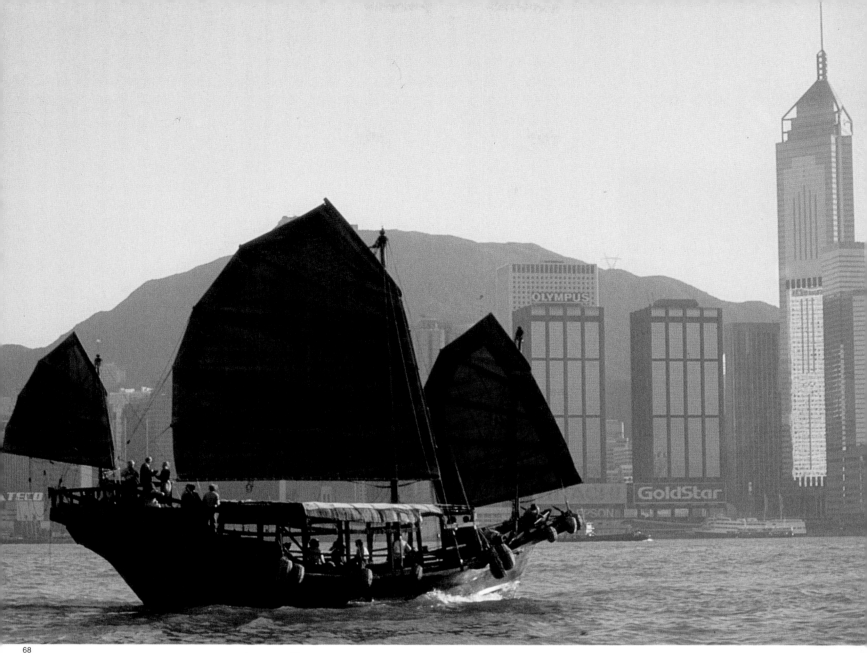

68

69

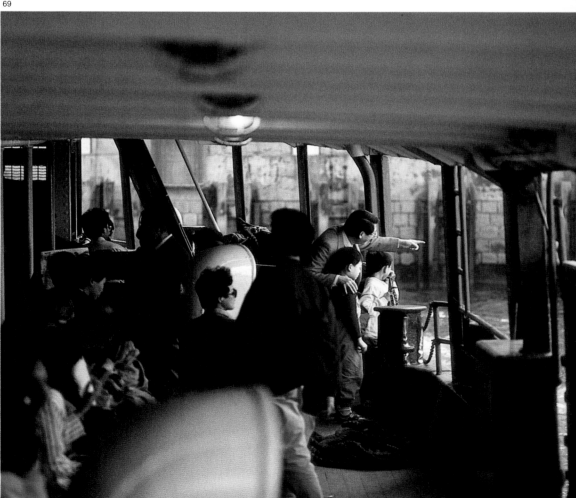

65. Lower deck — cheap rate! — passengers on board one of the Star Ferries.

66. Kowloon junk *Noble House* moored in Victoria Harbour among brilliant neon reflections.

67. Looking across the waters at sunset over Hong Kong Island.

68. Tourists getting a flavour of sea-going life from a Chinese junk.

69. On board a Star Ferry a proud father points out the view to his sons.

KOWLOON AND THE NEW TERRITORIES

70

Across the waters from Hong Kong island lies the thriving modern city of Kowloon and beyond Boundary Road, the New Territories, consisting of a peninsula of 740sq kilometres (285sq miles) of largely rural lands. At the time they were acquired this was a quiet, underpopulated rolling green backwater.

Now the peninsula contains about half the population of Hong Kong, many of them concentrated sardine-like into the high rise blocks of Kowloon and the new satellite towns built by the government to house roughly two–three million people each. However the main charm of the New Territories lies out in the tranquil agricultural pastures and the few remaining traditional walled villages with their temples to local deities, and the small coastal fishing villages. Away from the thronging towns many people still lead a rural life on their ancestral lands working closely with the soil — or in the fisherman's case, with the sea. They make up roughly two percent of Hong Kong's workforce but feed much of the population with their efforts. Their wide selection of vegetables are sent fresh to the local markets or sent on into the cities and towns around Hong Kong. Sadly, paddy fields and water buffalo are becoming increasingly rare as the land is turned over to more profitable vegetable growing. Small scale vegetable growing is a labour intensive process, particularly as most peasants still water the land as their ancestors did — by carrying it in two large buckets hung on a yoke across their shoulders. Snowy white ducks are a common sight quacking around the homesteads, grown for the pot and for extra money.

Another ancient way of using the land is by fish farming in vast ponds. Here the landscape stretches as far as the eye can see over bright blue waters cut across with a network of green dykes on and around which perch scattered fishermen's houses and cabins. The houses are festooned with nets drying in the sun ready for the next plunge into the waters. Most of the fish are different species of carp, a long time favourite of the Chinese. Here it is common to see rows of huge circular flat baskets drying fish in the sun to make fish paste.

Some coastal fishing villages, such as Lau Fau Shan, are entirely devoted to the oyster, to such an extent that the ramshackle buildings are actually erected on long discarded oyster shells. Go down to the main jetty to look out over Deep Bay and on to mainland China, swivel round to look at the land and all you can see are huge hills of oyster shells containing countless millions of old shells. Those oysters that don't go to the fish markets are turned into oyster sauce.

Gau lung, as the Chinese call Kowloon, translates as Nine Dragons: according to legend a young boy-emperor belonging to the 13th century Song Dynasty arrived in the area after running away from the advancing Mongol hordes. He was told that there was a dragon in each of the hills above the bay, in total eight hills, so eight dragons. Ever attentive acolytes said that, as he was an emperor, there were in fact nine dragons there!

In the early days of settlement the Kowloon peninsula remained largely undeveloped except for the fortified garrison. Called the Walled City the area remained Chinese and became a notorious retreat from British authority for all kinds of bandits and evil-doers. In the early days (since 1912) the main reason people arrived here was to catch the romantic Orient Express which had its Far East terminus at the imposing columned station. From here travellers could journey to Peking (Beijing), or catch the Trans Siberian Railway. The grand station was demolished as recently as 1978 when the station relocated and now the only reminder is the 45m high clock tower built in 1921.

Kowloon is considered the best place to go shopping in all Hong Kong: Nathan Road, otherwise known as the 'Golden Mile', is a long commercial artery thronging with crowds most of the time and vivid with neon at night. Here shops sell gold, silver, precious stones, cameras — fake and real — great bolts of vivid silks imported from China, and clothes, clothes, clothes. Supposedly the neon signs are not allowed to flash at night for fear of incoming pilots mistaking it for the runway!

Hong Kong's international airport, Kai Tak, is a vital link to the outside world, but this, it is hoped, will change in 1998 when the new airport at Chek Lap Kok is finally completed. Until then Kai Tak holds a very special, some would say unique, place in the hearts and minds of pilots and passengers. It is one of the very few urban-sited airports and consequently has one of the most hair-raising approaches of any international airport. By 1956 it was apparent that a new runway was needed and the most amazing landing strip was built on reclaimed land running 4km right out into the middle of Kowloon Bay. The flight into Kai Tak is one of the most exhilarating and terrifying approaches and landings anywhere in the world. The landing tests the nerves of even the best pilots who, having flown in over the surrounding mountains, have to make a manual descent from 200m (650ft) up above the city. The plane comes in to land skimming only a few precarious feet above and between the high-rise blocks of flats immediately beside the airport, so close that even veteran passengers expect to hear the sound of the rubber wheels scraping and screaming on the rooftops, before the aircraft banks into a sharp 47° turn to line up with the runway, shooting out straight out into Kowloon Bay.

70. Wonderful fresh produce on sale in a Kowloon market. All the vegetables will have been grown locally by farmers in the New Territories.

71. A Boeing 747 Jumbo Jet over Kowloon. Kai Tak is one of a very few urban airports in the world.

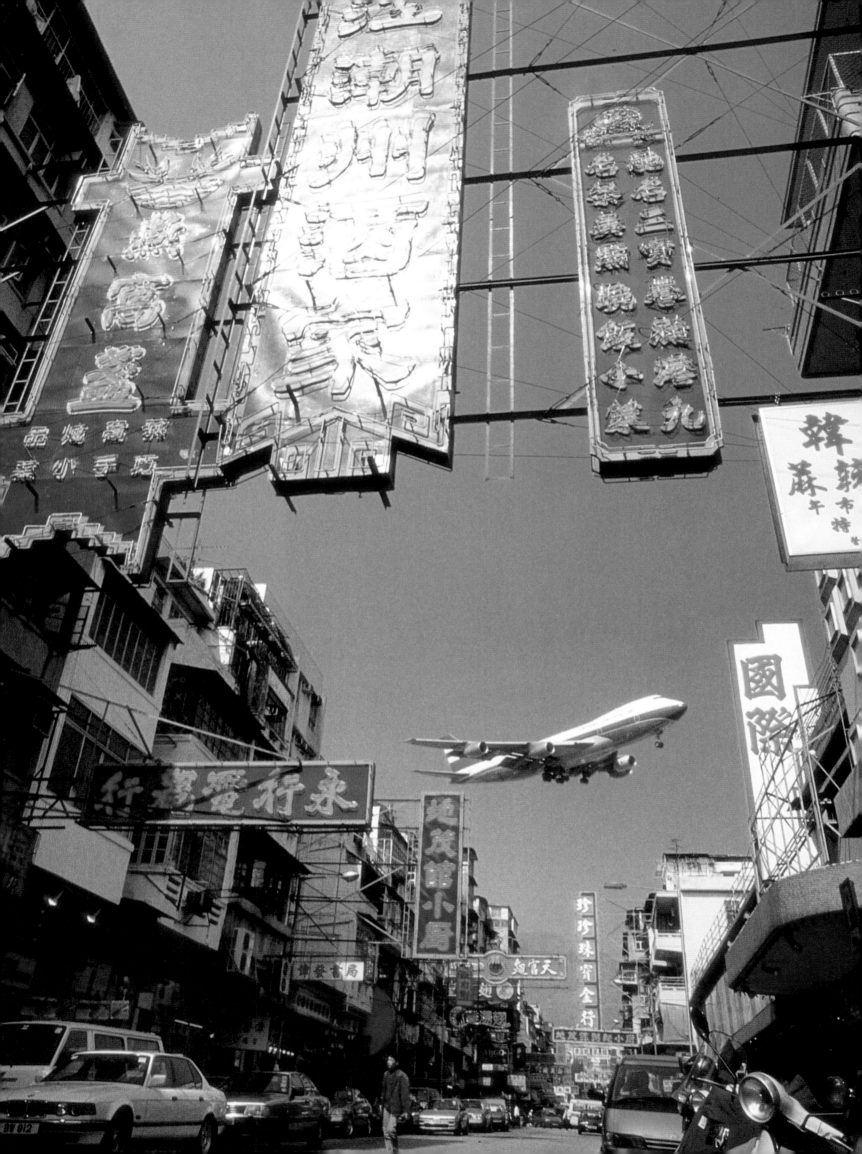

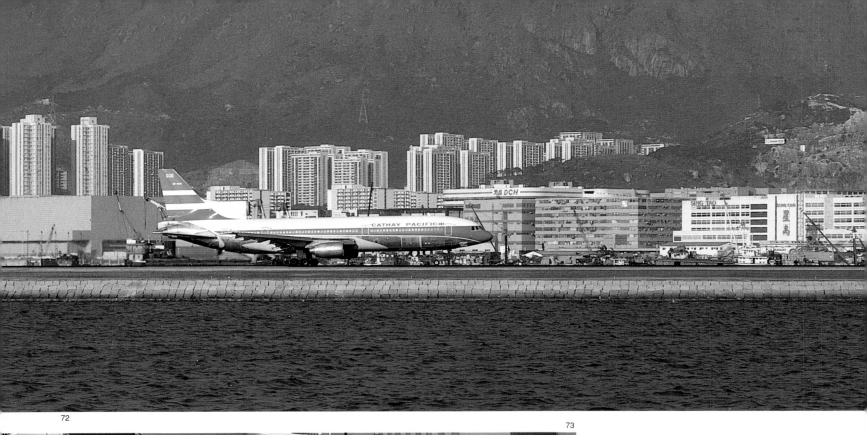

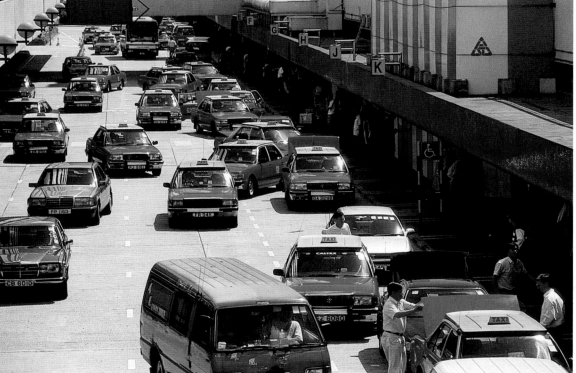

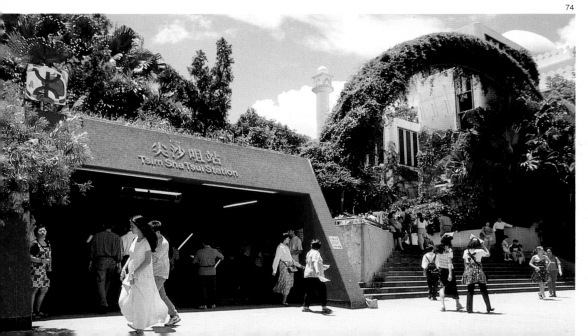

72. A Cathay Pacific Lockheed TriStar on the runway at Kai Tak.

73. Taxis waiting for customers at Kai Tak airport.

74. Shop until you drop at Tsim Sha Tsui; then recover with a meal or drink at one of the numerous restaurants and bars. This is the entrance to the MTR — the Mass Transit Railway.

75. The neon signs on the Nathan Road in Tsim Sha Tsui are not allowed to flash at night for fear an incoming plane might mistake it for the runway!

76. The spectacular view from the promenade at Tsim Sha Tsui.

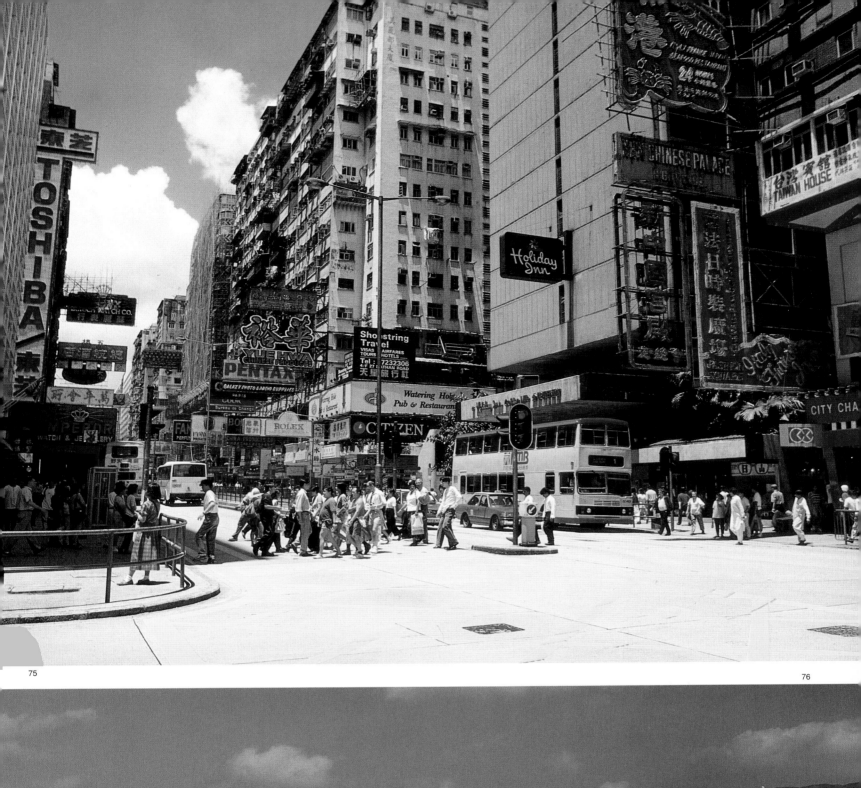

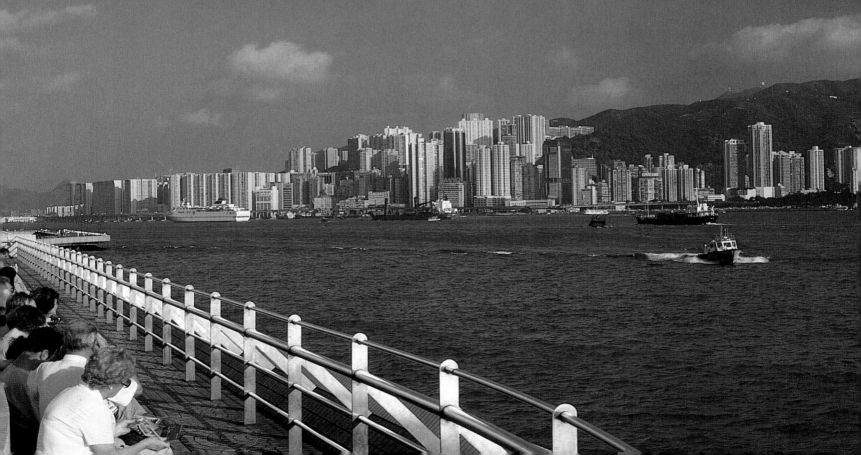

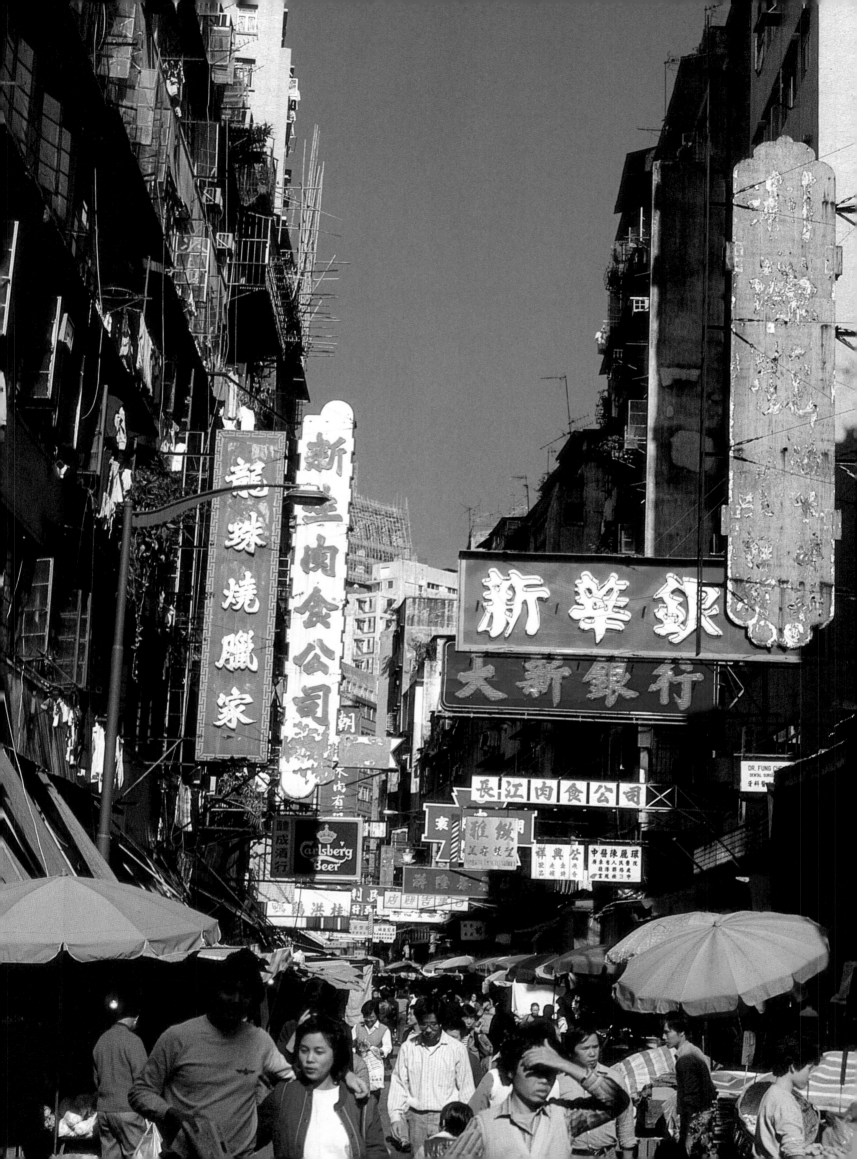

77. The streets are always thronging with people rushing about their business, or just enjoying the shopping.

78 and **79.** Go to Tai Po market in the morning to see the covered stalls selling goods of all descriptions.

80. Heavy traffic on the main road through Kowloon.

78

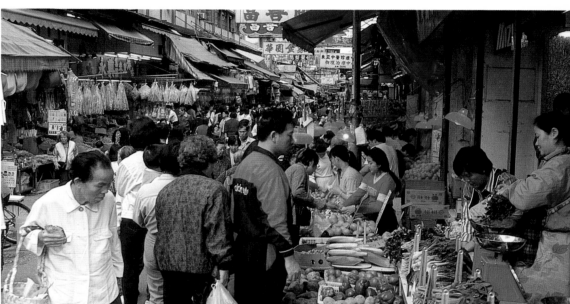

79

80

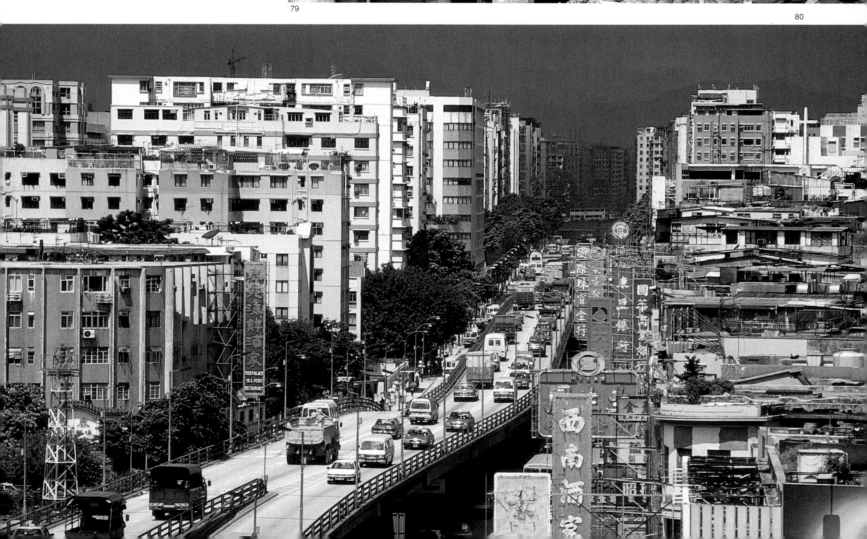

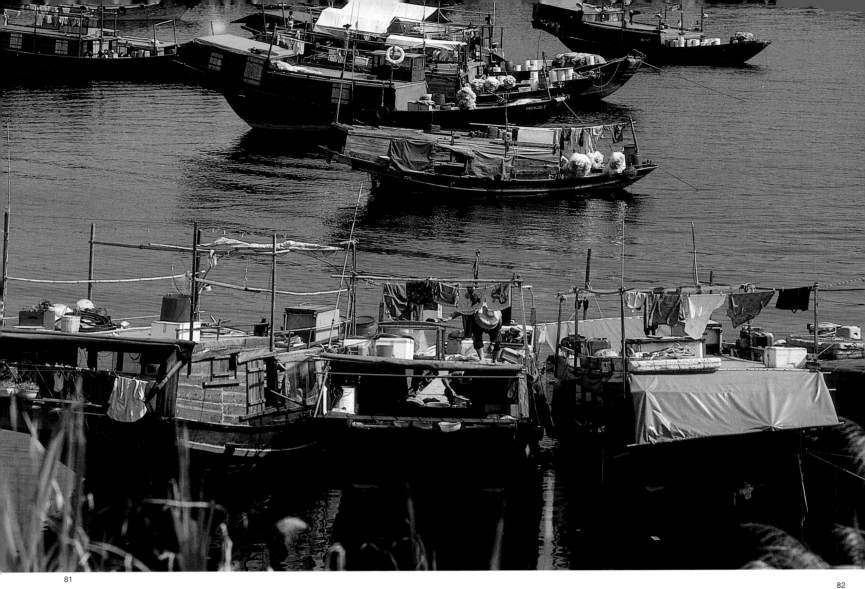

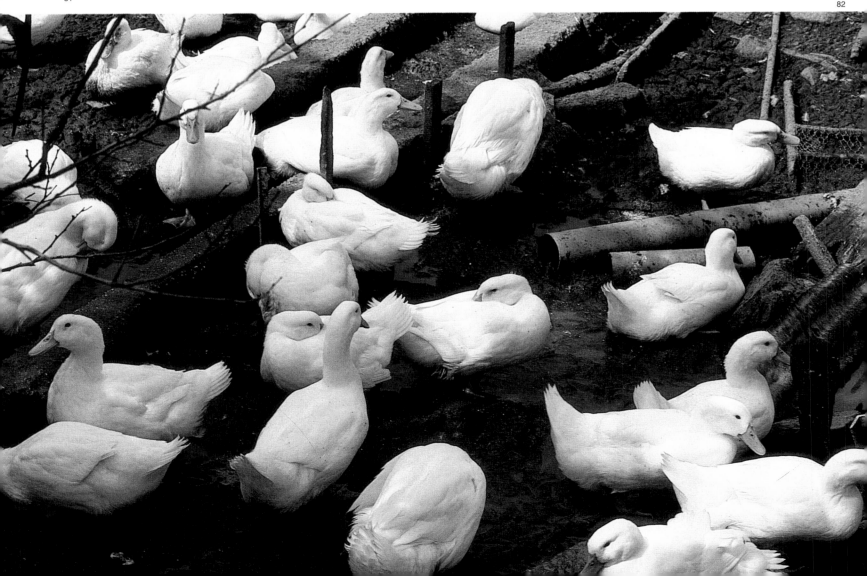

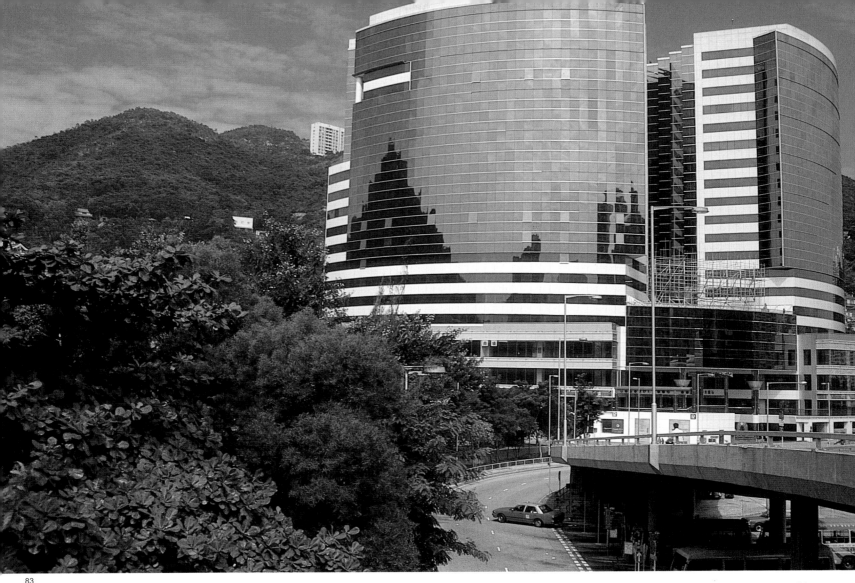

81. Chinese junks near a fishing village in the New Territories.

82. Ducks are frequently kept by smallholders to supplement their income — both for the pot and the market.

83. Grand Central Plaza in Sha Tin, in the southern New Territories. Most of the town has been built since 1970 on reclaimed mud and sand from the Shing Mun river.

84. A fish seller tending his wares in a Kowloon street market.

85. Built in the 1920s the Peninsula Hotel in Kowloon used to be on the waterfront until land reclamation robbed it of its prime position. However, it is still one of the most expensive and exclusive places to stay in the Far East.

86. Seafood is a speciality at the busy outdoor cafés in Temple Street, where around 8–11pm a thriving night market takes place.

87. The piers and buildings of China City, Kowloon.

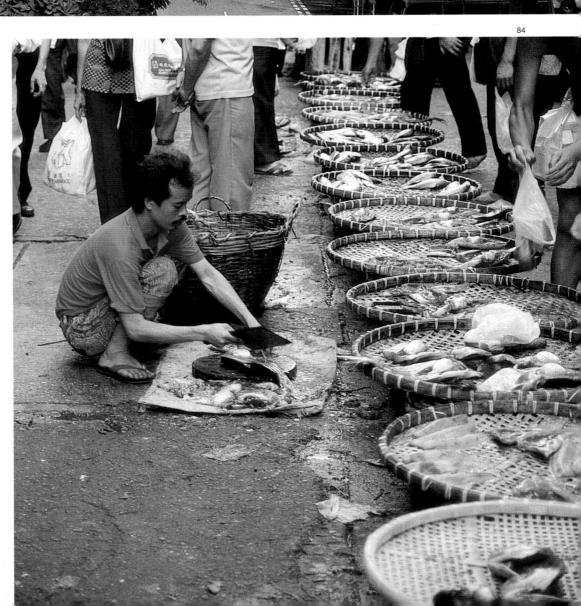

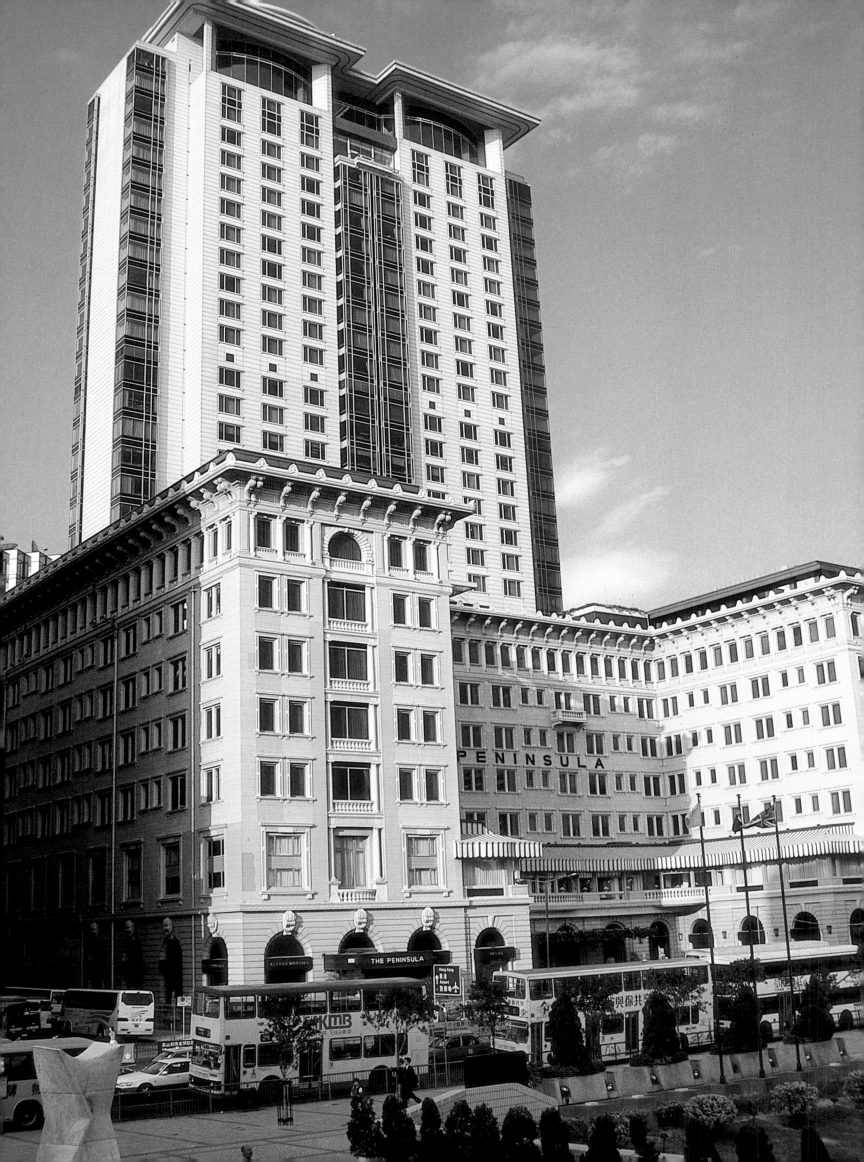

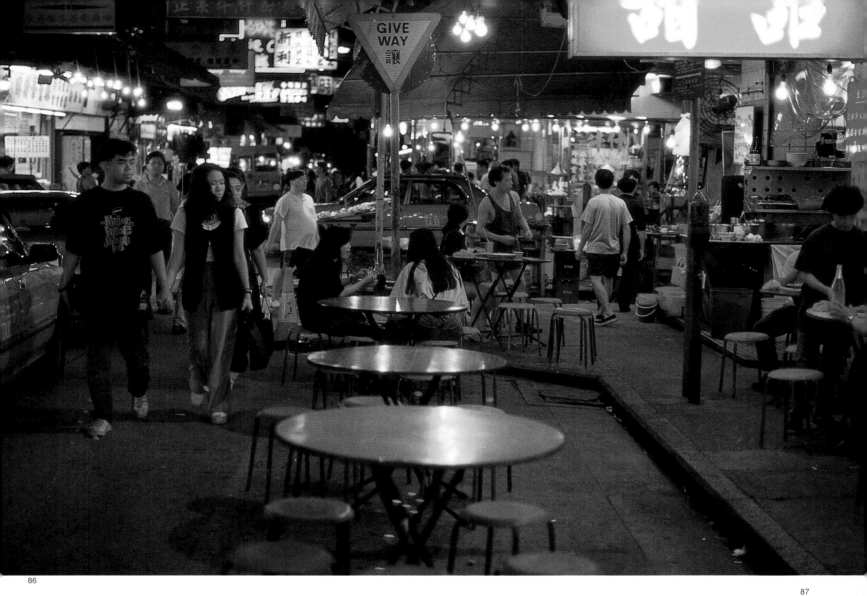

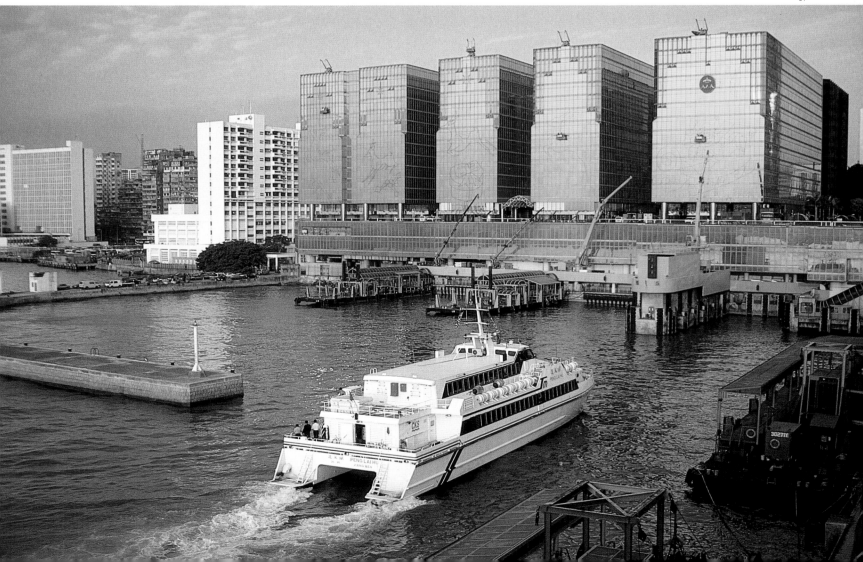

88

Despite being such an ultra-modern city Hong Kong's heartbeat pounds to the rhythms and dictates of ancient custom and belief. Religion plays a big part in daily life in Hong Kong with every major world belief represented here. However, by far the largest numbers are Taoist, Confucian and Buddhist, of which the first has easily the most adherents. Everywhere across the territory are hundreds of temples and shrines dedicated to one or more local gods; many of these are makeshift altars in private homes or even outside on the open pavement, all the way up to the huge elaborate temples where hundreds come to regular worship. Furthermore many of the public holidays are directly attributed to religious occasions.

Most temples are relaxed places, open roughly from dawn to dusk, with people drifting in and out making offerings and saying prayers. At festival times the temples are lavishly embellished with colourful flags, banners and decorations and filled to the brim with people laughing and chattering between the chants and prayers. Food and paper goods are burnt as offerings to the dead. Dancing is a popular entertainment, as is Chinese opera, which is performed to placate marauding ghosts as well as to charm the hearts of humans.

The Chinese calendar works on a 12-year rotation with each year named after an animal and being credited with having the characteristics of that animal. The story goes that Lord Buddha asked the animals of the world to join him on Chinese New Year's Day to pay him homage and receive a reward in return. The first to arrive was the rat, followed by the ox, tiger, rabbit, dragon, snake, horse, sheep, monkey, cock, dog and, finally, the pig. No other animals arrived. To honour their loyalty Buddha named successive years after each of them in a repeated 12-year cycle called the *kan tse*. Buddhism came from India in the first century AD. Adherents believe that world suffering can only be relieved by attaining *nirvana* (extinction) — a state of personal enlightenment which is defined as a state of true bliss. This is achieved through meditation. There are lots of slightly different Buddhist sects in Hong Kong; they differ in that they have fewer temples than the other religions and these temples are often built in beautiful, rural places well away from the hurly-burly of crowds and traffic. They are relaxed places with much more muted decor and atmosphere than the usual temples in Hong Kong. They have resident monks and nuns.

Taoism dates from 6BC and espouses a philosophy known as the Tao or 'the way'; this is a search for the truth in the way of things. Superstition and fortune telling have particular significance to Taoists. Their gods are mainly legendary figures with specific attributes and powers, who reside in very colourful temples which host the rowdiest of the annual festivals. You can usually tell a Taoist temple just by looking at the roof which is often decorated with colourful porcelain figures depicting heroes and dragons from Chinese legends. Inside will be stalls selling joss sticks and slow burning incense spirals. There's usually a stall or fortune-telling room — these are decided by shaking sticks in a cylinder until one falls out. Attached to the stick is a fortune paper which has to be paid for and taken to a fortune teller at the stall for explanation.

Confucius lived some 2,500 years ago, probably the best-known and influential thinker in Chinese philosophy. His followers follow a philosophy not actually a religion, though it has acquired many religious-type traits. It is based on piety, loyalty, education, humanitarian and familial devotion as advocated by Confucius. Here there are few temples and even fewer religious observations.

Confusingly, gods from various religions are often worshipped in other religious temples – for instance Buddhist deities are often worshipped in Taoist temples.

88. Chinese opera at the Cheung Chau island four-day bun festival in May, held to appease vengeful spirits.

89. Local people burning joss sticks at Wong Tai Sin Temple in Kowloon; this is one of the major Taoist centres in Hong Kong.

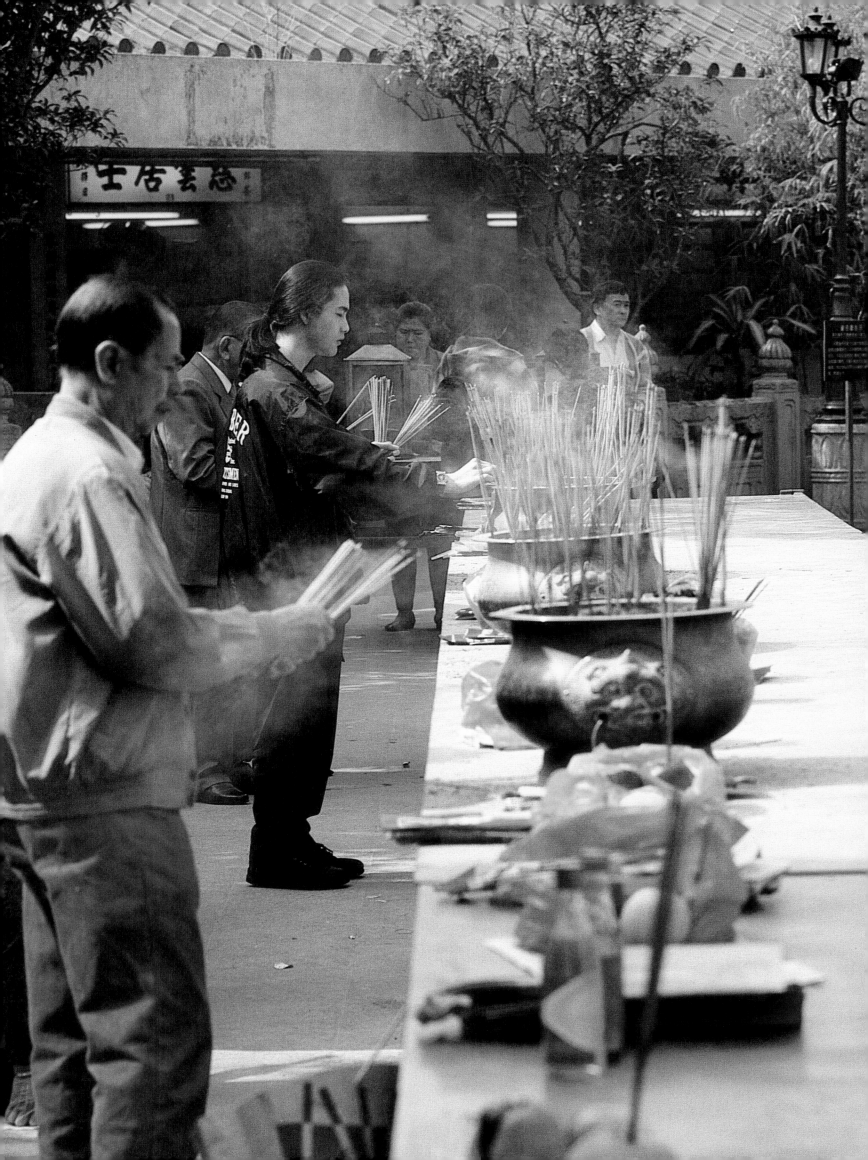

WONG TAI SIN TEMPLE, KOWLOON

90

Across Victoria Harbour lies the peninsula on which sits Kowloon. Like Hong Kong this is a modern city whose shape and structure are defined by 20th century commerce. But dig deeper than the obvious high-rise surroundings and the history and traditions of the people will appear. One such fascinating example hidden amidst modern towering skyscrapers is Wong Tai Sin Temple, a major Taoist centre of worship. This is actually a very modern temple opened in 1973, though dedicated to an old and popular god who cures illness and brings good luck — particularly to gamblers who follow horse racing.

The god Wong Tai Sin arrived in Kowloon in 1915 with a Chinese family who brought him in the form of a favourite painting that they had originally worshipped in a Chinese temple called Sik Sik Yuen. They then moved the image to Wan Chai where it remained for six years before bringing him to Kowloon. Having decided that Kowloon was to be his resting place, the next problem was to find exactly the right situation for his temple. Local geomancers were consulted and asked to discover precisely the right spot for the temple, one which had good *Feng Shui*. They pointed to the powerful Lion Rock and pronounced that this site occupied the right situation with the sea directly in front. The temple was completed in 1921 and served as a place of private family worship until 1956 when the public were allowed in for the sum of HK$10 each.

The temple proved very popular with its adherents and a great deal of money was raised for charity. In fact so much money was raised that it was decided to demolish the temple and rebuild it. Consequently, in the 1970s it was pulled down and rebuilt on a much more massive and lavish scale, costing somewhere in the region of HK$4 million. Most of the stone for the buildings came from quarries in China which traditionally, for many centuries, have provided the stone for Chinese temples. The bright yellow roofing tiles came from much nearer — Kwangtung Province, just across the border. The vivid and exuberant colours of the temple and surrounding building dance before your eyes while your nostrils are filled with the aroma of burning incense. Every surface is covered with colour and decoration; even the priests wear scarlet ceremonial robes embellished with the symbols of yin and yang. Outside the Nine Dragon Wall Garden is constructed as an exact copy, as far as possible, of the famous mural in Beijing.

The rear of the main altar is carved to illustrate the story in calligraphy and pictures of the god Wong Tai Sin. It relates the legend that he was just a simple shepherd boy herding his sheep long ago over the hills of distant China. He was spotted and chosen by one of the Immortals to be blessed with the knowledge of how to refine cinnabar into an immortal drug. Overwhelmed with this god-given ability, Wong Tai Sin became a hermit for 40 years until his brother found him: his main concern seems to have been for the flock of sheep that disappeared with his brother all those years ago! Remorseful at losing his family the valuable animals, Wong Tai Sin took his brother to a place full of white boulders which he then turned into sheep for his brother.

Wong Tai Sin has become one of the most popular Taoist gods, with fanatical followers, many of whom are gamblers who pray and offer gifts to him to bring them luck and good fortune. His other aspect is that of being able to cure illness. With such useful attributes, Wong Tai Sin Temple as a consequence is always crowded — particularly so around festival times, especially Chinese New Year and his own festival which falls on the 23rd day of the eighth lunar month — usually in September.

At festival time huge excited chattering crowds throng to worship at the temple. They and tourists alike have to run the gauntlet of the stall holders at the entrance to the temple hawking their wares of joss sticks, paper money and lucky cards. Just outside is a street of covered booths where the fortune tellers lurk — for a price they will read the bumps on your head or the lines on your palm and foretell your future. For this they pay a monthly rental to the temple which goes to funding locals schools and hospitals.

90. The exuberant and elaborate roof details on Wong Tai Sin Temple.

91. Just outside the temple are small shops selling joss sticks and paper money to be burnt as offerings.

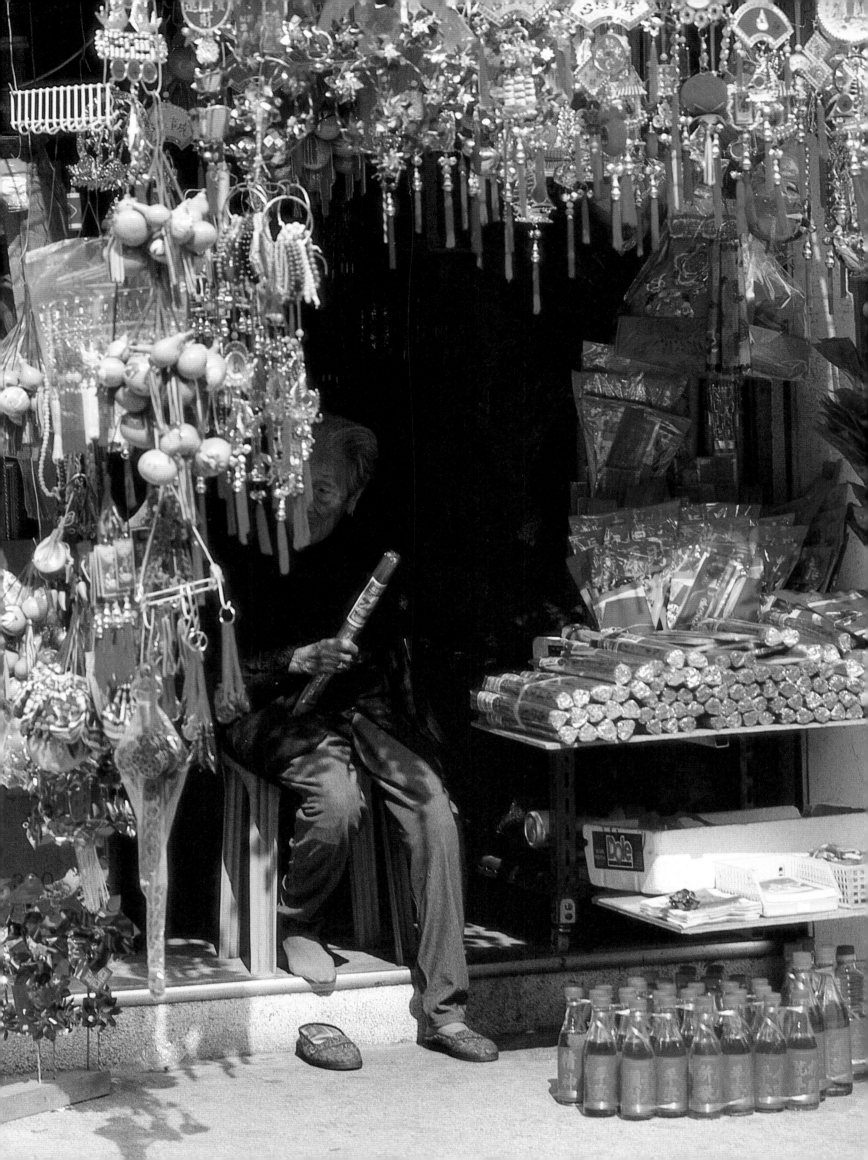

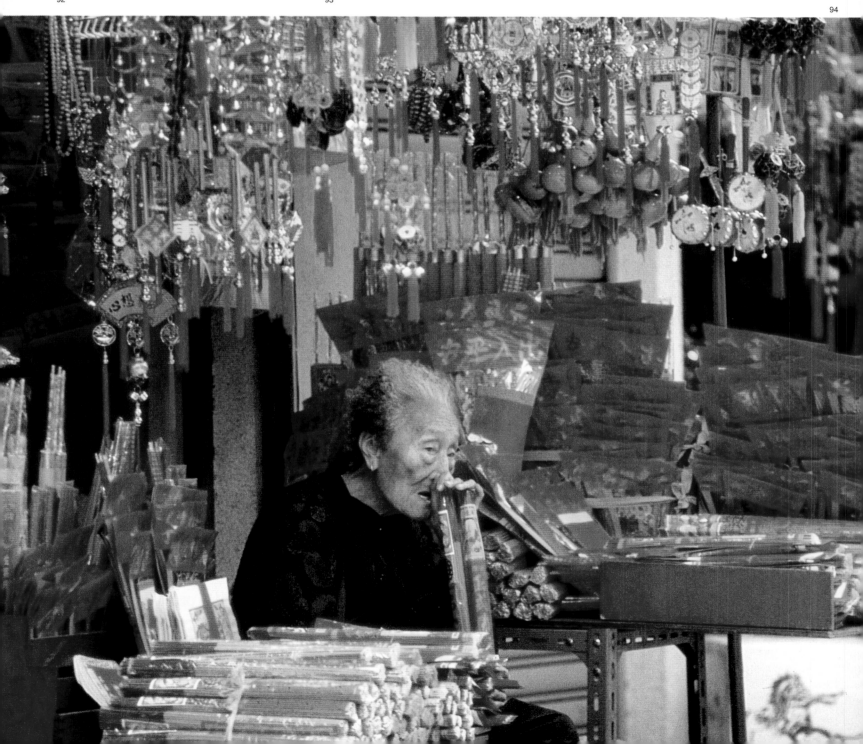

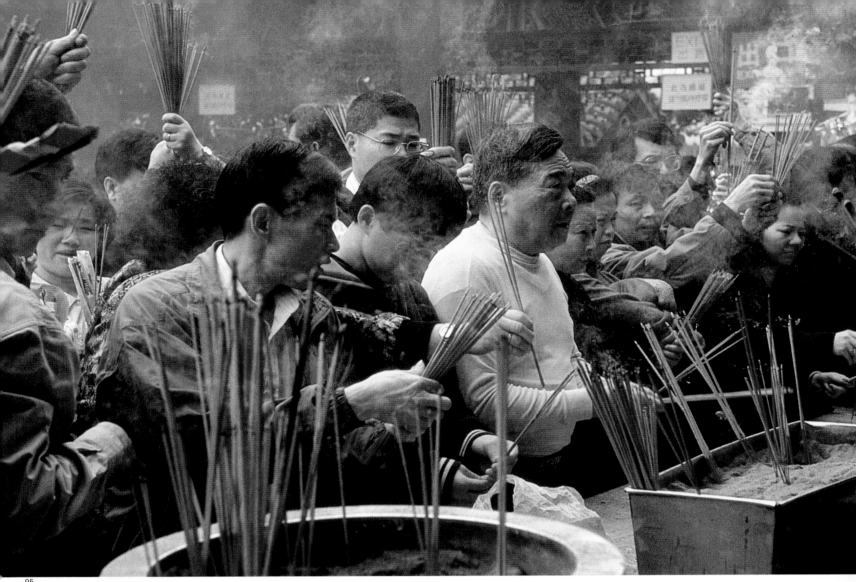

95

96

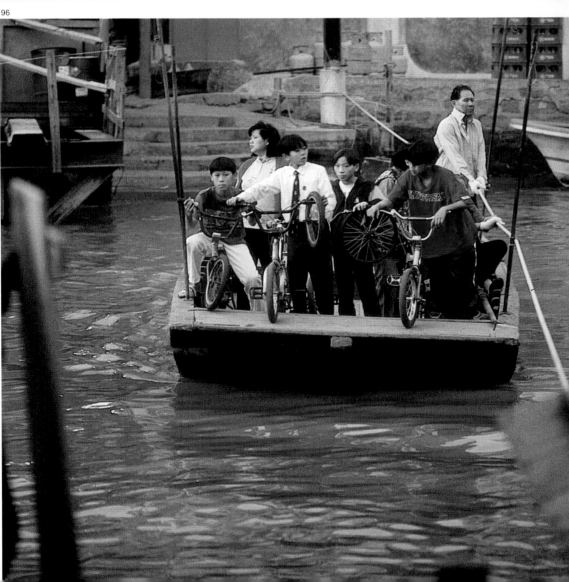

92. The scent of incense permeates the very fabric of the temple because of the huge amounts burned as offerings.

93. More rich detailing.

94. Red is considered to be the most lucky colour of all and is used particularly in connection with matters to do with the deities.

95. On festival days tumultuous crowds invade the temple, each person struggling to burn their own offerings to win favour from the gods.

96. The old rope ferry unites the split village of Tai O on the island of Lantau.

97

Hong Kong people are highly superstitious and their religions are threaded with arcane beliefs. An obvious manifestation of this is the belief in geomancy — *Feng Shui*. Literally meaning wind and water, *Feng Shui* rules the environment dictating the position and planning of buildings to create harmony. But as well as being superstitious people in Hong Kong are religious, as witnessed by more than 600 temples scattered across the colony. Over half of them are Buddhist, although all the other major religions of the world are represented here. For example on the mid-Levels halfway up the Peak are the pale green Jamia Mosque, dating from 1915, spiritual home for the 50,000 Muslims who live around the area; further along the road is the Ohel Leah Synagogue built in 1902 and the only temple for Jews in the Territory.

More than one third of Hong Kong's population is Buddhist and nowhere do the Buddhists have a more beautiful temple than Po Lin (Precious Lotus or Golden Lotus) on the largely unspoilt and sparsely populated island of Lantau. The beautiful temple complex of Po Lin Monastery is built in the traditional Chinese architectural style. It was founded in 1905 by three monks and sits on top of the 750m (2,460ft) plateau of Ngong Ping in a magnificent setting of surrounding mountains, giving views over the island to the South China Sea beyond.

Actual construction didn't start until 1921, from when temples and pavilions have been erected over the years. For 50 years the gates of Po Lin were firmly closed to the outside world and the 100 or so monks and nuns lived a quiet life of contemplation and work. Everything changed in the 1970s when Po Lin opened its gates to religious followers and tourists alike. Now the inhabitants have to deal with a huge influx of tourists — all the guidebooks talk of the queues for the No 2 bus from Mui Wo (Silvermine Bay) — who have come to see the wonders for themselves. Visitors can now enjoy simple vegetarian food in the huge main dining hall and can stay for the night on hard planks in Spartan dormitories — separate ones for men and women.

Amid the smaller outlying pavilions rises the marvellously ornate Tian Tan temple (Temple of Heaven) in a double storey some 18m (60ft) high, an edifice reminiscent of buildings in Thailand or Laos. Despite its colourful paintwork and carvings, it manages to maintain a calm and serene quality. Inside the main hall are three statues of the Buddha, each nearly 3m (10ft) tall. Po Lin's other attractions include the figures of 500 lohan (followers of Buddha) sculpted in marble. Around the walls are icons and depictions of the life and travels of Buddha.

Up on a hillside behind the temple is the focal point for visitors — the tallest free-standing figure in south-east Asia, if not the world, at 34m (111ft 6in) high. It is a statue of the Buddha, dedicated in 1993. It is reputed to have cost HK$68million raised by subscriptions from Buddhists principally in Hong Kong and China, but also from believers all over the world. The bronze figure was carefully designed and built in China, then shipped in 164 pieces to Lantau island and assembled in situ.

Lantau (Great Island Mountain) is the largest island in the area and is twice as big as the far more populous Hong Kong Island to the east. It has the colony's only tea plantation, the 24-hectare Lantau Tea Gardens, a few hundred metres from Po Lin Monastery. Behind Po Lin rises Fong Wong Shan (Lantau Peak) — 934m (3,064ft) high and the colony's second largest peak. From here the most amazing sunrise can be enjoyed, and on a clear day you can even see as far as Macau, still Portuguese until the handover to China at the end of 1999. Lantau boasts other sites of interest including a temple to Kwan Ti, the God of War, and the Trappist Haven of Tai Shui Hong set up by monks in 1956 as they fled the Chinese mainland.

Lantau Island is largely unspoilt although its peace is being eroded by the building of Hong Kong's new airport, Chek Lap Kok, on a small island off its northwest coast. Already a new satellite town has grown up on Lantau's north coast to provide homes and services for the new airport's staff. An earlier development was Discovery Bay — although locals shortened this to Disco Bay to reflect its lifestyle — a cosmopolitan area on the northeast shore of the island.

97 and **98.** The giant bronze statue of Buddha above Po Lin Temple can be seen from the Chinese mainland.

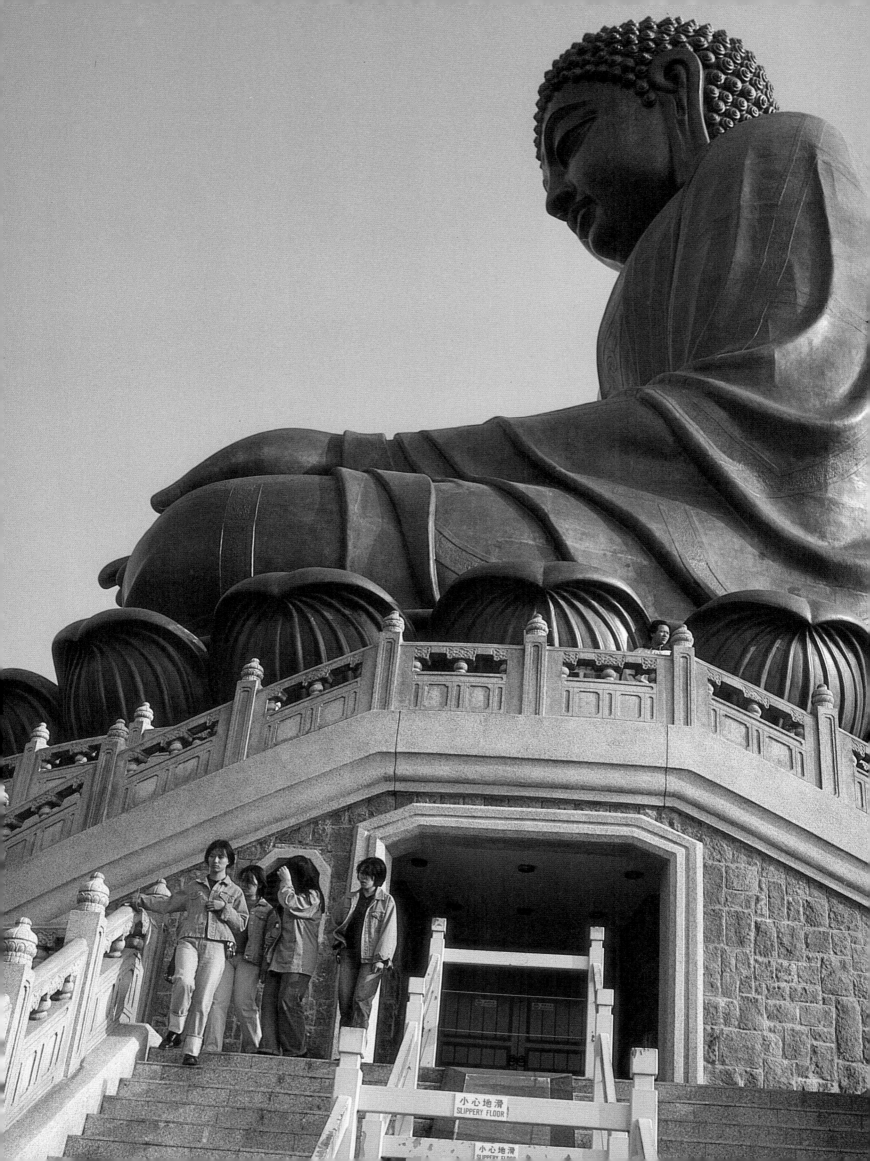

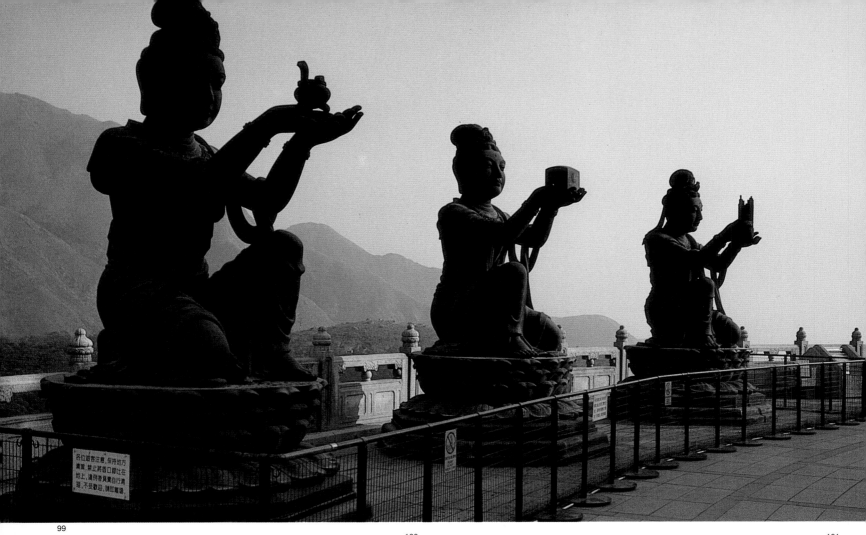

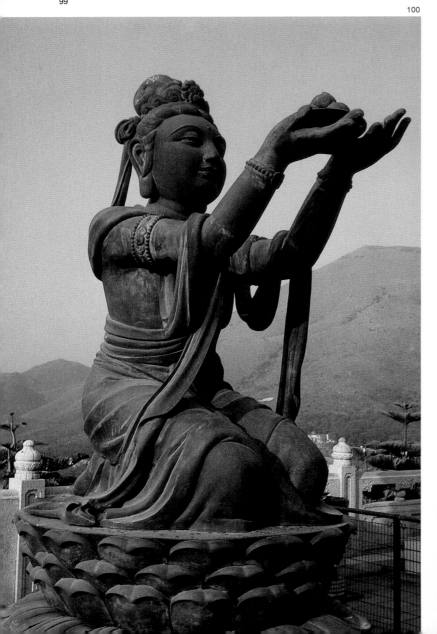

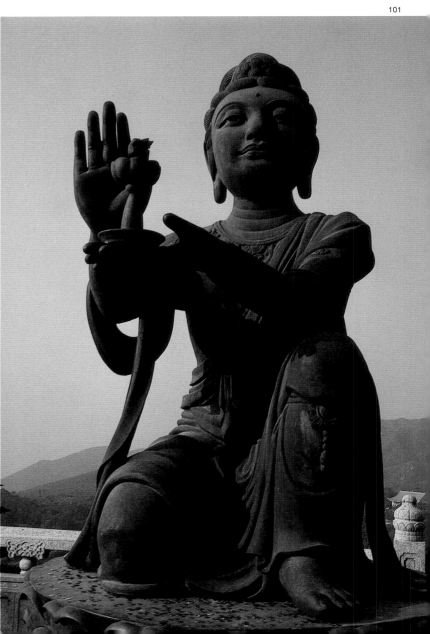

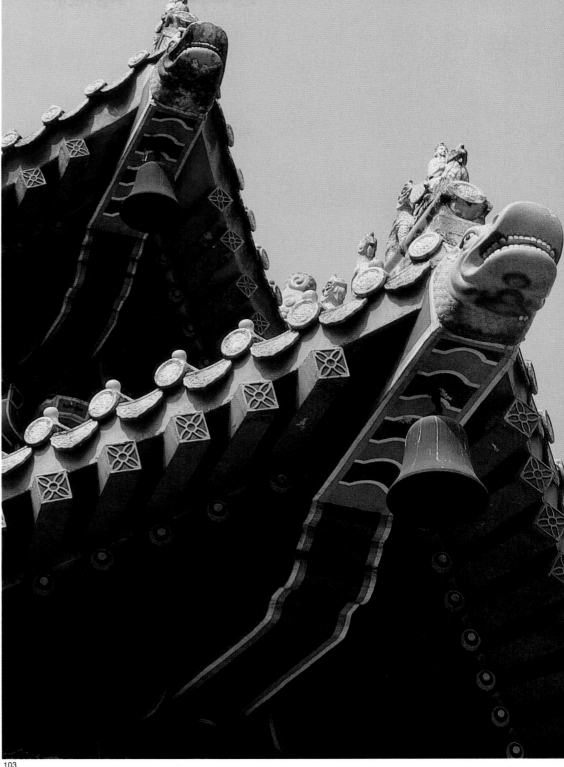

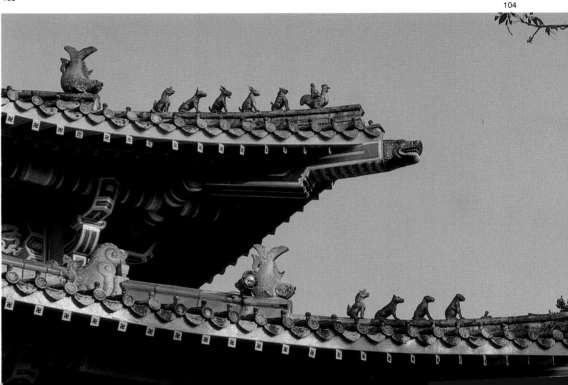

99, 100 and **101.** Studies of the statues leading up to the huge statue of Buddha, with the magnificent backdrop of mountains.

102. The statue of Buddha sits 35m tall and 750m above sea level in isolated splendour above the temple complex.

103 and **104.** Extravagant roof details help to make Po Lin monastery one of the finest examples of Chinese traditional architecture in the territory.

105. Po Lin Monastery.

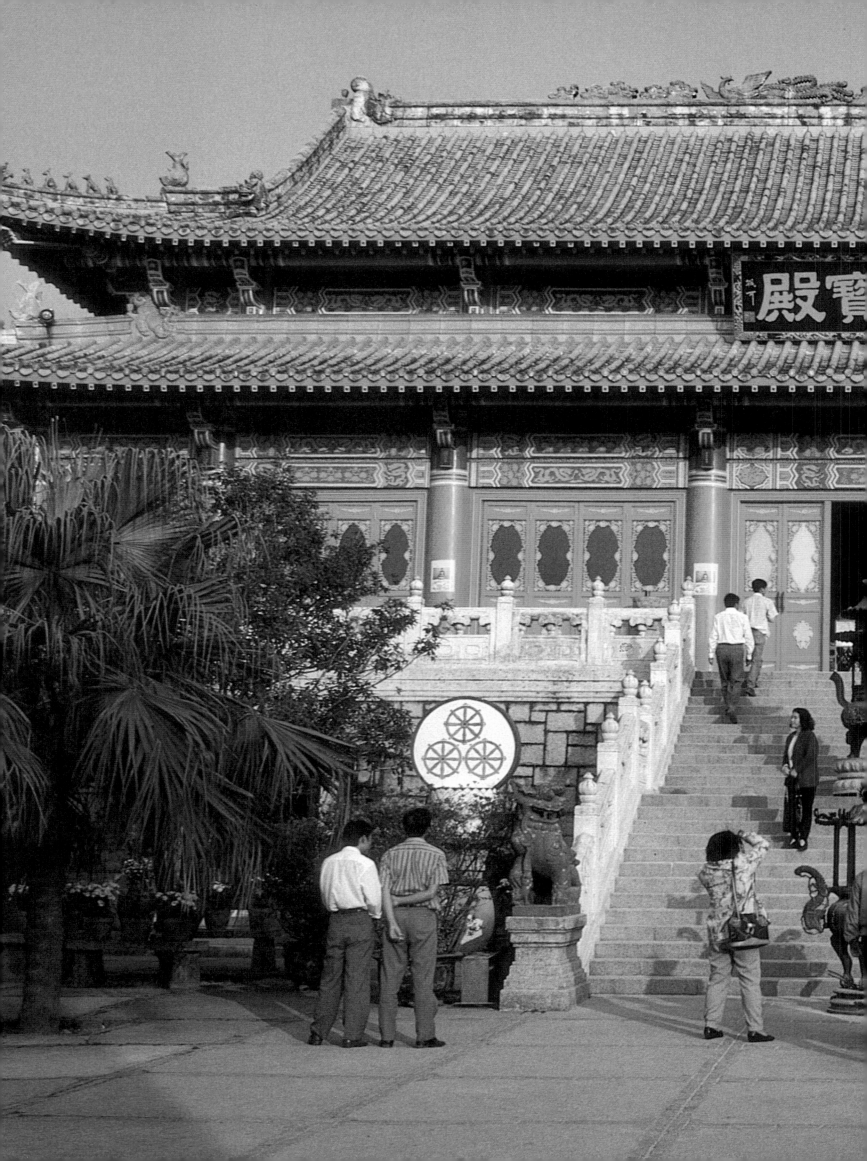

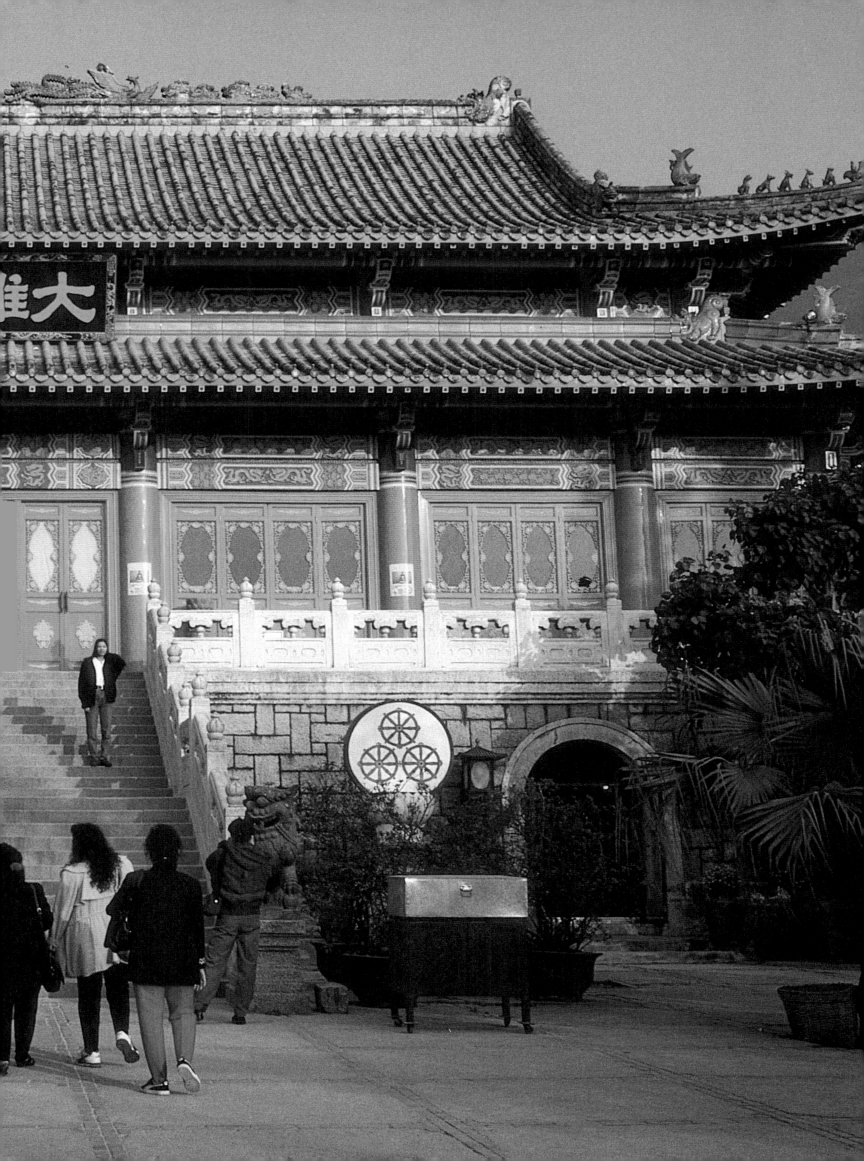

THE URBAN BEEHIVE

Hong Kong is one of the most densely populated cities in the world — which accounts for the ruinous rents and rates which are also some of the highest in the world. On average, each person — and the population is nearing six million — has less than a square metre (9sq ft) of living space. Parts of Kowloon, in particular Shamshuipo, has a population density of 165,000 people per square kilometre — the highest density in the world! In Hong Kong only the very wealthy have gardens because everyone else lives in apartments!

There are two main reasons for the lack of living space: much of Hong Kong is rocky and therefore difficult if not impossible to build on; and due to a previous complete lack of planning controls, sprawling ramshackle developments account for much of the problem. Furthermore Hong Kong has been, since its foundation, a relatively easy port for thousands of refugees and immigrants fleeing hostile regimes around Asia. All this has led the planners in Hong Kong to pay serious attention to land reclamation. Land which has gone into creating Central has been dredged out of the harbour and across on the mainland in Kowloon similar efforts have been made. However, by the late 1950s environmentalists and town planners began to get really concerned that the harbour was silting up because reclamation had so changed the configuration of the waterfront that tidal currents were unable to wash through the waters as successfully as they had in the past. In particular there were concerns about the amounts of raw sewage floating around the typhoon shelters that were not apparently being dispersed by the tidal flow. A halt was put on the reclamation while extensive studies of the environment were undertaken. Interestingly, at the end of the day it was discovered that the fears were largely unfounded and reclamation was allowed to resume.

The island of Hong Kong was ceded to Britain by the Viceroy of Kwangtung in January 1841. He was not too concerned about the loss as it was only a tiny, neglected part of the San On district of Kwangtung. some 1,500 miles from Peking. The sparcely scattered population numbered a few thousand fishermen lliving on boats and settlements along the shoreline plus some farmers in about 20 remote villages.The population the British inherited fell into four distinct communities: the Punti or 'local people' who had gradually emigrated down from Kwangtung province about 1,000 years previously; the Hakka or 'strangers', peasants who spoke their own distinct dialect and who had settled the island in the 14th century; the Hoklo, fishermen from the coastal areas of Fukien; and the Tanka, Cantonese speaking boat people who were only admitted to the privileges of Chinese citizenship in 1723. All these different tribes lived in separate villages and traditionally regarded each other with suspicion and hostility. Furthermore the Hoklos and Tankas were notorious as pirates and smugglers on the South China Seas and were generally feared and despised and so avoided by the rest of the more law-abiding and peaceful Chinese.

Thousands of Chinese have always lived in Hong Kong, many of them arriving in the 1930s when they fled the Japanese invasion of China. (The Japanese would catch up with the refugees following the attack on Pearl Harbor on 7 December 1941 when they turned their attention to Hong Kong and overwhelmed it.) Unplanned ramshackle developments were rushed up to accommodate the refugees, and building really started in earnest with mainly simple high rise flats. By the 1960s so many refugees had arrived that the authorities closed the border — this didn't stop them but it made it more difficult for refugees to get shelter. After the war the population had dwindled to around half a million but in the 1950s during the Chinese civil war numbers swelled to two million. A continuous stream of refugees arrived making housing desperately short.

Today's bustling city is captured in the photographs of this section: the movement and massing of commuters and shoppers; the markets and malls; the glittering neon night and the hot humid days. The urban beehive of Hong Kong is full of life and buisness. But what of the future? It awaits its new masters with some trepidation. When Chris Patten, last of the 28 British governors, leaves and the Chinese reclaim their territory there will be great rejoicing and — as always in Hong Kong — a lively party. It is hoped that the island is still joyful in the years to come.

106. Songbird owners often take their pets with them when they go out — especially when buying locusts!

107. Sometimes it is almost impossible to see the sky through the signs and the buildings.

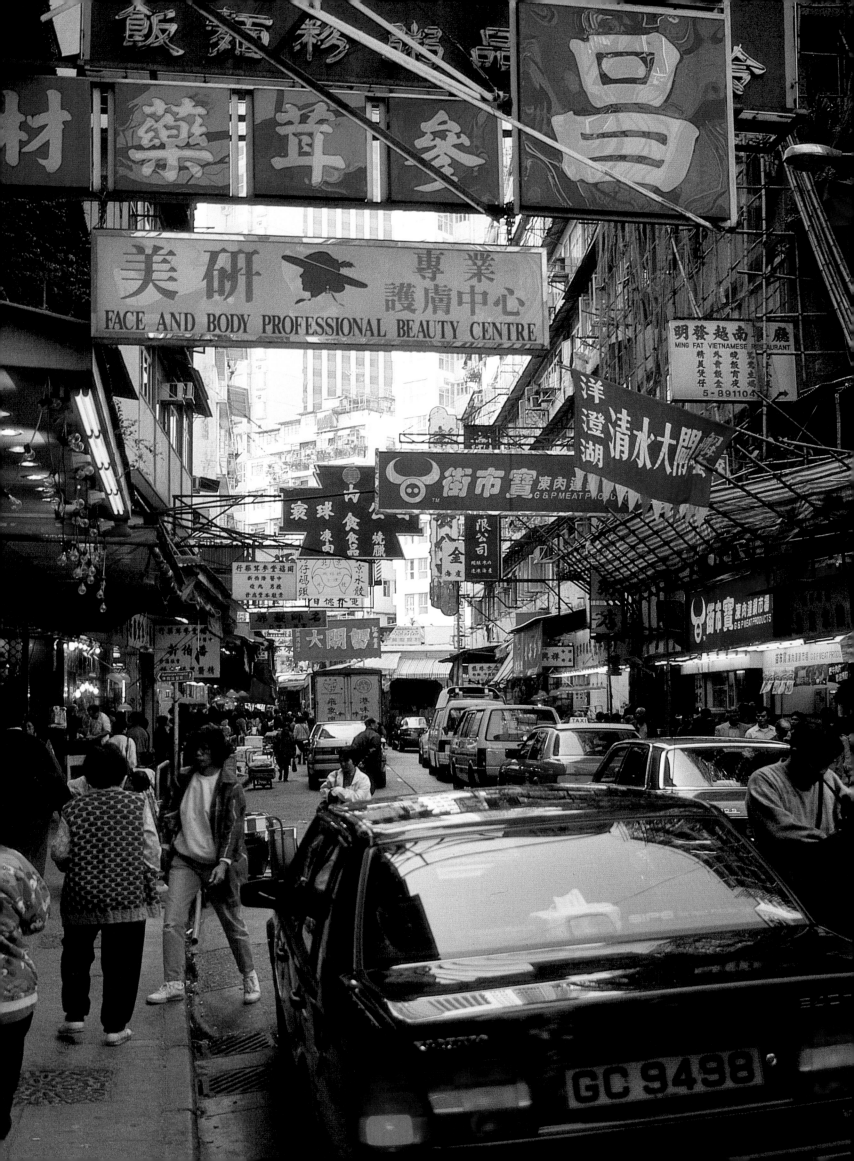

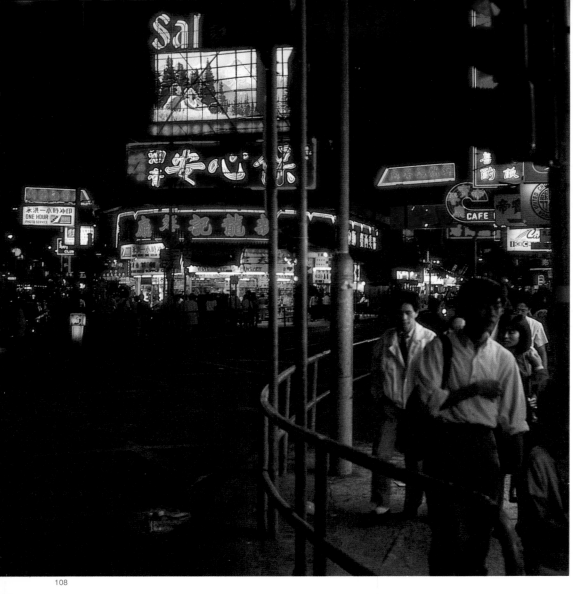

108. At night the neon signs dominate Hong Kong's vibrant nightlife.

109. The 60m high atrium inside the Hongkong and Shanghai Bank designed by Norman Foster and rumoured to be the most expensive building in the world.

110. Even the most technologically advanced buildings are built with the aid of bamboo scaffolding in Hong Kong.

111. A Chinese construction worker using bamboo scaffolding to work on a roof.

112. Hong Kong weddings are a mixture of eastern and western culture: eastern traditions and western trappings.

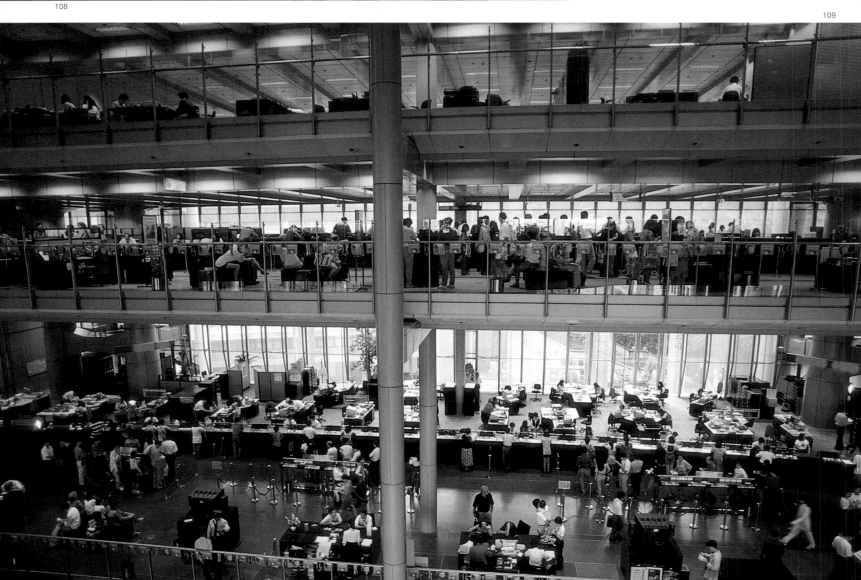

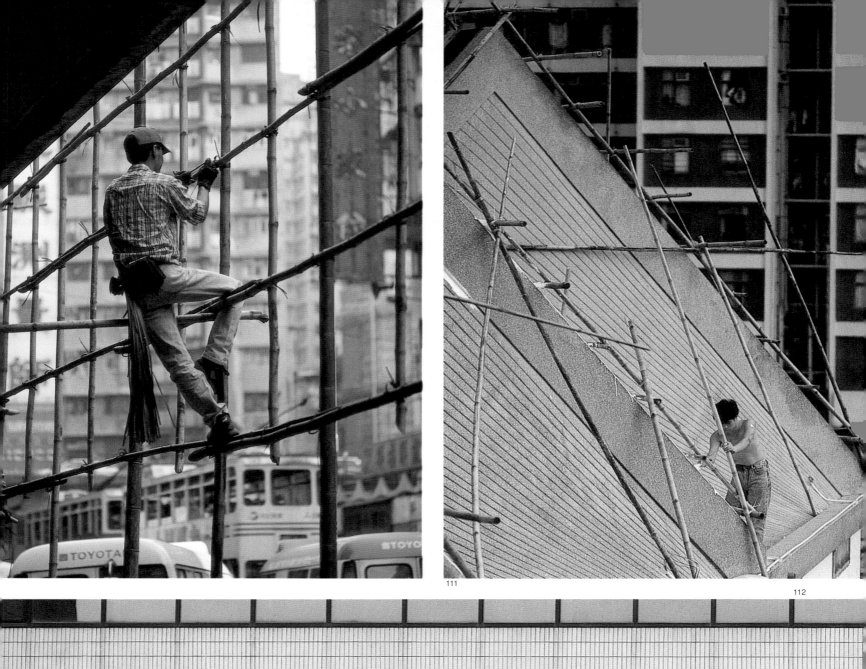

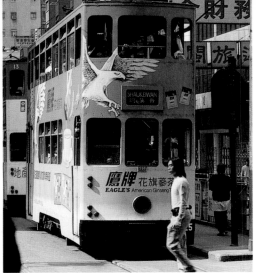

113, 114, 115, 116. One of the great sights of Hong Kong — double-decker trams. These run along the tram lines constructed early this century. All the trams were built locally by Hong Kong Tramways. Only Alexandria and Blackpool can boast a similar form of transport, most of the world's trams today being single-deck only.

117. Hong Kong also has a remarkable heritage of elderly British buses.

113

114

115

116

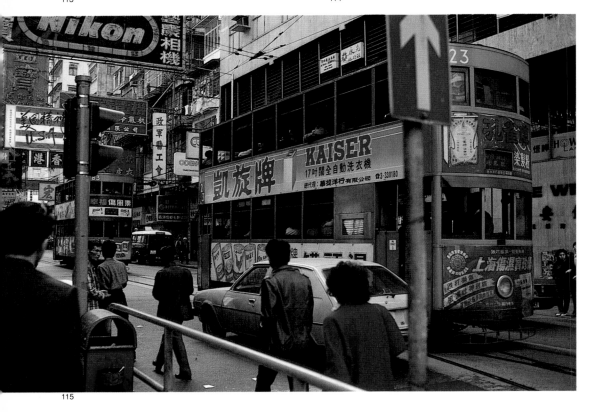

118

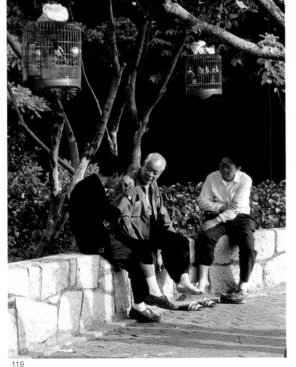

119

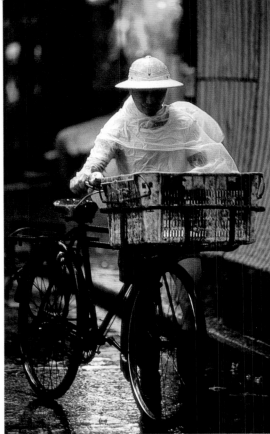

121

120

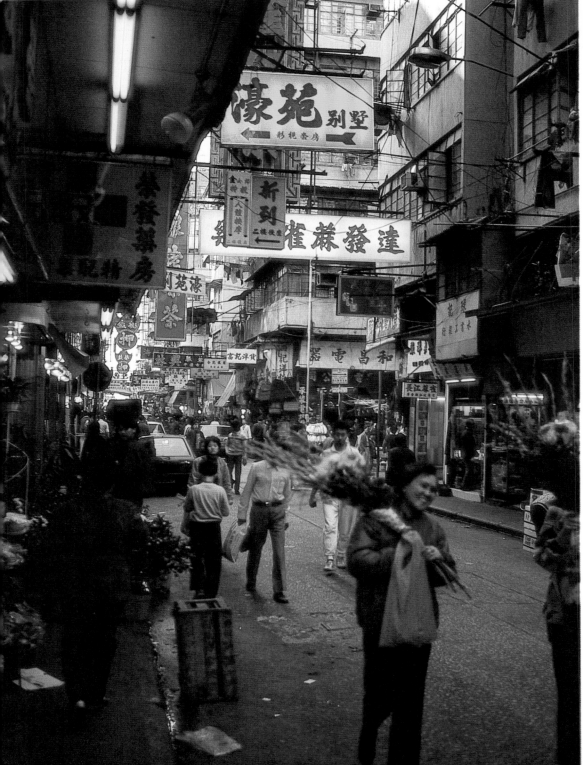

118. A proud mother and daughter on graduation day.

119. Old men out in the sunshine enjoying a chat while their caged birds get some fresh air.

120. When it rains, it pours.

121. For city dwellers everywhere, fresh flowers are a valuable breath of the countryside.

122. Caged chickens in a street market are a common sight.

123 and **124.** A huge variety of fresh seafood is plentiful and readily available in all the street markets.

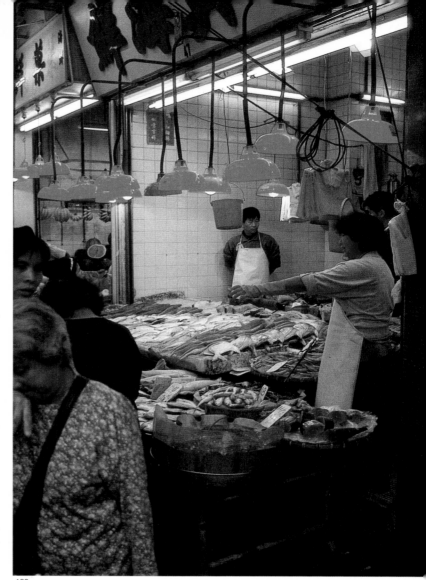

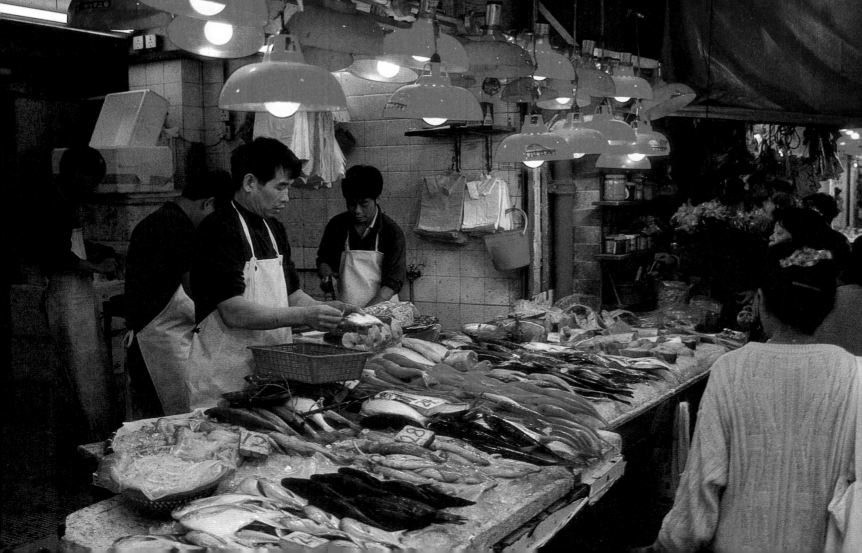

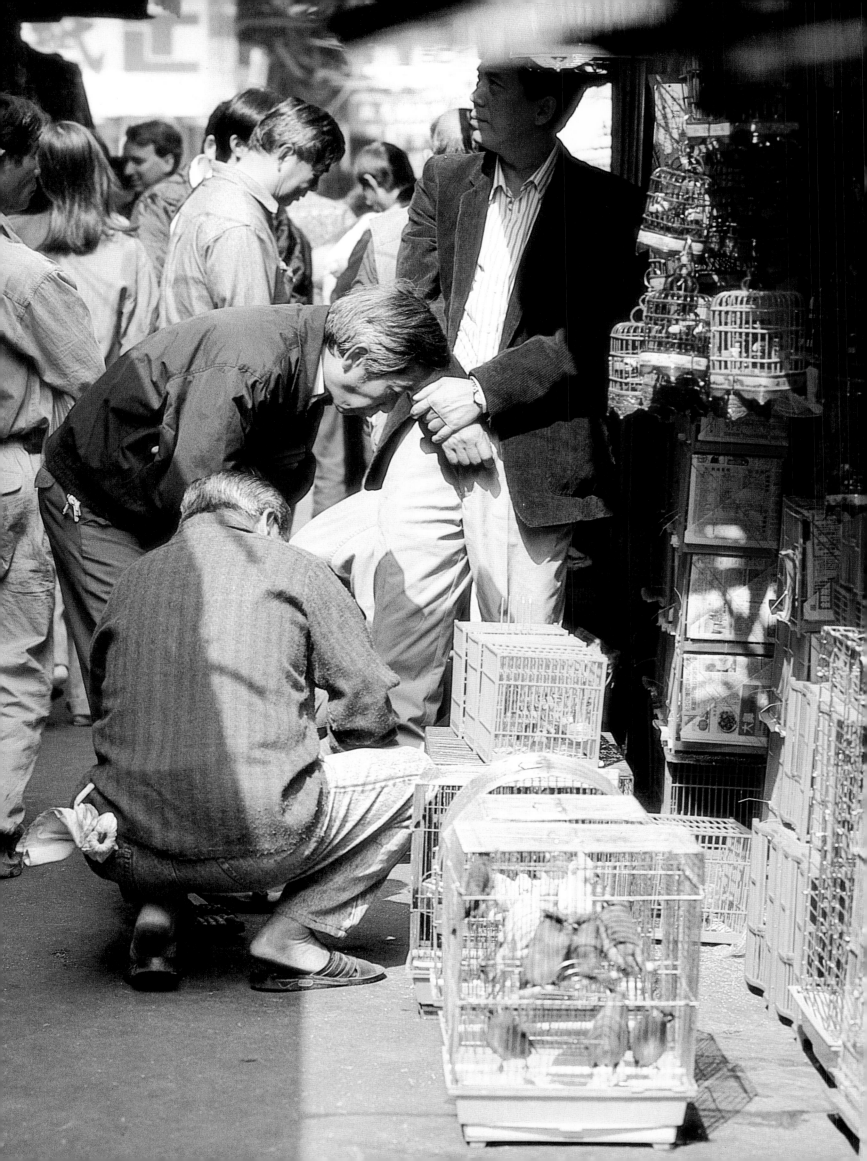

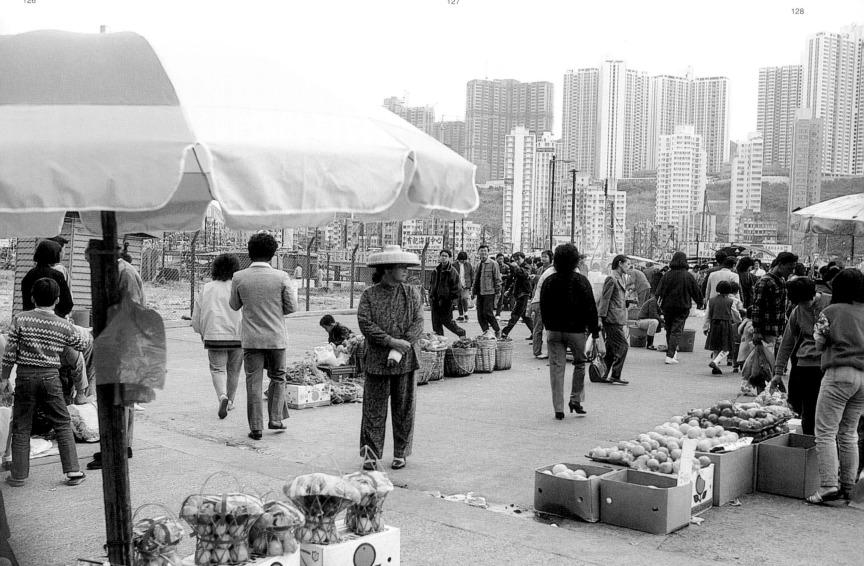

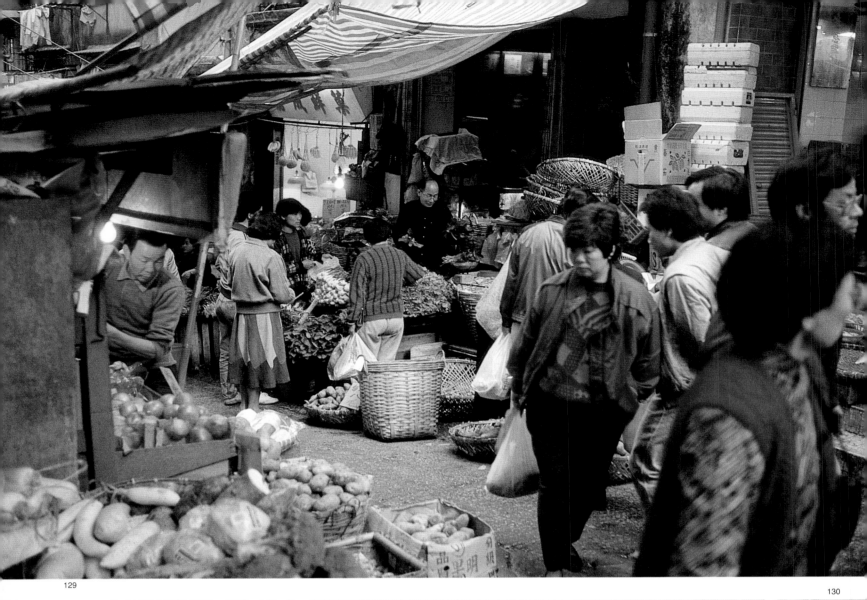

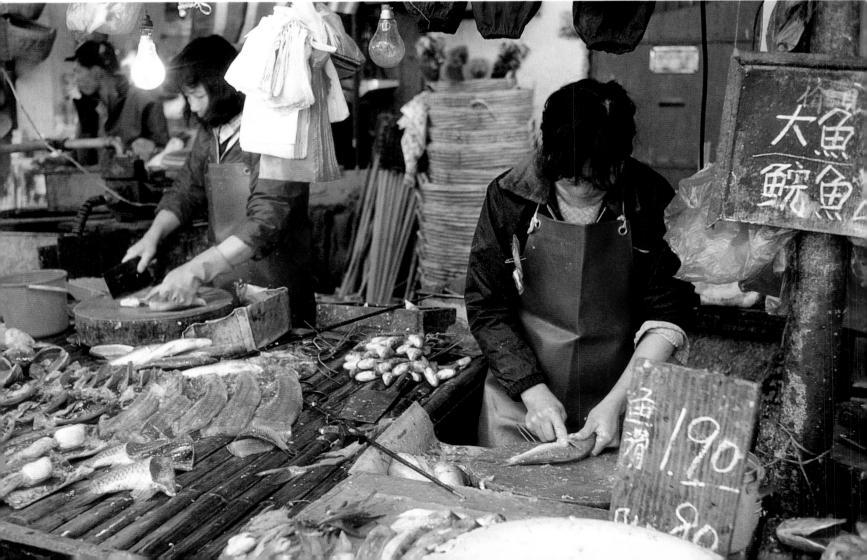

131

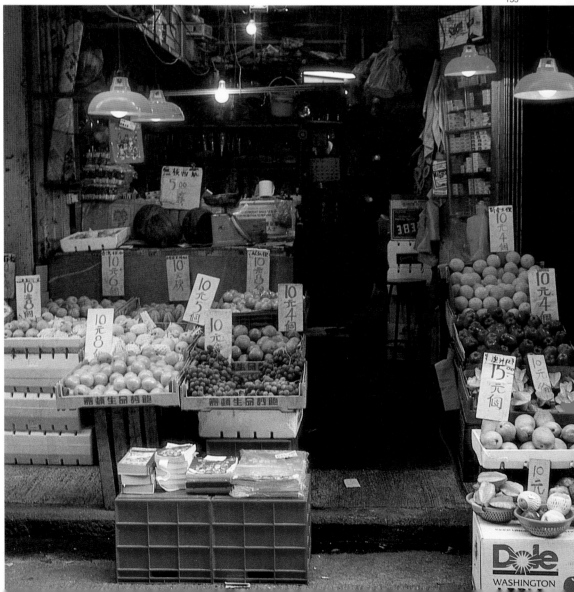

125, 126 and **127.** The Bird Market is found in Hong Lok Street in Kowloon City. Bird fanciers come from miles around to buy new companions, locusts or cages.

128. The market in Aberdeen.

129 and **130.** Fresh produce of all kinds is laid out for inspection and purchase in hundreds of markets across Hong Kong.

131. Everything is beautifully decorated and arranged.

132. In a society where most people don't own cars, huge pannier baskets are the answer to transportation problems for produce.

133. A typical fruit shop.

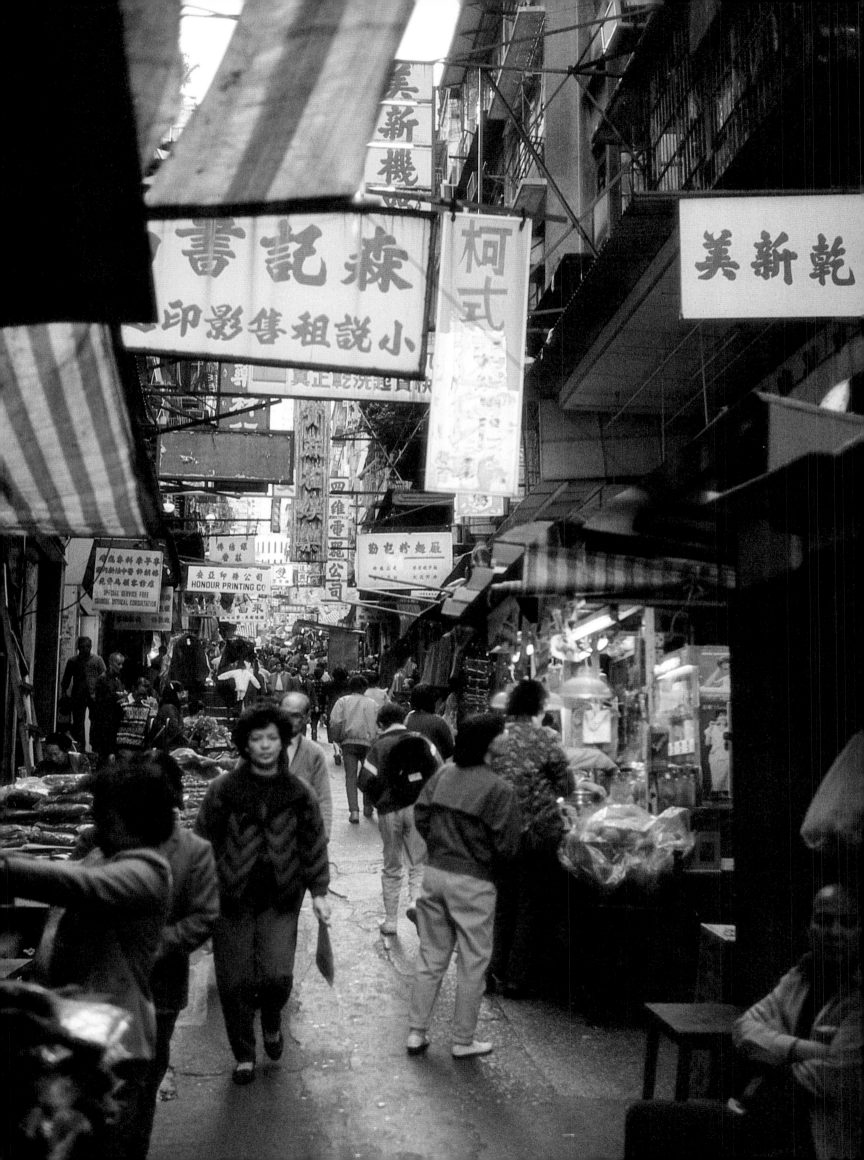

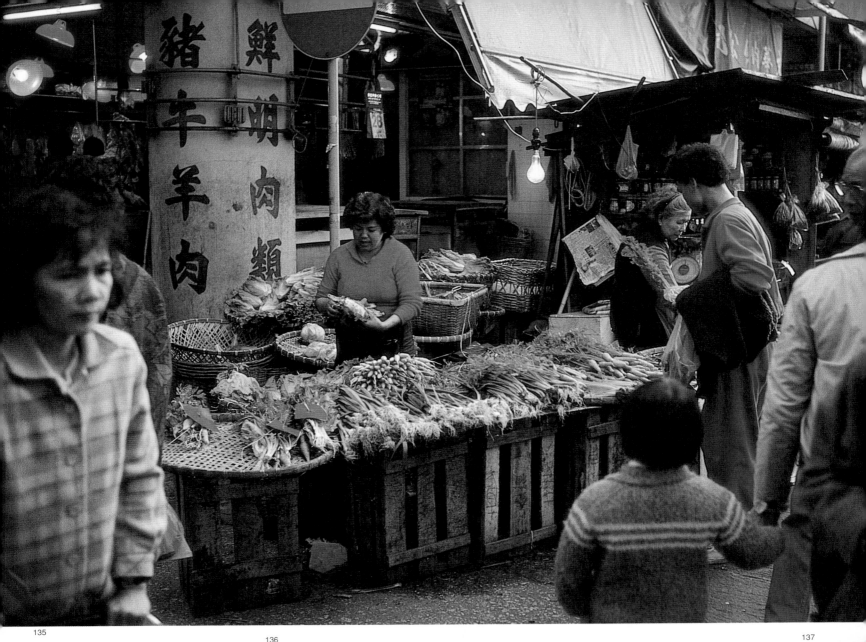

135

136

137

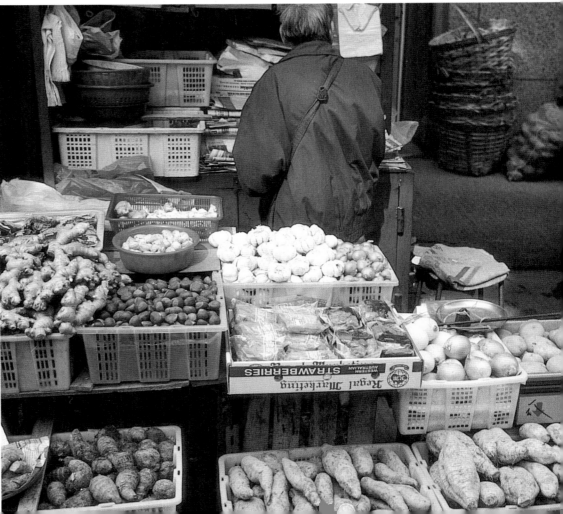

134, 135, 136 and **137.** Market scenes around Hong Kong and the New Territories.

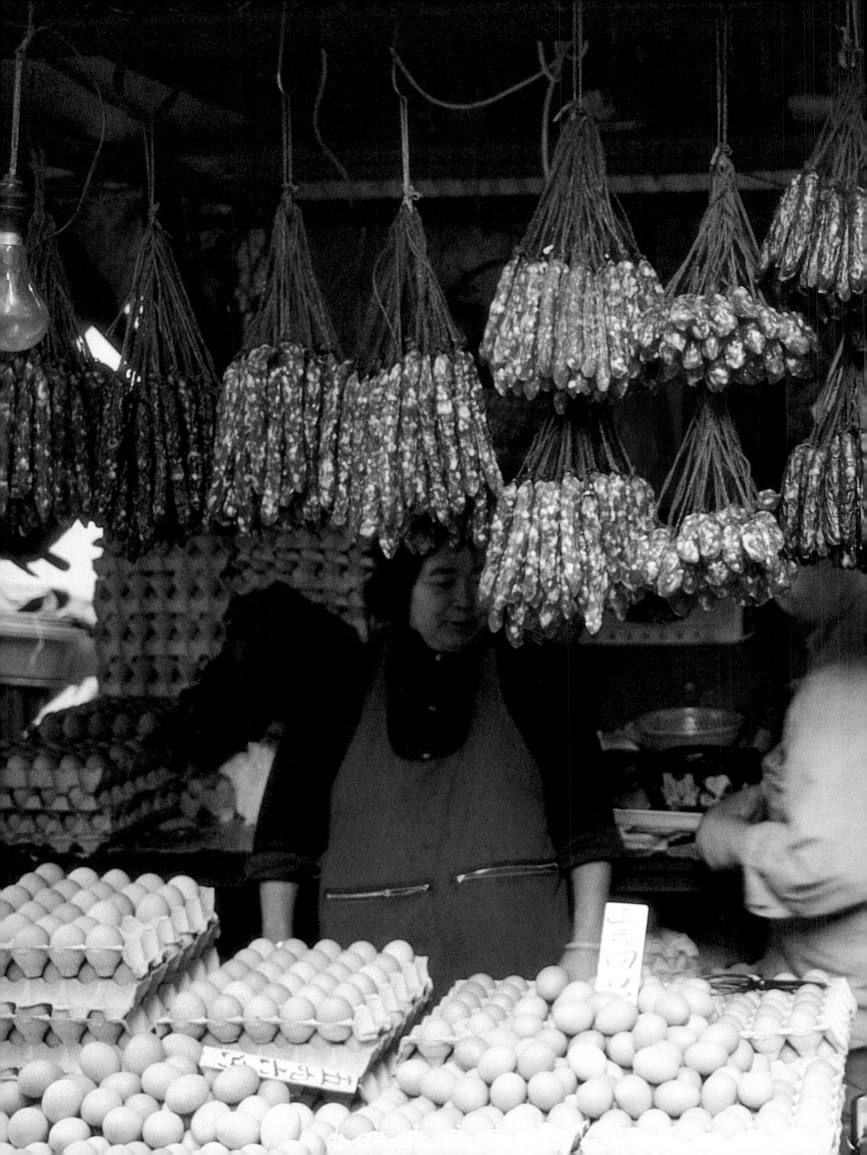

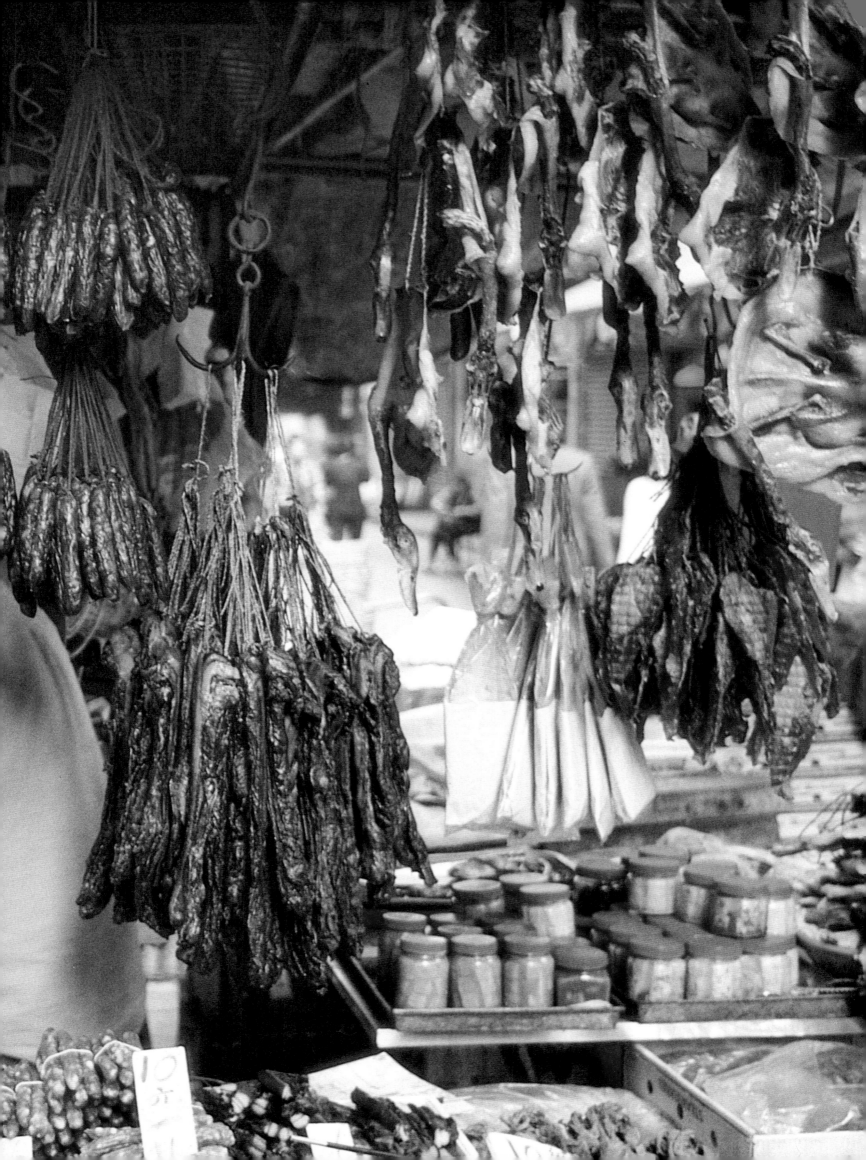

138, **139**, **140**, **141** **142**, **143** and **144**. The markets come alive at night offering a wonderful selection of locally produced Chinese delicacies and produce.

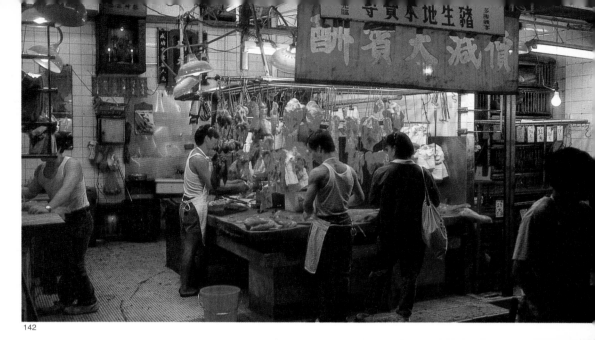

142

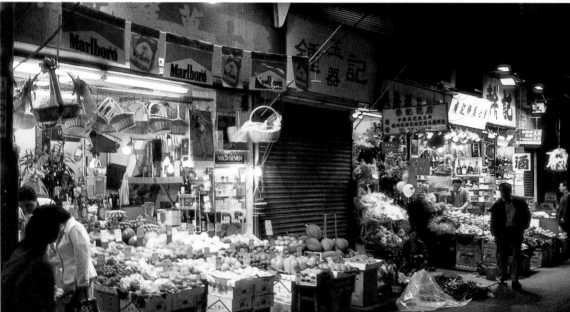

143

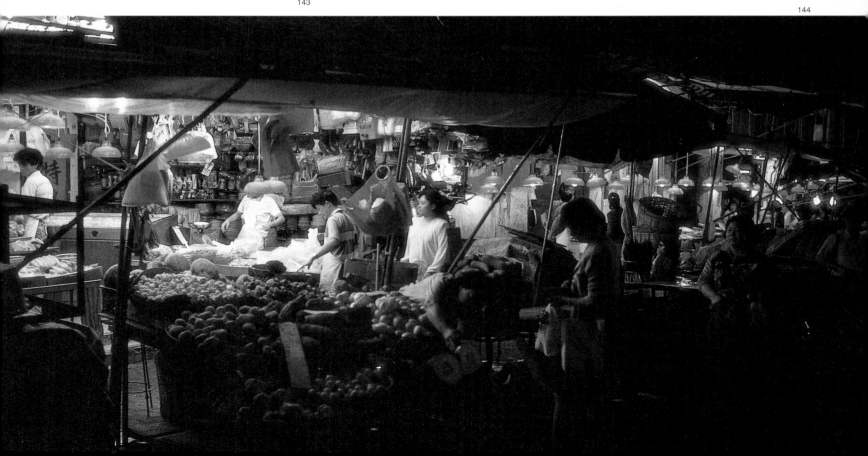

144

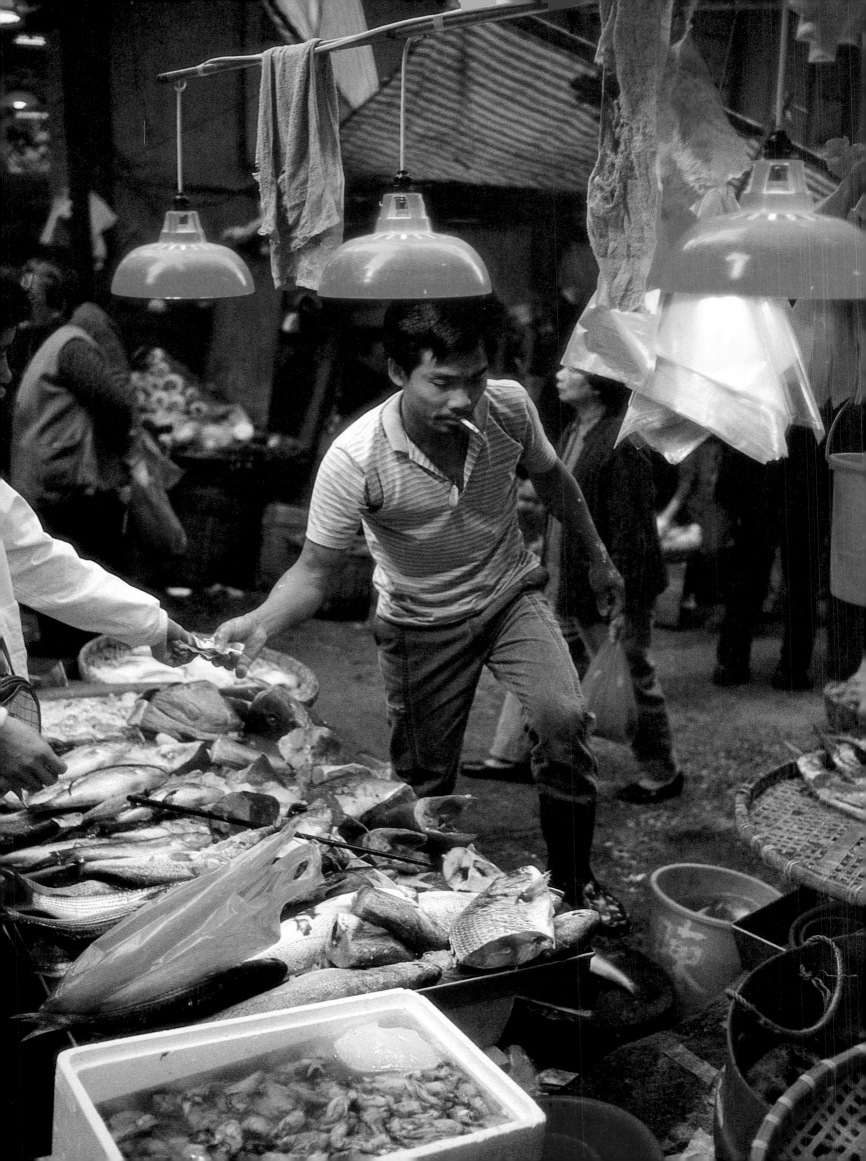

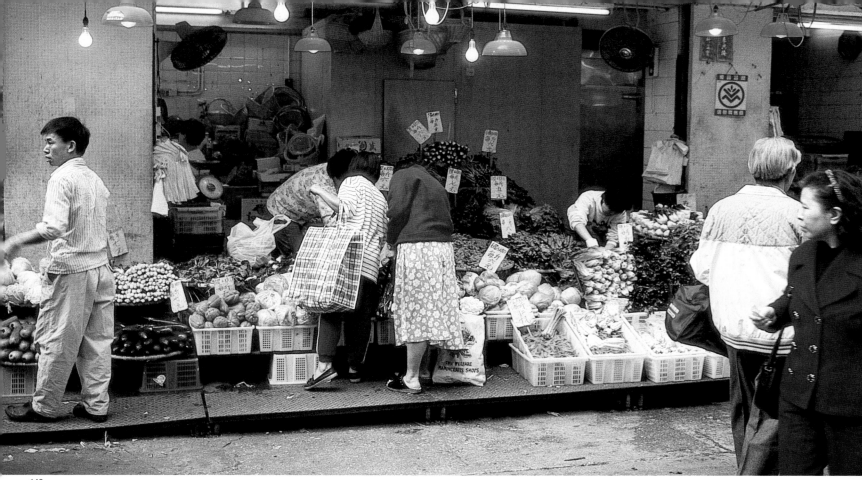

145. Chinese smoke continuously, no matter what they are doing.

146. Hong Kong housewives are choosy and knowledgeable about their greens, but then they are spoilt for choice.

147. Another type of shopping experience altogether — in one of Hong Kong's many malls.

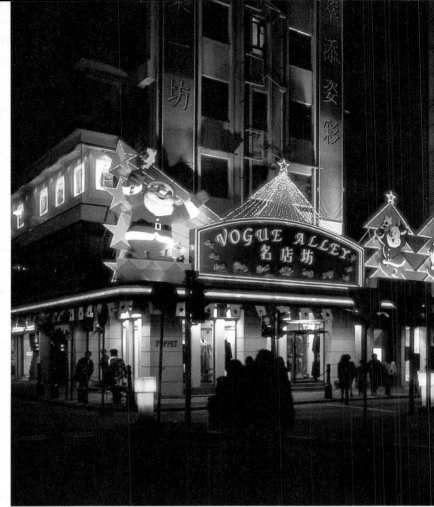

148, 149, 150, 151, 152 and **153.** Even more brashly commercial at nightime the neon signs of Hong Kong and Kowloon blaze out their messages in Cantonese and English.

151

152

153

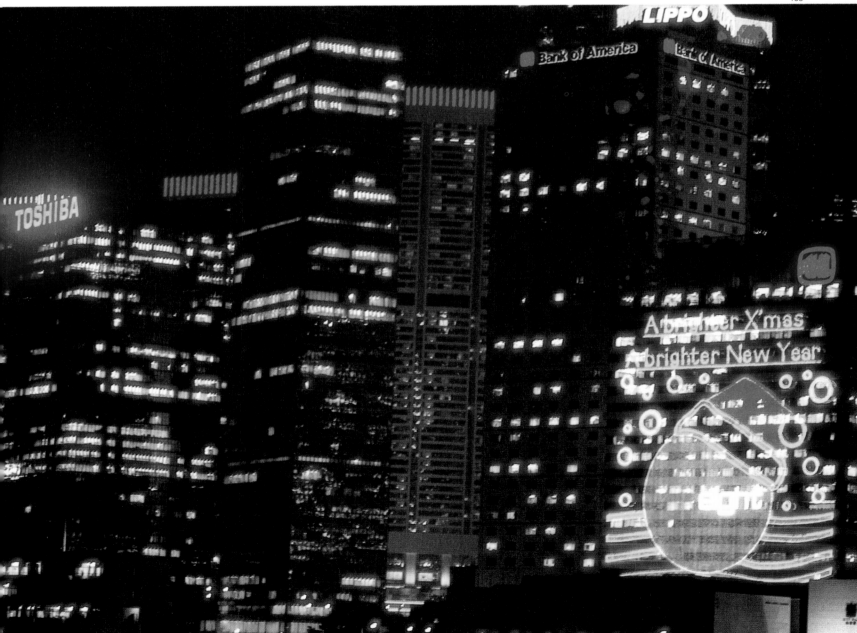

PHOTOGRAPH CREDITS

Ulrich ACKERMANN:

PAGES 2-3. 4. 10 above. and N° 3. 4. 5. 6. 7. 8. 13. 14. 15. 17. 18. 19. 20. 22. 38. 40. 41. 42. 44. 45. 46. 50. 57. 59. 60. 62. 65. 69. 72. 81. 82. 89. 90. 91. 92. 93. 96. 97. 98. 99. 100. 101. 102. 103. 104. 105. 106. 107. 108. 110. 111. 112. 113. 114. 115. 116. 117. 121. 122. 123. 124. 125. 126. 127. 128. 129. 130. 131. 132. 133. 134. 135. 136. 137. 138. 139. 140. 141. 142. 143. 144. 145. 146. 148. 149. 150. 151. 152. 153.

GAMMA/

Ph. BERG ALISTAIR/SPOONER : N° 43.

A. BERG/SPOONER : N° 119.

Alain BUU : PAGES 5. 8. 9. 10 right. and N° 1. 27. 28. 58. 61. 63. 68. 71. 88. 94. 95. 118. 120.

Peter WALLER : N° 47. 48. 49.

Guy WENBORNE/KACTUS : N° 23.

LIFE FILE PHOTO LIBRARY/

Su DAVIES : N° 25.

Peter DUNKLEY : N° 30.

Bob HARRIS : N° 77.

Juliet HIGHET : N° 147.

Jeremy HOARE : N° 9. 10. 12. 39. 51. 52. 53. 73. 74. 75. 80. 86. 109.

Ken McLAREN : PAGE 1. and N° 2. 16. 21. 26. 29. 32. 33. 34. 35. 36. 37. 54. 55. 64. 67. 76. 78. 79. 83. 85. 87.

Glenn MILLINGTON : PAGE 6.

Mike POTTER : PAGE 11. and N° 11. 24.

Richard POWERS : N° 84.

Char SAYERS : N° 70.

Catrina THOMPSON : PAGE 7.

Cliff THREADGOLD : N° 31. 56. 66.

Author : Sandra FORTY
Design : Robert WILCOCKSON

Printed in E.C. for Parkstone Editions
Copyright : 3rd term 1997
ISBN 1 85995 375 1
©Parkstone Press Ltd, Bournemouth, England, 1997

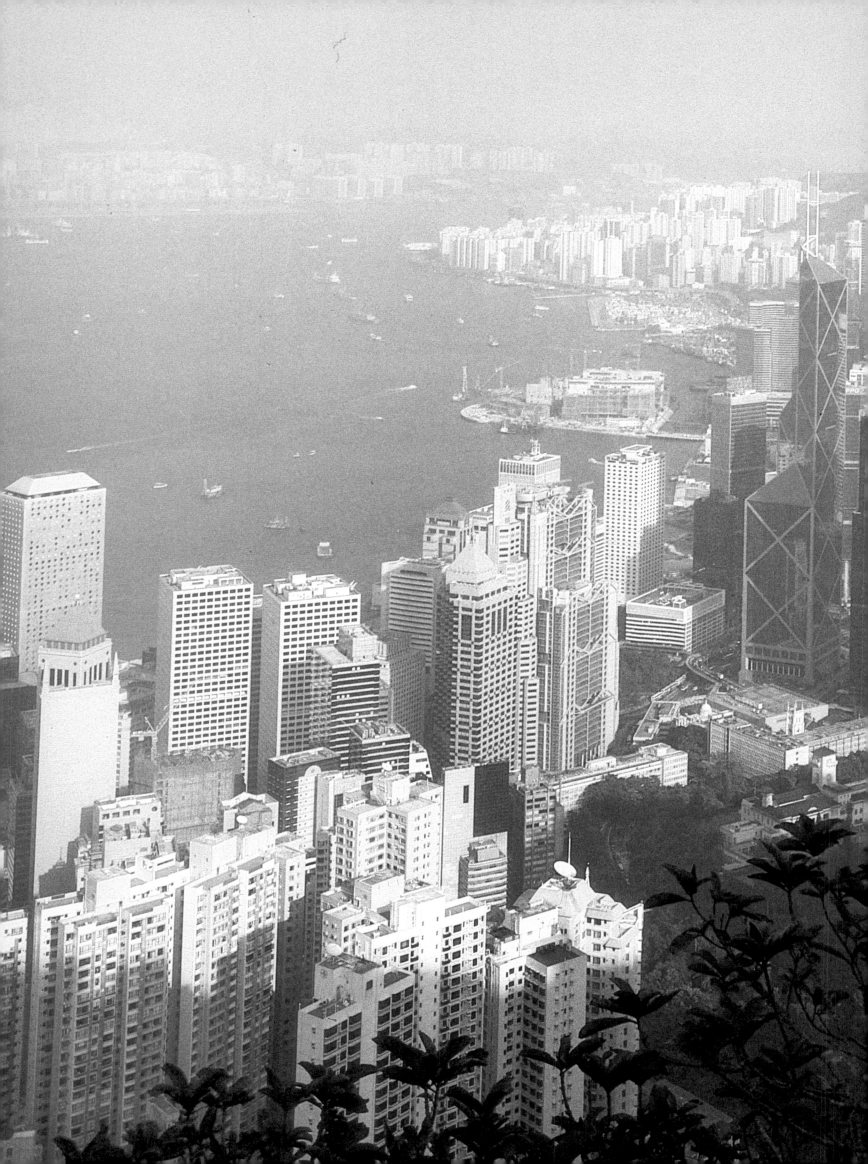